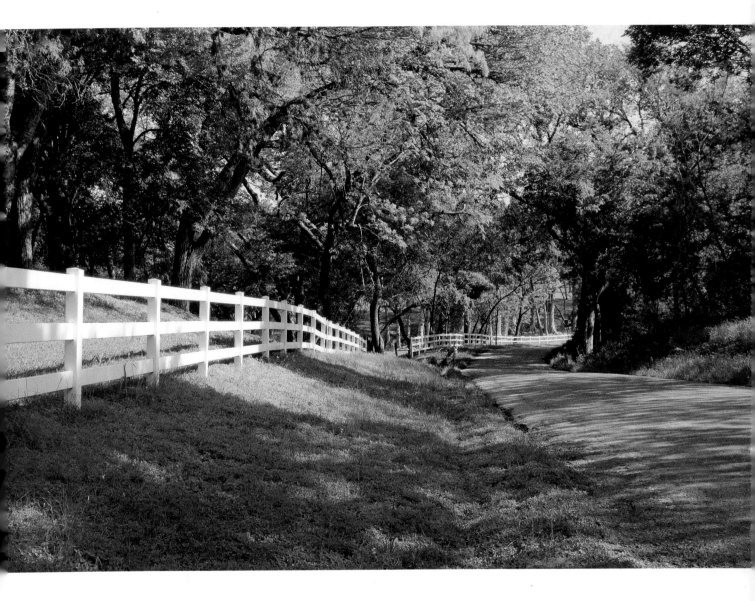

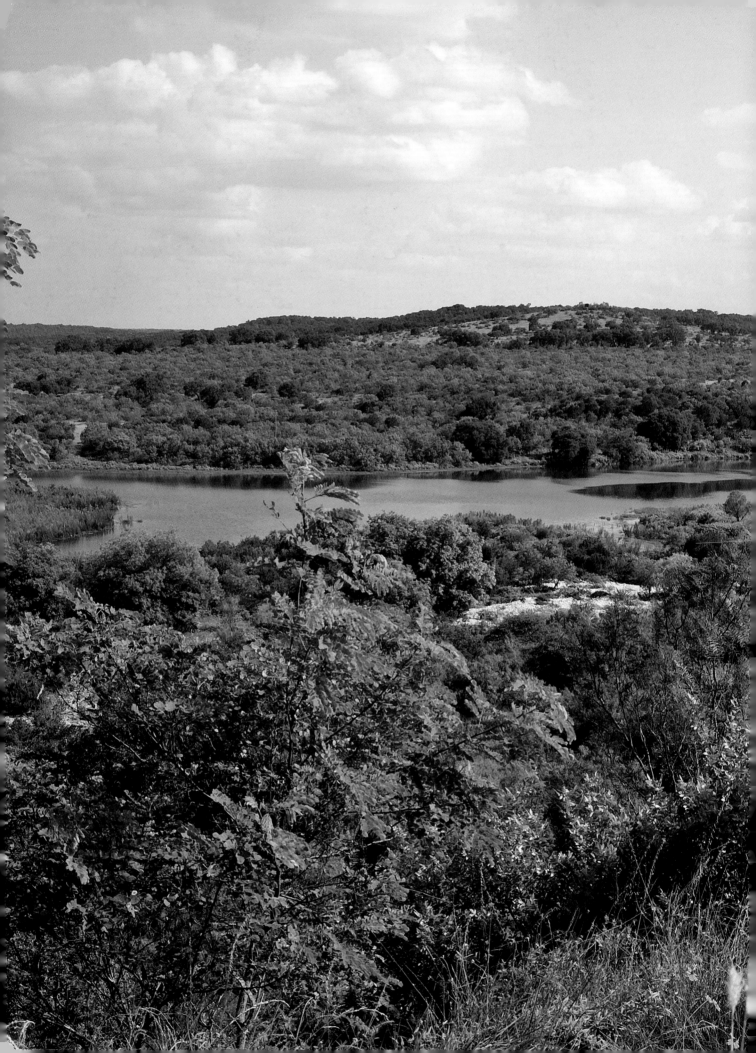

Backroads
of the Texas Hill Country

YOUR GUIDE TO THE MOST SCENIC ADVENTURES

TEXT BY **Gary Clark**
PHOTOGRAPHY BY **Kathy Adams Clark**

Voyageur Press

DEDICATION

To our parents, who made us Texans, and to our sons, Michael and Christian,
who continue our Texas legacy.

First published in 2008 by Voyageur Press, an imprint of MBI Publishing Company,
400 First Avenue North, Suite 300, Minneapolis, MN 55401 USA

Voyageur Press titles are also available at discounts in bulk quantity for industrial or sales-promotional use.
For details write to Special Sales Manager at MBI Publishing Company, 400 First Avenue North, Suite 300,
Minneapolis, MN 55401 USA.

To find out more about our books, join us online at www.voyageurpress.com.

Library of Congress Cataloging-in-Publication Data

Clark, Gary, 1943–
Backroads of the Texas Hill Country : your guide to the most scenic adventures / by Gary Clark ;
photography by Kathy Adams Clark.
 p. cm.
 Includes index.
 ISBN 978-0-7603-2690-9 (sb : alk. paper)
 1. Texas Hill Country (Tex.)–Description and travel–Guidebooks. 2. Automobile travel–Texas–Texas Hill Country–Guidebooks. I.
Clark, Gary, 1943– II. Title.
 F392.T47C53 2008
 917.64'30464–dc22

 2008017266

Edited by Jennifer Bennett and Danielle Ibister
Designed by Brian Donahue / bedesign, inc.

Printed in Singapore

FRONTISPIECE: Fence-lined road between Waring and Welfare.

PREVIOUS PAGE: The South Llano River. **INSET:** Lone Star gate ornament hanging from cedar posts.

OPPOSITE: The three-bell tower, or *espadana*, of Mission San Juan.

NEXT PAGE: Texas bluebonnets decorate Ranch Road 2323 between Llano and Fredericksburg.

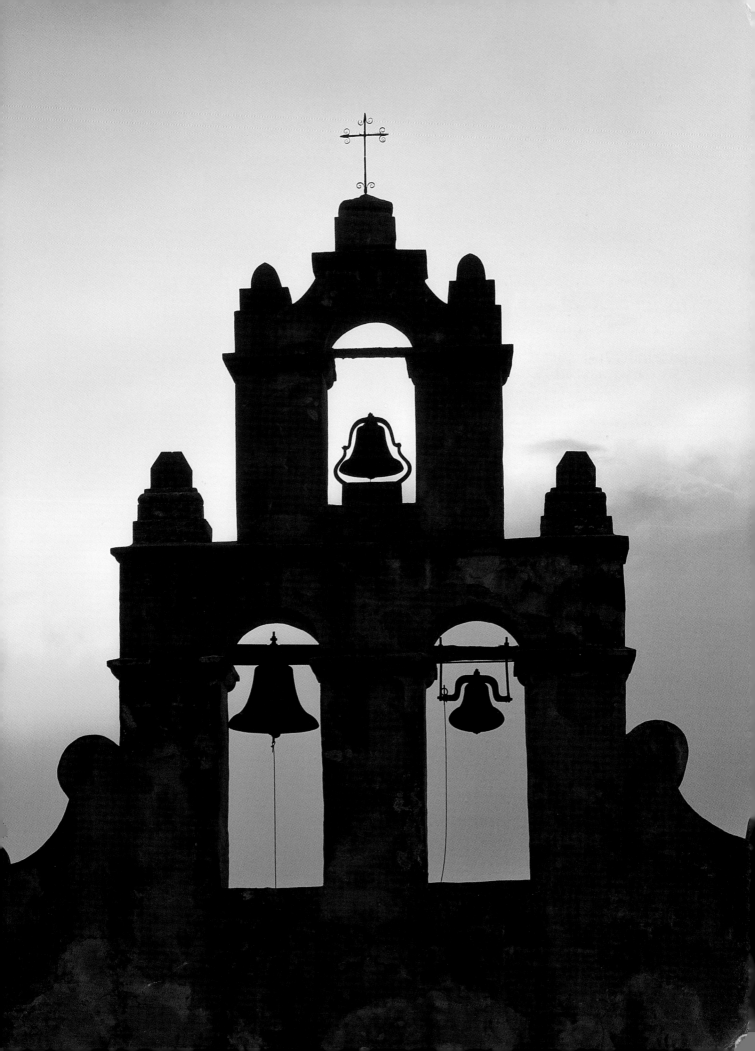

CONTENTS

INTRODUCTION

The Texas Hill Country is more a state of mind than a geographic location because hills curve over many sections of Texas, save the coastal plain. Nonetheless, we can corral the mental perception of the Hill Country into a specific geographic locale marked by gentle, tree-lined limestone hills accented by verdant valleys and rivers with cool, crystal-clear water. The serenity of the land along its backroads contrasts sharply with the bustling, car-jammed Hill Country cities such as San Antonio and Austin, although those cities surely signal its spirit. Surrounding San Antonio and Austin and veering off the raging thoroughfare of Interstate 10 that bisects the land are scenic towns and pastoral byways that give the Hill Country its magical, peaceful, and utterly alluring character.

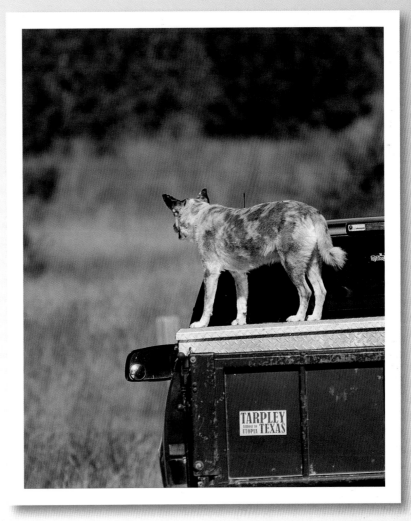

A dog is out for a drive in the back of a pickup truck near Tarpley.

OPPOSITE: The Red Hill Overlook on Park Road 11 at Palmetto State Park in Gonzales County offers a view of the surrounding countryside.

Geographically, the Hill Country may be described as resting in the center of Texas, bounded on the south by U.S. Highway 90 between Seguin and Del Rio, on the north by Texas Highway 29 between Georgetown and Menard, on the east by U.S. Highway 183 between Gonzales and Taylor, and on the west by U.S. Highway 377 between Del Rio and Junction. However, these geographic boundaries are arbitrary. The Hill Country gradually takes shape just east of Austin and fades out just west of Junction. Some would say it stretches south to the Mexican border and abuts the Great Plains to the north. We would not argue. Geologically, the Hill Country has been largely defined by ancient upheavals that created the Edwards Plateau running through south-central Texas between the Colorado River to the east and the Pecos River to the west. The rolling hills that give the land its special character lie on the eastern part of the Edwards Plateau, circumscribed by the Balcones Fault Zone to

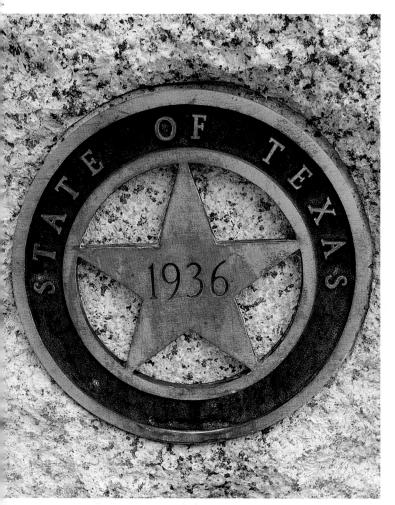

A bronze State of Texas marker graces a granite block outside the Blanco County Courthouse in Johnson City.

the east and the Llano Uplift to the north and west. Physically, the land has a rugged character boldly accented by limestone and granite rocks. Although the climate is arid, rivers and creeks crisscrossing the landscape infuse the air with a refreshingly cool feel and nourish the greenery of sprawling grasslands and Ashe juniper, oaks, and cypress trees that cover the hills and river valleys.

But in the end, Kathy and I would simply say the Hill Country is about vistas of peaceful valleys and undulating hills stretching endlessly before the eyes. It's a place you cannot get tired of, but more important, it's a place for tired minds. Relaxation seems to come from just breathing the air. The unhurried streets of the small towns compel you to relax, as do the fields of wildflowers, the cool waters of spring-fed rivers, the songs of birds echoing in canyons, and the residents who never fail to greet you with a broad smile and say to you in a slow drawl, "Howdy!"

Kathy and I make no apologies for our love of Texas. We are both native Texans with deep family roots. Kathy's family arrived here from the Alsace region of France in the 1840s, and mine came from the eastern United States about the same time. We've lived in the state our entire adult lives except for time spent away from the state for business. We have criss-crossed the state many times—and the Hill Country in particular—on countless driving expeditions to see birds, butterflies, and the other natural treasures of Texas. And we have always relished the small towns along the backroads with their rich history and matchless Texas hospitality.

In the spirit of Texas hospitality, we're now showing you some of our favorite journeys through the Texas Hill Country. All are on improved roads ranging from modern interstate highways to small rural roads. A passenger vehicle with a full tank of gas is all you need to follow the routes we've laid out. On some routes, we describe opportunities for hiking or strolling down nature trails as we, ourselves, have done untold times. Some routes suggest a strenuous but manageable hike into the countryside. Other routes require no more walking than is necessary to go into a bakery or diner for a sweet treat or plate of barbeque, as we have done so often over the years.

We offer you hundreds of stops including places with enthralling history, enchanting scenery, and delightful people. The routes can be traveled any time of the year. Winters in Texas are mild, but the Texas Hill Country will occasionally have snow or ice between

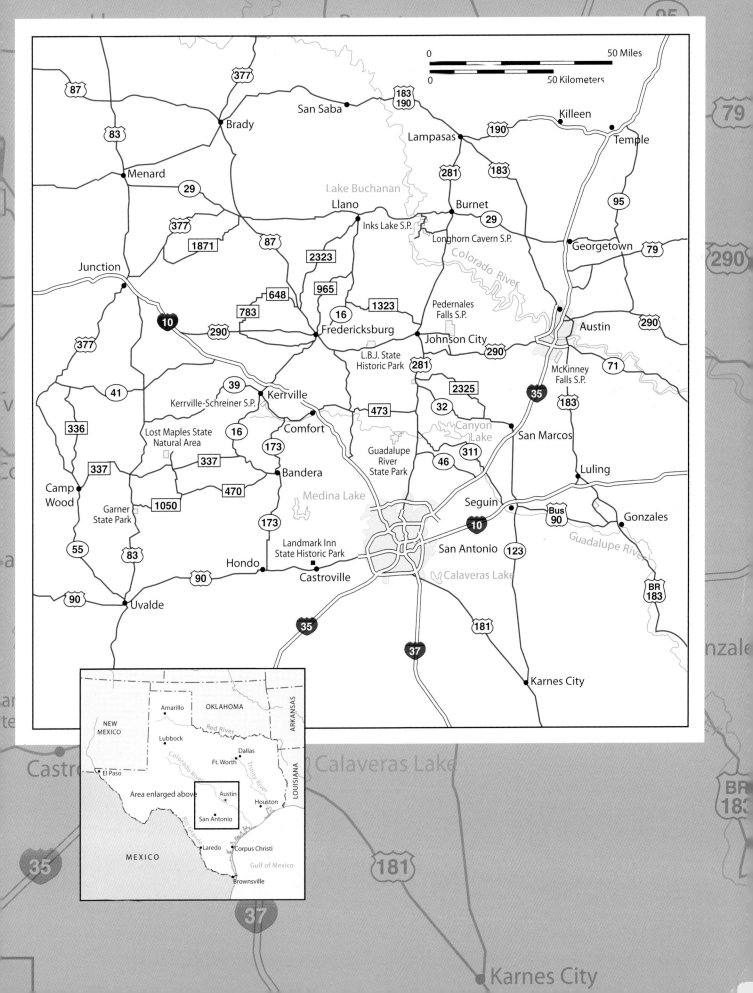

December and March. Wildflowers begin blooming in March and peak in April and May. Summers are mild but can be hot toward August. Fall begins around mid-October and continues through November. No need to let weather hold you back from exploring the Hill Country, because as we Texans say, if you don't like the weather, just wait a minute and it will change.

Each route takes you through a wonderful, natural environment, where you'll want to have binoculars and a camera. Watch for such birds as sparrows flushing out of the grass, bobwhite quail perched on fence posts, scissor-tailed flycatchers on telephone wires, and red-tailed hawks soaring overhead. Drive with a keen eye out for raccoons, opossums, squirrels, coyotes, and jackrabbits that might be crossing the road ahead of you.

Some of our routes go through Austin and San Antonio. Both cities have seen tremendous growth since the 1980s and are spreading out into the countryside. But the cities still hold their original charm, and we've created routes that will help you experience that charm.

Remember to take your time while you're exploring the Hill Country. Forego the fast-food chain restaurants for local diners with unique Texas-style cooking. Stop at any of the shops, boutiques, or bakeries that we've mentioned. Say hello to the staff and let them know this book suggested you stop. Wherever you go, strike up a conversation with the local residents who may have a great story or two to tell you. That's part of the charm of the Hill Country.

A few travel suggestions: Carry current road maps, don't hesitate to ask directions from local residents, respect private property, and never cross a fence to get to a river or field—we offer plenty of public access points to scenic sites. Park courteously in designated areas, relax, put on a smile. You're in a relaxing and friendly part of the world.

Gary Clark
August 2007

OPPOSITE: Mansefeldt is a private estate north of Fredericksburg. The current owners took the original 1850s-era home and turned it into a showcase of interior design and Texan style.

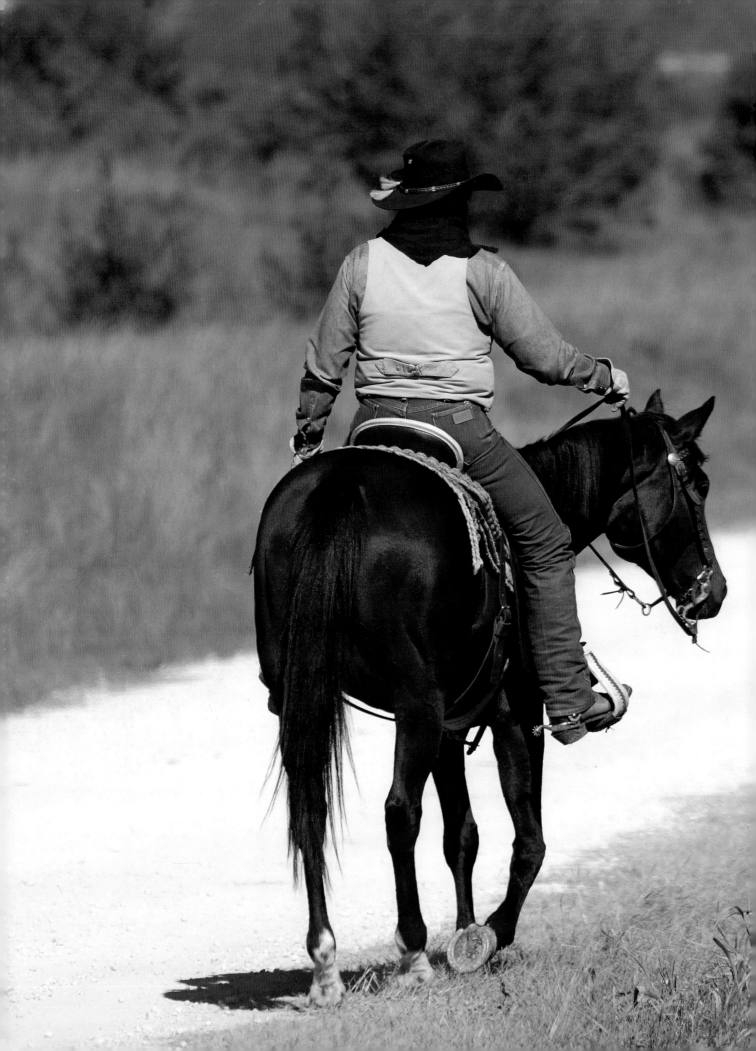

PART I

Southwest Region

Cowboy Culture and Fertile Farmlands

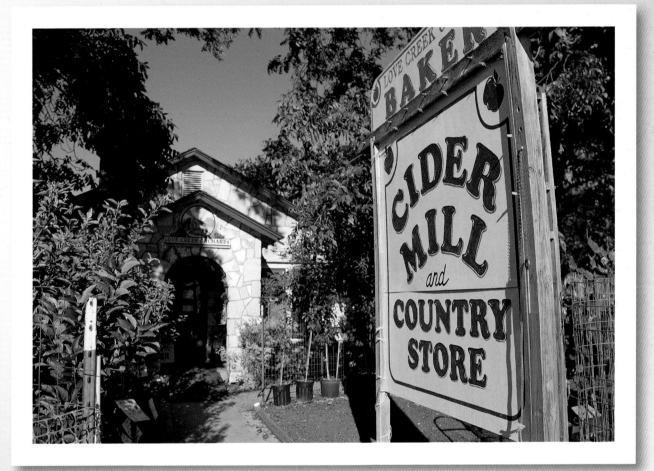

Love Creek Orchard Store in Medina offers fresh apples, baked goods, and kitchen supplies.

OPPOSITE: A cowboy rides his horse at the Hill Country Natural Area near Bandera.

The Hill Country west of San Antonio bounded on the south by U.S. Highway 90 and on the north by Interstate 10 is a land of vast ranches, verdant hills and valleys, ice-cold spring-fed rivers, and scenic parks that steal if not soothe the heart. It's a land tamed by cowboys, cultivated by farmers, and enriched by merchants.

Places like Bandera are home to the culture of cowboys, right down to the savory breakfasts of eggs and bacon served at local restaurants. A look at the sprawling ranches surrounding the town signals a land of real cowboys doing the real work—and hard work at that—of herding cattle. No wonder they eat a hearty breakfast!

Along the southern portion of the territory are expansive farmlands where cotton, corn, sorghum, and other crops flourish in soil made fertile by rivers including the Medina, Sabinal, and Frio draining sediments off the Balcones Escarpment. The farms (and ranches) were carved on the edge of the escarpment by settlers from Germany and France, and their culture of land cultivation, brick making, and mercantilism still reigns in the small towns.

Heart-stirring scenery among hills and valleys proves the magnetism the land had for nineteenth-century immigrants arriving from the Old World. Many of the vistas they had still exist but are nowhere more awesome than at parks such as Garner State Park and Lost Maples State Natural Area. Multiple campgrounds along the rivers offer views of tranquil, clear-water streams and peaceful valleys that must have seemed like a new Garden of Eden to early settlers.

History runs colorful and deep in this land—from the story of Charles Lindbergh, who crash-landed a plane in a local town three years before he succeeded in being the first person to make a trans-Atlantic flight, to the legend of John Nance "Cactus Jack" Garner, who, as a two-term vice president under Franklin D. Roosevelt, allegedly called the vice presidency "not worth a warm bucket of piss"—never say that Texas history isn't colorful.

ROUTE 1

Bandera to Concan

The drive from Bandera to Concan could consume one full day or one full week. Beautiful scenery and the lore of Texas history lie bountifully between these two cities. The towns along the route welcome visitors with a wide variety of things to do and see.

Texas Highway 173 leads north to Bandera off U.S. Highway 90 between Hondo and Castroville. Bandera is the county seat of Bandera County. The twenty-eight-mile drive to Bandera from

Route ①

Bandera is located at the intersection of Texas Highways 173 and 16. Travel north on Highway 16 and turn west on Ranch Road 470 toward Tarpley. Utopia is 19 miles past Tarpley on Ranch Road 470. Drive through Utopia, and on the outskirts of town, turn west on Ranch Road 1050 to reach Garner State Park. Leave Garner State Park on Ranch Road 1050 and drive a short distance west to U.S. Highway 83. Concan and recreational facilities along the Frio River can be reached by heading south on U.S. 83 and turning off at Uvalde County Road 348 or River Road.

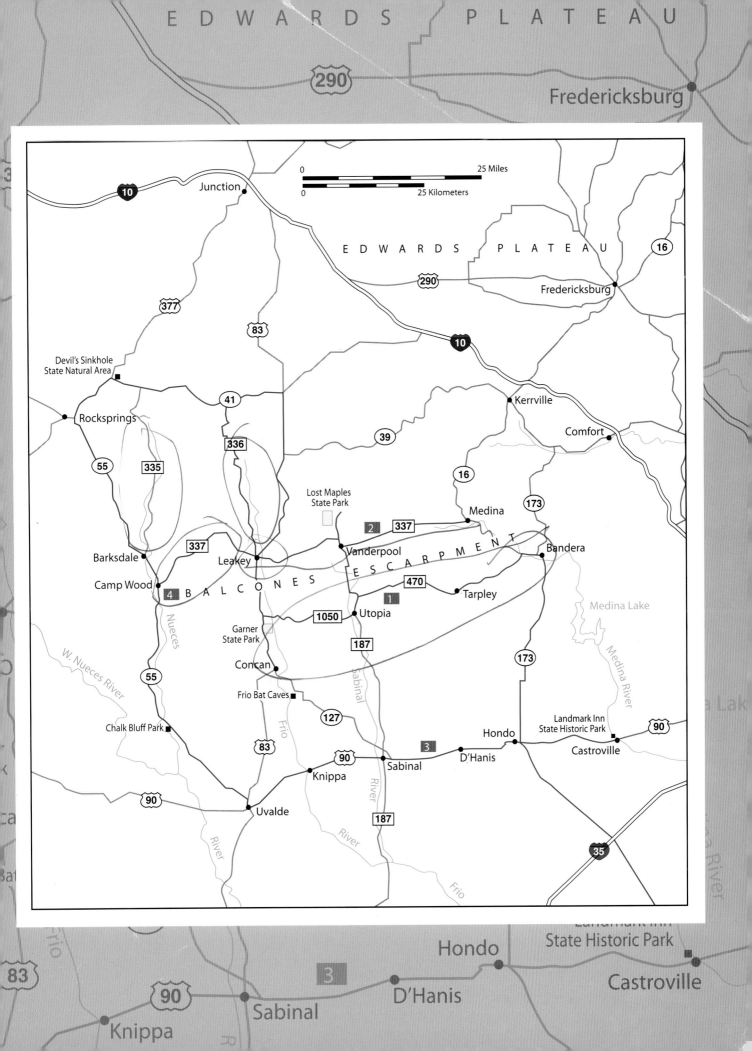

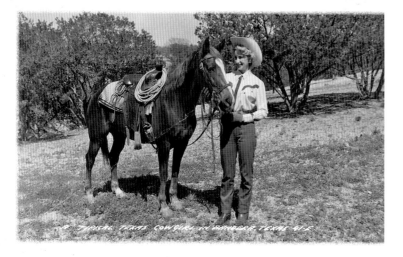

Bandera has always been cowgirl country. This image was made in the 1950s by a traveling photographer working for a postcard company.

Highway 173 crosses farming country where grains grow in the summertime and wildflowers line the road nearly all year.

Highway 173 starts to gain elevation after about five miles and the vegetation changes to typical Hill Country terrain of low-lying brush, oaks, mesquite, Ashe juniper, and grasslands. Gnarled limestone pokes through the vegetation and crops out in road-cuts.

A picnic area sixteen miles outside Bandera offers a chance to look back down the highway to the flat farmland along U.S. 90. The picnic grounds are also a great place to see the edge of the Balcones Escarpment, an area of rough-and-tumble terrain between the Edwards Plateau and the coastal plain.

The Balcones Escarpment stretches from Waco to San Antonio and forms the eastern boundary of the Texas Hill Country. Most of central Texas was uplifted several thousand feet about ten million years ago. That uplift caused hundreds of faults that are known today as the Balcones Fault Zone.

Glen Rose limestone is visible looking south from the picnic area on Highway 173, and Edwards limestone becomes the predominant rock to the north.

Legend has it that Bandera got its name from the red flag or banner that Mexicans flew to denote the dividing line between the hunting areas for Mexicans and the areas for Native Americans. Strife with Native Americans over rights to the land was commonplace. Early settlers from Mexico, and later from the United States, fought countless battles with Apaches and Comanches over game, water, and land. Eventually, the Native Americans lost their battle for the land and were driven out.

Settlers built a lumber mill to make cypress shingles in Bandera in 1853 on the banks of the cypress-lined Medina River. Shortly thereafter, sixteen families from Poland arrived to work in the mill, blending their heritage with the existing mix of settlers.

The Polish families brought their Catholic faith with them and established the St. Stanislaus Church. Today, St. Stanislaus is the second-oldest Polish Catholic parish in the United States. The current church on 7th Street dates back to 1876. A visit to the grounds is a chance to see historic architecture in a quiet setting.

But the real heart of Bandera unfolds back on Highway 173, where the city has done a remarkable job of conserving its cowboy look and feel by blending old stores with new ones.

Nothing bespeaks Bandera's cowboy character like a small café on Highway 173 called the OST Diner. It hasn't changed much since its construction in the 1940s, and you really haven't tasted breakfast

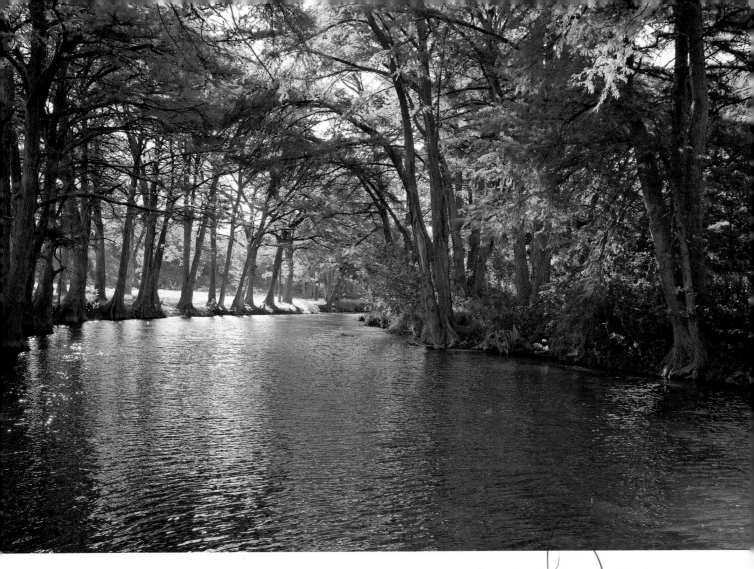

until you drop in for a cup of steaming hot coffee, fresh eggs, crisp bacon, warm biscuits, and sumptuous gravy. On any given morning, you'll find ranchers, businesspeople, hunters, and tourists gathered at the diner for conversation and food.

On weekends, the OST Diner is likely to be crowded at breakfast with people taking a getaway weekend from big cities such as Houston, San Antonio, and Austin. The diner is a favorite weekend stop for motorcyclists who include an odd mix of doctors, lawyers, and business executives—both male and female—dressed in black leather pants and jackets and cruising into town on pricey Harley-Davidson, Honda, and BMW motorcycles.

By whatever means you use to get to Bandera, park anywhere along Highway 173 and stroll along the sidewalks of this little town known as the Cowboy Capital of Texas. Sidewalk shops are filled with western clothes, antiques, decorative items, and crafts. Hardware stores, clothing stores, and offices stand alongside the shops. Many fine hotels offer a nice evening's rest should you decide to spend the night—not a bad idea.

The Bandera County Courthouse, a focal point of downtown, was built in 1890. Local quarries provided the white limestone for this classic example of Second Renaissance Revival–style architecture.

The banks of the Medina River in Bandera are lined with cypress trees.

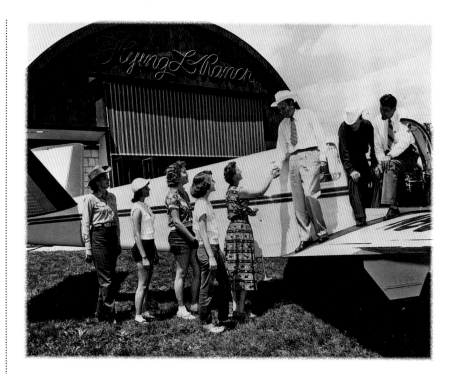

Staff welcome visitors to the Flying L Ranch near Bandera in the 1960s. The resort is still open and welcomes visitors throughout the year.

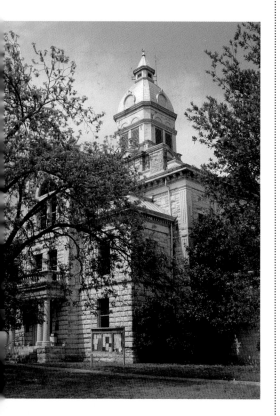

The Bandera County Courthouse was built of native limestone in 1890 in second Renaissance Revival style.

The three-story courthouse with a cupola and clock tower became a Texas Historic Landmark in 1972.

Tour the courthouse grounds for a little slice of history. There are markers dedicated to the soldiers of World War I, World War II, and Desert Storm. Markers also commemorate legendary Texas cowboys.

Travel north on Texas Highway 16 on the outskirts of Bandera along the Medina River. Turn west on Ranch Road 470 toward Tarpley, and immediately after you cross the river, you'll see a small picnic area where you may linger a bit longer on an eminence in Bandera.

Ranch Road 470 is an excellent driving road that crosses rolling hills dotted with oaks and Ashe juniper. Ranch gates of varying styles mark entrances to properties along the route. Each gate, depending on its plain or ornate structure, may offer a hint about the property it protects in the beautiful hills, from a modest family homestead to an elaborate corporate hideaway.

Past Tarpley, a simple town with a grocery store and a couple of shops, Ranch Road 470 climbs over steep hills and loops around tight curves rounding the terrain. The land is lush with grass and vegetation.

Most of the land is private, as is typical of Texas where all but 2 percent of land is held in private hands. Nonetheless, landowners tend to be good land stewards by nurturing property that may have been in their family for over a century and a half.

Some of the ranches along the highway are open to the public as bed and breakfasts, hunting lodges, or dude ranches. Check with the local Chamber of Commerce for contact information.

You'll find no official pull-offs along this road, but you can easily pull off on any number of wide paved spaces in the shoulder. Enjoy

TEXAS HILL COUNTRY DRIVING

DON'T FEEL AS IF you have to hurry along any Texas two-lane country road. Take your time and enjoy the scenery. If you notice someone tailgating you, then slow down, politely pull as close as you can toward the side or shoulder of the road, and let the person pass. It's probably a local person trying to make a doctor's appointment or trying to pick up a child at school, and most of the time, the person will wave at you in thanks. If the person doesn't wave, it's probably a tourist who has yet to shed the hustle and bustle of big city life.

The traditional mode of transportation in Texas' rural communities is the pickup truck or SUV. Male drivers usually place a cowboy hat on the dashboard between the driver and passenger seats. He is likely to greet oncoming vehicles with a slight bow of the head and wave of the hand. The wave is usually just two or three fingers raised off the steering wheel. Wave back. Texans living along the backroads are a friendly lot and proud of their reputation as the "Friendly State."

the view from the side of the road and take a few pictures, listen to bird songs, and look at wildflowers. *Do not cross fences*, no matter how tempting the scene beyond them may be.

Utopia is nineteen miles from Tarpley in a flat area covered in grasslands and oaks. Notice that the oak trees in the region have trunks that grow in a crooked, wavy pattern. Local lore describes the trees as drunken oaks reveling in the beauty of Texas.

The town of Utopia seems as peaceful as its name implies. It has a gas station, bank, post office, and general store mixed in with antique shops, cafés, and ice cream parlors. The Utopia Methodist Church at the corner of Oak and Johnson streets was built on the site of a former brush arbor where services were first held in 1868 under the towering oaks. The church was constructed in 1892. Eastern bluebirds that always seem heaven-sent flit among the blissful oaks.

Ranch Road 1050 east out of Utopia leads to Garner State Park. Named for Cactus Jack Garner, vice president under Franklin Delano Roosevelt, the 1,419-acre park gives prime public access to the Frio River.

Garner State Park is one of the busiest state parks in Texas. Thousands of visitors come to the park to camp, swim, fish, hike, and enjoy the outdoors. The park welcomes visitors with a miniature golf course, store, cabins, and unparalleled scenic beauty.

Lining the Frio River in and around the small village of Concan, seven miles south of Garner State Park, are private campgrounds—many with comfortable cabins—and bed and breakfasts. The resorts, campgrounds, and vacation rentals around Concan offer a fun and relaxing place to spend a couple of days. But a truly exciting attraction in the Concan area is the Frio Bat Caves. An estimated 17 million Mexican free-tailed bats emerge from the cave every evening

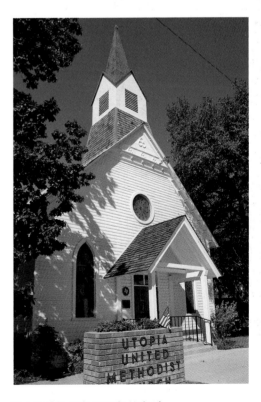

The Gothic-style Utopia United Methodist Church in Utopia was originally built in 1892.

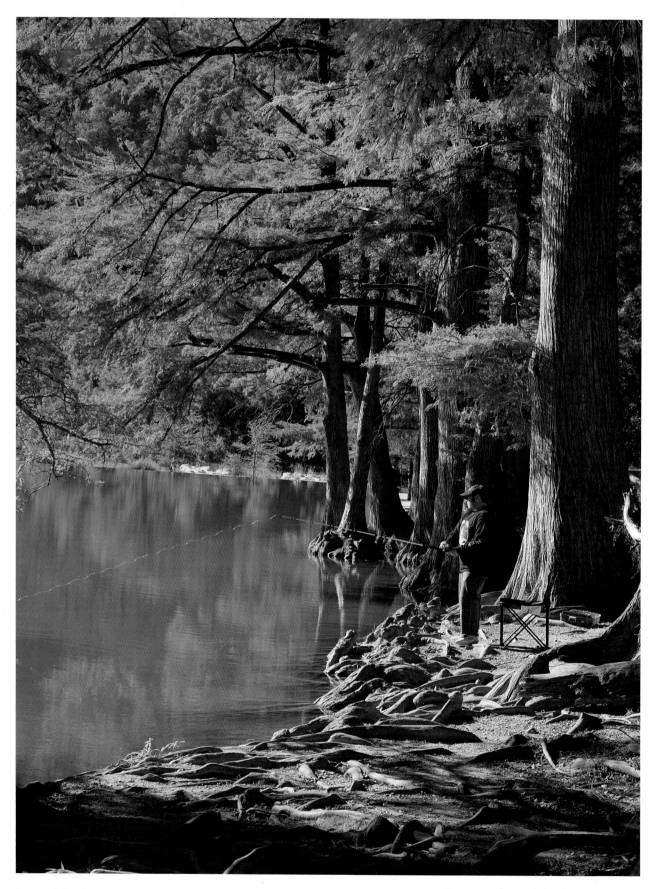

ABOVE: Frio River at Garner State Park near Concan is popular with anglers.

OPPOSITE: A prominent limestone outcrop towers above the Frio River near Concan.

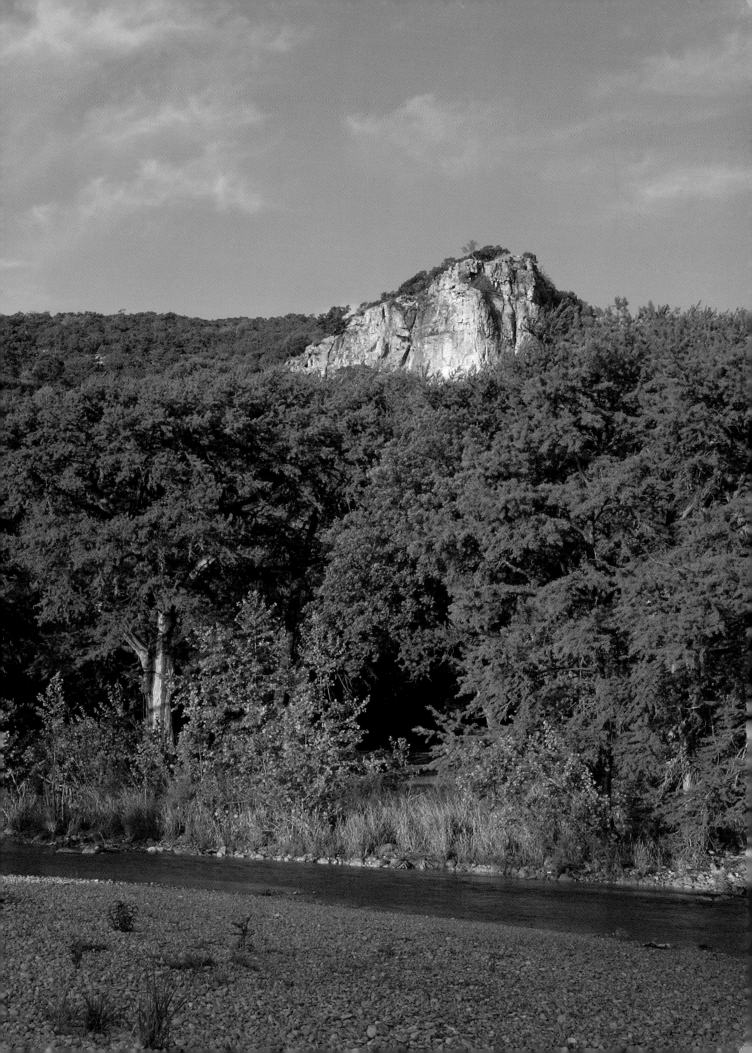

A quiet two-lane road near Concan invites travelers to explore.

from March to October. The cave is located on Ranch Road 2690, about 4.5 miles from the intersection of U.S. Highway 83 and Texas Highway 127. (See Route 3 for more information.)

Accommodations similar to those in Concan are also scattered along U.S. 83, a four-lane highway that connects Uvalde to the south with Interstate 10 to the north. Uvalde County Road 348, which locals call the River Road, meanders along the Frio River and embraces a number of famous vacation resorts.

ROUTE 2

Leakey to Lost Maples State Park, Vanderpool, and Medina

The quaint town of Leakey (pronounced LAY-key) is forty-one miles north of Uvalde on U.S. Highway 83. The little crossroads town of the Texas Hill Country has been inhabited since the time of the Comanche and Apache Native Americans. Although Mexican explorers didn't come through Leakey per se, they did move through nearby Camp Wood between 1542 and 1700. European settlers arrived in the Leakey area by the early 1800s. Today, the town is a mixture of ranchers, small-business owners, and tourists.

The cemetery in Leakey is a tangible piece of the region's history. The first burials in the cemetery were settlers killed by Lipan Apaches. A marker on the west side of the cemetery tells the story of the victims.

Several roads run in and out of Leakey, but take Ranch Road 337 east to Vanderpool and Medina. The road is a favorite route for motorcycle and sports-car enthusiasts because it climbs and winds over and around hills and presents extraordinary Hill Country vistas. The fifteen miles of road to Vanderpool could consume your entire morning or afternoon as you stop at the pull-offs to photograph the scenery or listen to birds.

Vanderpool offers no services, shops, or cafés—no need to hurry to get there.

A short and highly worthwhile diversion is Lost Maples State Park on Ranch Road 187 north of Vanderpool. The gem of the Texas

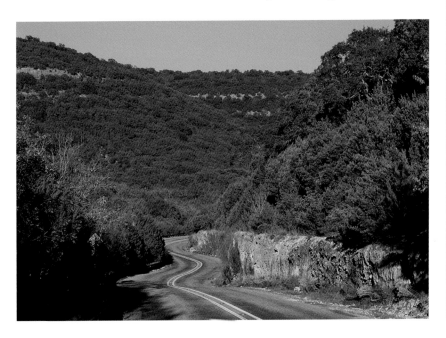

Route 2

Leakey is at the intersection of U.S. Highway 83 and Ranch Road 337. Ranch Road 337 east leads to Vanderpool and then Medina. Lost Maples State Park is a short distance north of Vanderpool on Ranch Road 187.

The twists and turns between Camp Wood and Medina make Ranch Road 337 a favorite with drivers.

state park system is known for its lovely fall foliage. The array of golden-yellow, orange, and red leaves lining the park's canyons in early November attract scores of "leaf peepers" (people who seek out autumn leaves) coming from around the country.

As Ranch Road 337 continues out of Vanderpool, it crosses open country until it reaches Medina. This section of 337 is equally as beautiful as the road out of Leakey. Rolling hills accented by smooth valleys carved by eons of creek erosion stretch from horizon to horizon.

Pull off at one of the many designated areas or drive the road straight to Medina. Travelers frequently find Ranch Road 337 worth several trips in one day.

Spend a little time in Medina, though. It's the Apple Capital of Texas, with orchards and shops producing unbelievably tasty apple pies and fritters, along with apple butter and fresh apples. The annual Apple Festival in July offers fun for the entire family. In the fall, the orchards open their doors to the public to walk the pumpkin patches, maybe buy one to take home, and even enjoy an old-fashioned hayride.

Bigtooth maples offer spectacular fall color at Lost Maples State Natural Area.

OPPOSITE: Stop and greet the locals as you approach Medina.

LOST MAPLES STATE NATURAL AREA

LOST MAPLES STATE NATURAL AREA encompasses 2,174 acres and protects a stand of bigtooth maples that are believed to be a remnant maple forest from the Pleistocene ice age.

The park contains day-use picnic areas, parking, and restrooms. Camping areas with electricity, showers, and dump stations allow for overnight or extended stays.

The park boasts more than ten miles of hiking trails that descend to the Sabinal River and ascend to rocky hillsides with breathtaking views, particularly in autumn. Hikers of all skill levels enjoy this park because of its varied terrain.

White-tailed deer are common in the park and wild turkeys are often seen on the roads and trails. Birdwatchers and naturalists enjoy the park because it straddles western and eastern ecosystems. As a result, a western tanager (bird of the west) might pop up alongside a summer tanager (bird of the east). And butterflies of the west, like a California sister, might flutter alongside a butterfly of the east, like a common buckeye.

The park contains three state champion big trees—escarpment chokecherry, Texas ash, and bigtooth maple—which have been nominated for the American Forestry Association Big Tree program.

Admission to the park is $5 per adult with children under 12 free. Call for information at 830-966-3413. Camping reservations are through Texas Parks & Wildlife at 512-389-8900 or on the web.

Once a stagecoach station, Landmark Inn State Historic Site in Castroville today houses a museum and hotel.

OPPOSITE: The bathhouse balcony at the Landmark Inn overlooks the gardens of Castroville. Built in the mid-1840s, the bathhouse now functions as two sleeping rooms for the bed and breakfast operated by Texas Parks & Wildlife.

Route **3**

The 81-mile drive from Castroville to Uvalde is along U.S. Highway 90. All historic attractions mentioned in the text are found within a couple of blocks of U.S. 90. The Sunset Bat Flight Tour at Frio Cave is 36 miles north of Sabinal on Texas Highway 127.

Castroville to Uvalde

Castroville is a town with deep roots in Texas history. Both Native Americans and immigrants from France have left a noticeable mark on this historic town. Today, vacationers and residents rave about the homeyness and hospitality found in Castroville.

The town rests on a flat, agricultural plain at the base of the jagged hills that make up the Balcones Escarpment. The Medina River flows through town, and U.S. Highway 90 forms the main traffic artery. Restaurants, cafés, bakeries, shops, and historical attractions welcome visitors.

Comanche and Lipan Apache were the first humans to settle in this valley along the Medina River. Paths used by Native Americans traveling between northern Mexico and settlements in San Antonio were expanded by the Spanish Army in the early 1800s.

The "Texians," as they were called during the Texas fight for independence from Mexico, defeated the Mexican army in 1836 and opened up Texas to immigrants from other countries. One of those immigrants, Baron Henri de Castro, recruited twenty-seven French and German settlers to build a settlement where present-day U.S. 90 crosses the Medina River. On September 12, 1844, the settlers held an election and named the settlement Castroville. Also on that day, Bishop Odin stood on the banks of the river under the shade of pecan trees and dedicated the cornerstone of a new church.

Today, the church dedication spot is preserved by Texas Parks and Wildlife as part of the Landmark Inn State Historic Park. The inn is a good starting point for any visit to Castroville. The park preserves progeny of the historic pecan trees, a grist mill, several outbuildings, and the old Vance Hotel. The main buildings in the park are preserved as a bed and breakfast and historic site.

Walk through the grounds and imagine stagecoaches and wagon trains stopping here in the mid-1800s on their way to Mexico and El Paso. Imagine covered wagons passing this way in 1849 on their way to California during the country's legendary gold rush. The Landmark Inn contains a small museum, gift shop, bookstore, and warm, friendly staff willing to answer your questions. (For reservations, call 512-931-2133.)

September Square is across U.S. 90 from the Landmark Inn. The shaded square is in the center of town and contains a small garden surrounded by cafés and shops offering antiques and crafts. The town offers a walking tour from the shaded square. Ask for details at any business.

No trip to Castroville is complete without a visit to Haby's Alsatian Bakery on U.S. 90. The fresh-baked bread, pastries, and cookies are a welcome treat for visitors and residents alike.

Castroville's main square offers a wide variety of antique and gift shops.

U.S. 90, heading west out of Castroville, climbs up the ancient banks of the Medina River. Pull into the roadside park at the top of the bluff to enjoy the panoramic view of Castroville in the valley below before driving to Hondo.

Hondo is a crossroads town in the Texas Hill Country. Many people drive through Hondo on their way to the parks and rivers to the north or major cities to the west, but Hondo is worth a stop.

The Galveston, Harrisburg & San Antonio Railway built a railroad through Hondo in 1881. The railroad fostered construction of a post office in 1882, and probably attracted the town's twenty-five residents by 1884. The restored railway platform adjacent to the current railway tracks and near the historic district of downtown is worth a look. Most of the historic buildings were built of D'Hanis brick.

The town of D'Hanis, eight miles west of Hondo on U.S. 90, is the fourth and last settlement started by Henri Castro. He sold plots of land in the area to some of the settlers he brought to Texas in 1847. The settlers built thatch and rock buildings and formed a community, but when the railroad bypassed the town, the settlers relocated along the tracks and called the new community New D'Hanis. Eventually, the name was simplified to D'Hanis.

The D'Hanis Brick and Tile Company began in 1883. The company still operates today just north across the railroad tracks in D'Hanis. Its deep, rust-colored bricks have been used throughout the region to build houses, schools, and commercial establishments like the Koch Hotel, which also stands just north across the railroad tracks.

Sabinal is twelve miles west from D'Hanis on U.S. 90. The town was originally called Hammer's Station when settlers founded the

community in 1854. The Second United States Cavalry established Camp Sabinal two years later and the town took the name Sabinal.

Because Sabinal sits near a favored hunting area, the town has developed such festivals as the Wild Hog Festival in March and the Bow Hunters Roundup in October.

Sabinal is also a gateway to campgrounds and lodges along the Frio River where scores of people go for relaxation throughout the spring, summer, and fall. Many tourists go through Sabinal to visit the Sunset Bat Flight Tour at Frio Cave, situated about thirty-six miles north of the town, toward Concan. The cave is the summer home of 10 to 12 million Mexican free-tailed bats. Female bats give birth in March and raise their young during the summer. Each evening at sunset, the bats emerge from the cave to create a spectacular show as they funnel out of the cave in great clouds and fan out across the Hill Country to consume millions of insects. (Contact Bain Walker, Hill Country Adventures at (830) 966-2320.)

Knippa is the last town west on the route along U.S. 90 before reaching Uvalde. The roots of Knippa go back to 1887 when George Knippa, a freight hauler, encouraged his friends to settle and farm the area's fertile land. Early settlers spoke German until the language was banned by Uvalde County during World War I. However, Knippa residents sued all the way to the U.S. Supreme Court, and in 1918 won the right to speak their native language.

U.S. 90 continues west into Uvalde, the seat of Uvalde County. The people of Uvalde want everyone to know that their community is the "City of Trees," an evident fact as travelers approach the center of town. Pecan and oak trees tower over the highway, creating a tranquil atmosphere to the town. All roads in Uvalde lead to the old town plaza. Historic buildings surround the plaza dominated by the Uvalde County Courthouse, a showcase of Texas Renaissance–style architecture built in 1927. The Grande Opera House on the northeast corner dates to 1891. Theatrical and musical productions are still hosted in the theater that has an ornate metal roof and a dragon on top of the steeple. Stop in and have a look at the historic photos lining the walls.

No visit to Uvalde is complete without a driving tour through the historic district, where all the early streets were laid out in a grid pattern with four plazas. Stately homes on Park, High, Getty, and Main streets, built in the late 1800s and early 1900s, are an indication of the wealthy farming and ranching families that settled in this area. The home owned by Cactus Jack Garner now houses a museum of his life on Park Street.

This limestone structure from an old mining operation stands near the entrance to the Frio Bat Cave.

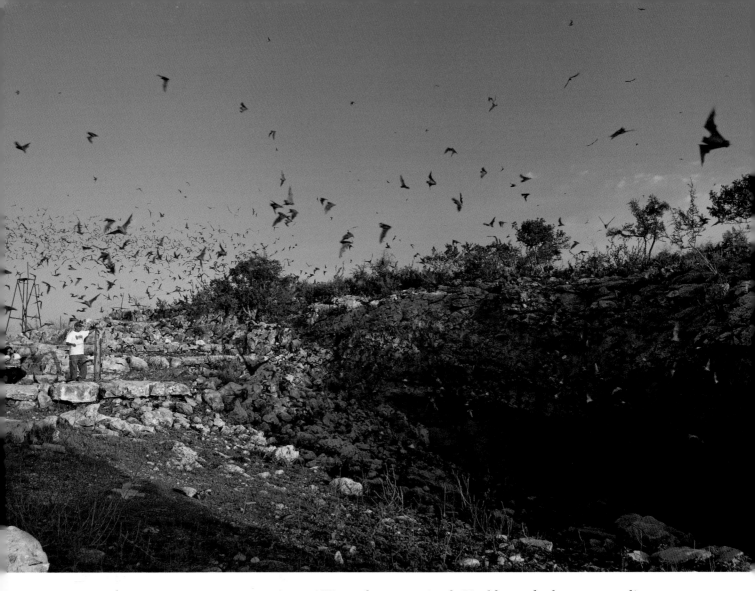

Mexican free-tailed bats stream out of the Frio Bat Cave near Concan at sunset in a spectacular display.

Water has sustained Uvalde and the surrounding country throughout its history. Because of the abundant water, people have farmed pecan trees and vegetable crops and raised beef and goats for more than 150 years. Today, the city uses the slogan "County of 1,000 Springs" to attract visitors to the outdoor recreational opportunities of the area.

ROUTE 4

Camp Wood Scenic Loop

The area around Camp Wood offers an opportunity to get out on open, rolling, and twisting country roads. It's been said that County Roads 335, 336, and 337 are the holy trinity of motorcycle routes in Texas. Yet, anyone with an appreciation for driving the open road will enjoy this loop.

Camp Wood lies 37 miles outside Uvalde. Highway 55 crosses barren, open land that resembles a limestone moonscape covered

in cacti—a stark contrast to the beautiful, tree-lined streets of Uvalde and the rolling terrain ahead in Camp Wood.

There is an entrance road to Chalk Bluff Park fourteen miles northwest of Uvalde on Highway 55. Turn on the road and drive under the white stone entryway with the wrought-iron arch to visit this private park.

Chalk Bluff Park is listed as site 023 on the Heart of Texas Wildlife Trail. Birdwatchers, campers, and families visit this rustic park located on the Nueces River. Birdwatchers flock to the pecan grove on the south end of the park for a chance to see great kiskadee, hooded oriole, and green kingfisher. Campers stay in tents, cabins, houses, and recreational vehicles. Moms and dads with children fish in the shallow water rippling in the shade of the towering white limestone bluff that gives the park its name.

Highway 55 parallels the Nueces River to Camp Wood. The Spanish named the river the Nueces, or River of Nuts, after the pecan trees commonly found along the banks. Early Spanish Catholic missionaries built the Nuestra Señora de la Candelaria Mission along

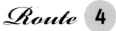

Route **4**

Leave Uvalde on U.S. Highway 83 north, turn northwest on Texas Highway 55, and drive 40 miles to Camp Wood. There are several ways to return to Uvalde. Take Ranch Road 337 east to Leakey and then return to Uvalde on U.S. 83. Or, alternatively, continue north on Highway 55 out of Camp Wood to Rocksprings, then take U.S. Highway 377 northeast to Texas Highway 41 east and turn south on Ranch Road 335 for the 35-mile drive back to Camp Wood. Or, Highway 41 eventually connects with U.S. 83 for a longer drive back to Uvalde.

THE DEVIL'S SINKHOLE

THE 1,859-ACRE Devil's Sinkhole State Natural Area near Rocksprings is administered by Texas Parks & Wildlife Department. The main attraction is a large breeding colony of Mexican free-tailed bats. Thousands of bats emerge from the cave between April and October.

To protect the bats, the park limits access to the area. However, guided bat-viewing trips are available at the Devil's Sinkhole Visitor's Center in Rocksprings at 101 North Sweeten Street. Advance reservations and a fee are required. Contact the Devil's Sinkhole Society at 830-683-BATS (2287) to reserve your place on a tour. More information is available at www.devilssinkholetx.com.

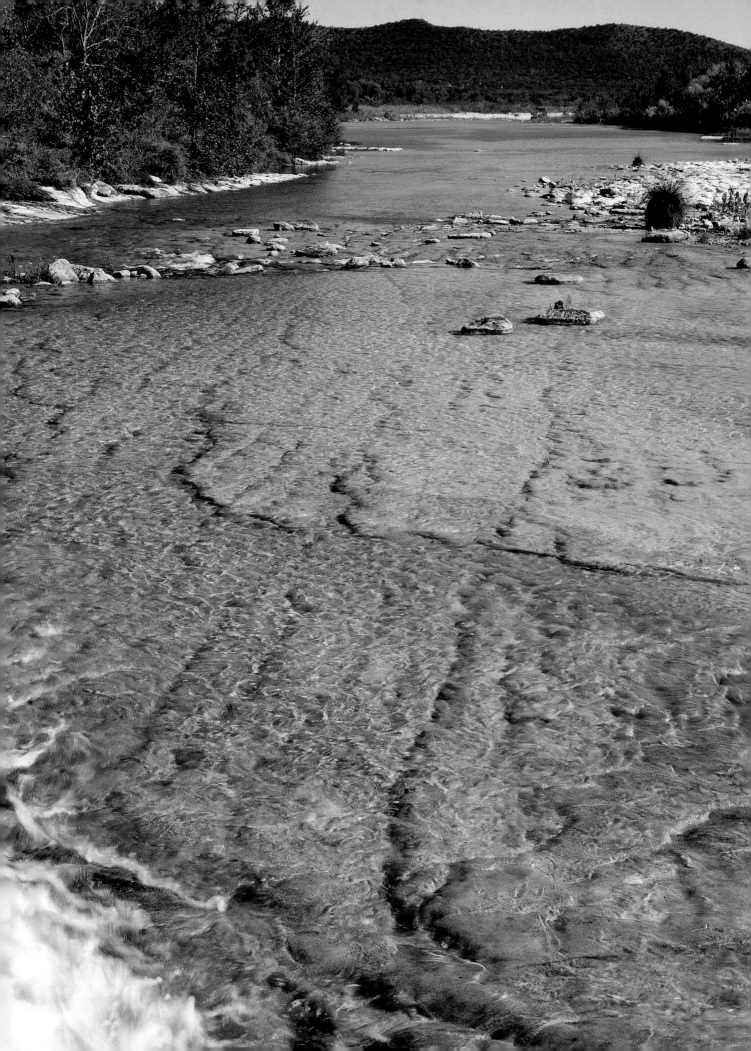

the river in 1762, but abandoned it in 1767 because of disastrous raids by Comanches and Apaches. The only reminder of the mission today is a roadside historical marker.

Outside Camp Wood, Highway 55 begins to climb back up into the low-lying hills of the Balcones Escarpment. The small community of Camp Wood is a favorite stopping place for travelers. Charles A. Lindbergh stopped here in 1924 on a barnstorming flight to California, three years before his famous solo flight from New York to Paris. He accidentally crashed into Warren Puett's store while trying to take off. Although Lindbergh graciously offered money to repair the store, Puett and the townspeople didn't want to take money from the dashing, young, superpolite pilot.

The town has a park named for Lindbergh at the corner of 6th Street and Nueces. The peaceful park shaded by oak and pecan trees covers an entire city block. Stop and have a picnic at one of the tables, sip a cold drink in the shade, or watch the birds flutter through the trees.

Ranch Road 337 splits from Highway 55 in Camp Wood. You can take the spectacular twisting and winding 337 back to Leakey or continue on Highway 55 to Barksdale. In Barksdale, Ranch Road 335 splits off to the north and follows the Nueces River along a scenic, winding route.

Stay on Highway 55 for the journey to Rocksprings—the heart of Edwards County. In Rocksprings, the Edwards County Courthouse and historic jail surround the town square as is typical of many Hill Country towns.

Linger in Rocksprings or continue northeast on U.S. Highway 377 to Texas Highway 41. Turn east on Highway 41 and enjoy a thirty-five-mile-long route through choice Hill Country habitat. Return to Camp Wood via Ranch Road 335, or for a longer journey, continue on Highway 41 to U.S. Highway 83 on which you can drive back to Leakey and Uvalde. Either route is a chance to experience the wide-open spaces that made Texas famous.

The Edwards County Courthouse, built in 1891 in Rocksprings, is a simple yet stylish limestone building.

BELOW: Ranch Road 337 between Camp Wood and Medina offers drivers miles of fun.

OPPOSITE: The crystal-clear waters of the Nueces River flow outside Camp Wood on Highway 55.

PART II

Northeast Region

Pastoral Terrain Draped in History

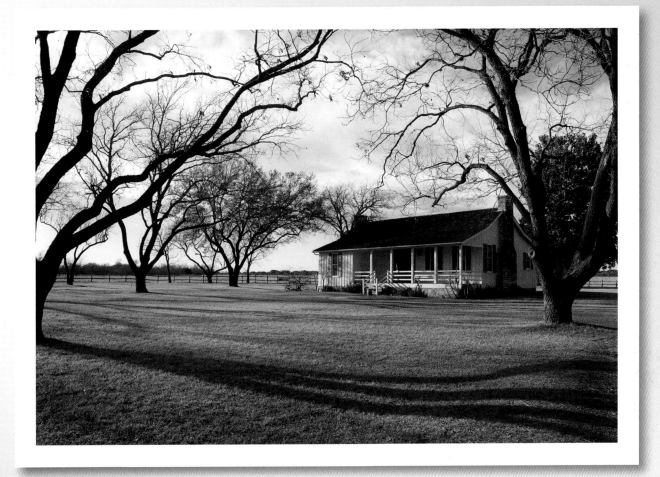

The birthplace of Lyndon B. Johnson is part of the Lyndon Baines Johnson State Park and Historic Site near Stonewall.

OPPOSITE: Prickly pear cactus grow on top of a ranch gate along Ranch Road 2766 outside Johnson City.

In the minds of most people, the Texas Hill Country stretches over the Edwards Plateau west of Austin and San Antonio. Throughout the land of rolling hills crisscrossed by winding, two-lane roads rest homey little towns where the pace of life is unhurried. People wave at each other as they pass on the road. When they walk into a store, they spend more time chatting than shopping. They enjoy their land and communities, and they feel no urge to rush through life.

Johnson City and the surrounding small towns typify pastoral life in the Hill Country. Accordingly, tourists flock to the area to experience the gentle pace that matches the gentle roll of the terrain. Even local residents who've lived on the land for generations join tourists on drives along country roads that lead to hills and valleys with eye-soothing vistas or to towns and parks with cheerful activities.

Yet the drapery of history, both geological and cultural, hangs like a theatrical backdrop over the land. A set of rocks west of Johnson City show that Earth's primitive features were carved here during the Precambrian era some 570 million years ago. The birth of the Texas Hill Country's landmass came between 20 and 50 million years ago when the Edwards Plateau was uplifted out of a shallow sea. Humans arrived on the scene about 12,000 years ago, eking out a living on a rugged terrain coursed by life-sustaining rivers. Apaches and then Comanches held sway over the land in the early 1800s, only to be gradually driven out by Mexican and Anglo settlers after Texas won its independence from Mexico in 1836. Texas became the twenty-eighth state of the United States in 1845, and in the following decades, many a Texan rose to national economic or political prominence and brought prosperity to Texas. Other Texans created a special kind of country-style music and shared it with the rest of the nation. But whether it was geologic forces or human forces, all left footprints on the Hill Country theater.

Nowadays, footprints are more likely to have come from hiking boots, water shoes, or other footwear that enable people to enjoy life. The area around Johnson City is replete with state parks and lakes that offer a variety of outdoor recreation. Whether by strenuous hikes in the hills, careful stepping into limestone caverns, or easy walking through city parks, people can't help but put their feet on Hill Country land. Area lakes are havens for people to swim, scuba dive, boat, and fish. Game hunting is a big sport in the land, but so is birdwatching and photography. As one old-time resident put it, "Everybody's got something to do in the Hill Country."

Among the many things visitors like to do is ferret out towns hosting celebratory events. For instance, people have the time of their lives at festivals celebrating such bounty of the land as lavender, peaches, and wildflowers. People also take in rodeos, musical

shindigs, or antique car shows. Still other people yield to the impulse for shopping, going from one town's market festival to another in search of one-of-a-kind knickknacks or just old-fashioned bargains.

Each town, park, and recreation area puts out a huge welcome mat for visitors. Each has unique charm and an array of sights and activities that supply a sense of harmony to the soul.

Get out and enjoy the Hill Country around Johnson City. Drive the roads and wave your hand at the locals. Relish the vistas. Stop at a store, fruit stand, or barbeque joint and strike up a conversation. Keep your pace slow. Savor every moment because as the slogan goes, "There's no place like Texas."

ROUTE 5

Blanco to Wimberley

The town of Blanco lies along U.S. Highway 281, about fifteen miles south of Johnson City. The town rests along the Blanco River and sits on the eastern edge of the Edwards Plateau. Typical of Hill Country communities, the land is hilly and rocky with streams set off by limestone benches and steep slopes. Oaks, mesquites, and Ashe junipers rise up on grasslands ideal for wildlife and grazing herds like cattle.

Indeed, cattlemen were the first European settlers in the area, but they had to compete with Comanches for dominance over the land. In the early part of the nineteenth century, Comanches had chased off Apaches and other tribes, and had staked their claim to all of what is now Blanco County. However, the cattlemen constructed cabins and a settlement along the Blanco River in 1853, and fortified themselves against the Comanches, ultimately winning out after many an "Indian war." The original settlement was right across the river from present-day Blanco and was named New Pittsburg in honor of General John D. Pitts, one of the founders of the Pittsburg Land Company. With the formation of Blanco County in 1858, the county seat

Old Blanco County Courthouse was built in the Second Empire Style in the 1880s. The building was used until 1890, when the county seat moved to Johnson City. Today the building houses offices and a gift shop.

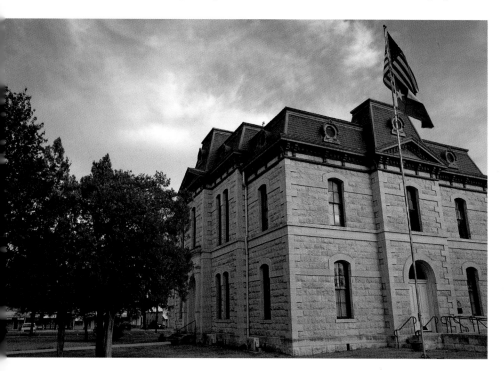

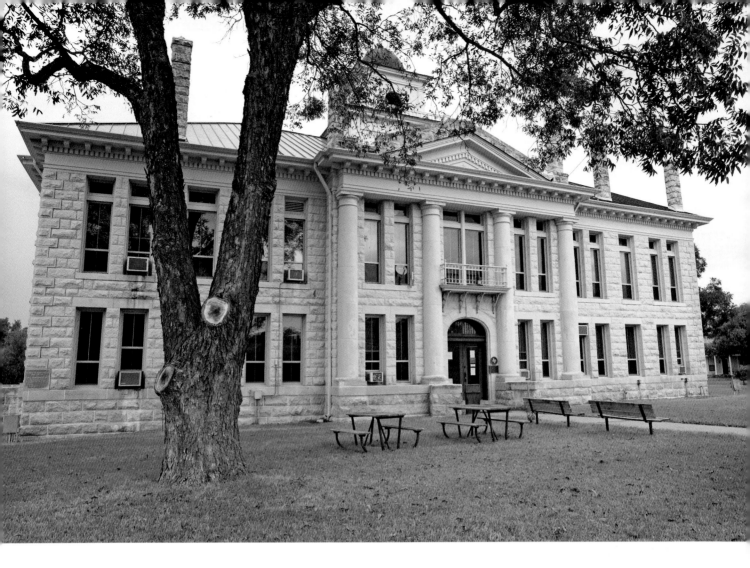

was positioned across the river from New Pittsburg and named Blanco, after the river.

In one of those twists of historical fate, a county election in 1890 repositioned the county seat in Johnson City on the premise that the county seat should be no more than a day's trip by horseback from any part of the county. But the premise irked the citizens of Blanco not only because of loss of pride, but because they had completed the construction of a county courthouse only four years earlier.

Go to the courthouse in the town square and take a gander at the edifice, even if you have only the slightest interest in architecture. Designed in the Second Empire architectural style, named after the reign of Napoleon III (1852–1870), the courthouse is a two-story, unornamented structure with a mansard roof. Similar buildings sprang up in northern and Midwestern states during the post–Civil War period, but were rare in southern states like Texas. Nowadays, the courthouse is a visitor's center with a gift shop and is listed on the National Register of Historic Places.

Adjacent to the town square and courthouse is a two-block city park with exemplary xeriscaping, which is a process of gardening with minimal amounts of water. The park connects the town square via the Town Creek Nature Trail to Blanco State Park, one of many

The new Blanco County Courthouse sits in the Johnson City town square.

Route 5

Blanco is located at the intersection of U.S. Highway 281 and Ranch Road 1623. Blanco River State Park is off of U.S. 281 south of town. From the park, take Ranch Road 32 east to Fischer and the Devil's Backbone. Ranch Road 32 intersects with Ranch Road 12 south of Wimberley. Follow Ranch Road 12 north to Wimberley, then return to Blanco on Ranch Road 2325 northwest; or backtrack along Ranch Road 32 west for another view of the Devil's Backbone.

Texas state parks constructed in the 1930s by the Civilian Conservation Corps (CCC). What makes this 110-acre state park unique is that it lies largely within the limits of a city, namely Blanco.

The park allows access to the Blanco River for swimming, fishing, and pedal boating. Visitors have access to camping and trailer sites, as well as to picnic areas, screened pavilions, playgrounds, restrooms, and showers. The three-quarter-mile Caswell Nature Trail loops through limestone hills covered in such trees as sycamore, buttonbush, pecan, and bald cypress. A self-guided tour booklet to the nature trail is available at the park headquarters for a small fee. There is an admission charge to the park, as is the case with all Texas state parks.

On the outskirts of Blanco, you'll reach Ranch Road 32 heading toward Fischer. The road parallels the course of the Blanco River, but river views are generally obscured either by vegetation or distance to the riverbank. Travelers interested in a closer look at the river may detour onto County Roads 404 or 405, which cross the river at low-water crossings.

Once you reach the town of Fischer, you'll find it to be typical of many small communities in the Hill Country with a museum, store, and antique shop. The community hasn't grown much since Hermann Fischer settled it in 1853.

Outside of Fischer, the terrain changes as Ranch Road 32 traverses a limestone ridge known as Devil's Backbone that rises suddenly to 1,274 feet above sea level. Look for the roadside park with a view of the ridge and surrounding valleys. The Devil's Backbone, as its name suggests, is filled with legend and lore. The locals say the hills are haunted and claim to have seen or heard the ghosts of Spanish monks, Native Americans, and Confederate soldiers. Stand still at the roadside park and see what ghosts you can find.

Ranch Road 32 meets Ranch Road 12 where signs point to Wimberley. Wimberley lies west of Interstate 35 about forty-five miles southwest of Austin at the crossroads of Ranch Roads 2325, 12, and 3237. It's a peaceful setting with an arching canopy of bald cypress trees along the banks of the Blanco River and Cypress Creek. Typical of Hill Country towns situated at intersecting roads in the late nineteenth and early twentieth centuries, Wimberley was once a market town where farmers and ranchers met with merchants and other buyers to sell produce and livestock.

Although no longer a primary place for exchanging agricultural goods, Wimberley still maintains its market history by hosting Market Days on the first Saturday of the month from April through December. The town rightly boasts that Market Days is not a synonym for a highfaluting flea market, but a time when more than 450 carefully approved vendors set up booths that stretch over a sixteen-acre zone.

The settlement that ultimately became Wimberley was a trading post as early as 1848. William Winters, who fought for Texas independence at the Battle of Jan Jacinto in 1836, established a gristmill on the banks of Cypress Creek at the settlement, which became Winters Mill. In 1874, Pleasant Wimberley bought the mill, and the settlement took the name Wimberley's Mill. When a post office made the settlement an official town in 1880, its name became simply Wimberley. The mill operated until 1925.

Nowadays, the town is a virtual resort, with multiple shops, restaurants, and rental houses along the Blanco River. It's a favored weekend getaway spot where people can relax under the shade of bald cypress and pecan trees along the creek banks and river. Among the sights to enjoy is the Bella Vista Ranch, a place that resembles an Italian family farm complete with an olive orchard, vegetables, and, of course, wine. Details about the ranch are on the web at http://bvranch.com. Also, Wimberley's Farmer's Market is held every Wednesday afternoon between 2:30 and 6:00 on Ranch Road 2325. Wimberley Glass Works, at 6469 Ranch Road 12 between Wimberley and San Marcos, holds glass-blowing demonstrations every day except Tuesdays and Sundays.

Stores, restaurants, and antique shops line Main Street, or Highway 12, in Wimberley.

The checkered white butterfly (*Pontia protodice*) is common in summer Hill Country wildflower fields.

A not-to-be-missed attraction is Jacob's Well, an artesian spring pumping thousands of gallons per minute of clean, clear water into Cypress Creek. It's a popular spot for swimmers and scuba divers, the latter enjoying exploration of caves deep under the water. The well is in danger of drying up because it's part of the Edwards Aquifer, which is being depleted of water from the demands of sprawling urban centers, like Austin and San Antonio, and from newly developed housing communities in the Hill Country.

You can take a return drive toward Blanco along Ranch Road 2325 or along Ranch Road 32 for another try at seeing ghosts on Devil's Backbone.

THE BLANCO RIVER

THE BLANCO RIVER begins with a series of springs flowing through Glenrose limestone from the Middle Trinity Aquifer in northeastern Kendall County. It flows southeast for eighty-seven miles through Blanco and Hays counties and through the cities of Blanco and Wimberley. The river drains four hundred square miles and is a part of the Guadalupe River Basin. It empties into the San Marcos River at San Marcos.

For the most part, the river is shallow with a series of small dams along its length, and it goes underground several times along its journey. Dinosaur tracks are in the limestone riverbed about three miles downstream from Blanco State Park. Two small creeks, Callahan Branch and Flat Creek, join the Blanco River in Blanco County; Little Blanco River adds more water to the river in Hayes County. Cypress Creek, fed by Jacob's Well, carries its water into the Blanco River at Wimberley.

The first recorded reference to the Blanco River was made by the 1721 Aguayo Expedition, which named the river for the white limestone that lines the streambed and banks. Bartlett Sims surveyed the land in 1835, and soon afterward, the newly formed Republic of Texas offered land grants along the river to settlers. Native American Apaches and Comanches also lived along the river until Anglo settlers drove them away in the 1850s.

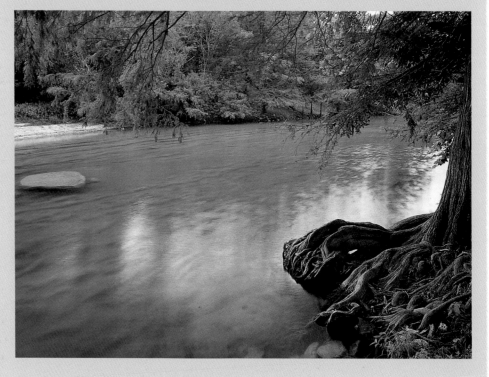

ROUTE 6

Johnson City through Stonewall to Luckenbach

At first, the road into Johnson City would seem a sleepy drive until you wake up to the legend of that larger-than-life figure, Lyndon Baines Johnson, known as LBJ, thirty-seventh president of the United States who grew up in this land by the Pedernales River. The rough-hewn land with gentle hillsides gives hints into what formed the personality of a president who engaged in bare-knuckle politics, yet shepherded the landmark Civil Rights Act of 1964, finally giving full citizenship to African Americans.

Johnson's ancestors settled the present-day Johnson City territory in the early 1800s. His grandfather's nephew, James Polk Johnson, was among the area's businesspeople who, in 1890, successfully persuaded residents of Blanco County to move the county seat from Blanco to Johnson City.

Johnson City is clustered around U.S. Highway 281 and U.S. Highway 290. At the intersection of those two major highways, turn west on U.S. 290—locally called 290—and slow down to enjoy the few blocks that make up Main Street where artisans, restaurateurs, and antique dealers have restored the city's old shops. Park your car and stroll the few blocks down the street, visit the stores, and then stop at the Silver K Café for a mouthwatering lunch or dinner.

Continuing your drive down Main Street, turn off at the brown sign for Heart of Texas Wildlife Trail site number 53 and go a couple of blocks along South Avenue F to the Lyndon B. Johnson National Historical Park. The visitor's center is situated under a canopy of towering shade trees with a large parking area planted with Turk's cap and lantana. The center is a treasure trove of historical information about the Johnson family and the Johnson City area.

Whittington's Jerky Shop in Johnson City on Highway 281 is filled with Texas-made food and wines plus gifts.

Route 6

Johnson City is located at the intersection of U.S. Highways 281 and 290. The Lyndon B. Johnson National Historical Park is located on Main Street in town. The Lyndon Baines Johnson State Park and Historic Site is located 20 miles west of Johnson City on U.S. 290. Continue on U.S. 290 and drive the short distance west to Stonewall. The turnoff for Ranch Road 1376 and Luckenbach is 10 miles west past Stonewall.

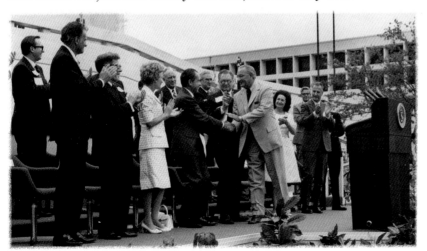

Left: Lyndon B. Johnson was larger than life. Here, he shakes hands with Richard Nixon at the 1971 opening of the LBJ Library in Austin. Reverend Billy Graham is on the left. Lady Bird Johnson stands on the right alongside Spiro T. Agnew, the former vice president.

Lyndon Johnson's boyhood home is across the street from the visitor's center. Stroll over and look at the example of an early twentieth-century family home in the Hill Country. You can take a guided tour of the home or walk the grounds alone and study the house, barn, shed, and cistern that were once so common in small Texas towns.

A trail leads from the visitor's center across a pasture to a series of historical buildings that have been restored to resemble the Johnson family property as it was in 1870. The buildings are also accessible by driving back to U.S. 290 and heading west a short distance. The barn, cistern, cabin, and outbuildings give visitors a dramatic indication of what a prosperous Texas ranch of the late nineteenth century looked like.

Stand on the shaded porch of the log cabin and notice that it's divided into two sections with a breezeway in between, forming a classic example of a dogtrot cabin. The name dogtrot comes from the folktale that a dog could trot down the breezeway, something many a dog actually did in those ranching days gone by. But the breezeway was also a comfortable place for people to rest and work on hot summer days when temperatures hit triple digits.

Ranching was the main income of the Johnson family in the 1870s, and cattlemen, or cowboys, as they were called, would drive herds of cattle up from the Hill Country to Kansas where the cows were sold and shipped by rail around the country. Most of the

Lyndon B. Johnson National Historic Park in Johnson City contains buildings used by the Johnson family dating back to the 1870s.

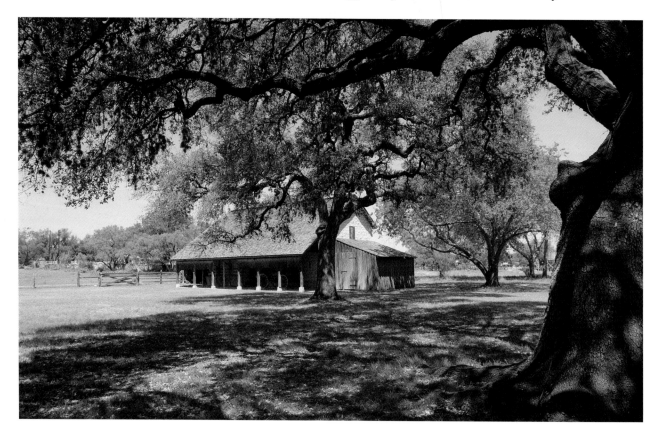

Lyndon Johnson lived in this house during his boyhood in Johnson City.

Johnson family's cows were longhorns, and longhorn cattle still graze the pastures around the historic settlement. Look for them on the journey back to the parking area and as you drive west out of Johnson City on U.S. 290.

Just past the small town of Hye, you'll see a large rest area with a well-maintained picnic area. Notice the bison on the right-hand side of the road behind a large game fence. Make a turn at Park Road 52 into the Lyndon Baines Johnson State Park and Historic Site, where lovely pecan trees surround the parking lot. The visitor's center is filled with historic displays, gifts, souvenirs, and books commemorating the life and times of Lyndon Baines Johnson. Walk the grounds to see more examples of buildings that housed people in the area during the 1800s.

Lyndon Baines Johnson and his wife, Lady Bird, donated the property for a public park in 1972. Regular tram tours along Park Road 1 lead you from the visitor's center to the church the Johnsons attended, to the home where he was born in 1908, and to the Texas White House where Lady Bird Johnson resided until her death. Although you won't be allowed too close to the house, you will be able to stand in awe at the cemetery where LBJ and Lady Bird are buried and to see the Pedernales River that they adored.

Before returning to U.S. 290, take a few moments to listen to the birds in the area. During the summer, eastern bluebirds nest in the boxes on the fence posts, purple martins nest in the birdhouses near the visitor's center, and barn swallows dive-bomb insects over the river. During the winter months, keep an eye out for hawks, meadowlarks, and sparrows in the pastures.

The next town on U.S. 290 is Stonewall, a small town proud of peach orchards and wineries. Check the Chamber of Commerce website (www.stonewalltexas.com) for festivals, jamborees, and rodeos celebrating both commodities.

Trinity Lutheran Church near Lyndon B. Johnson Park and Historic Site was the church the President and First Lady attended while staying at the Texas White House.

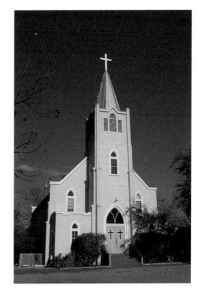

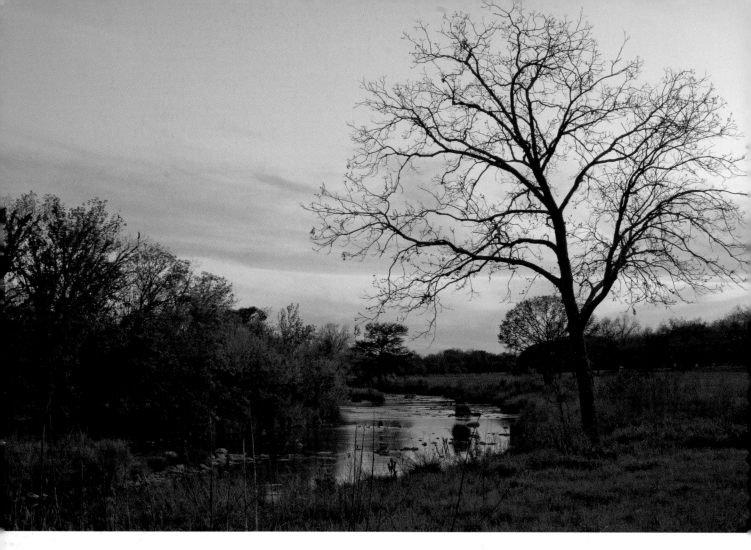

The banks of the Pedernales River in Stonewall offer a serene view of the Texas sunset.

Less than five miles outside of Stonewall, take the turn to the famous town of Luckenbach at the end of this route. A country-western song, "Luckenbach, Texas," written and sung by Waylon Jennings and Willie Nelson, made the town famous. As the lyrics say,

Let's go to Luckenbach, Texas,
with Waylon and Willie and the boys. . . .
Out in Luckenbach, Texas,
ain't nobody feelin' no pain.

Were it not for that song, Luckenbach would be merely an eye-blink's sight on the road. But the town has become part of popular culture and is alive with country music throughout the year, including monthly dances in the newly refurbished dance hall and Willie Nelson's annual 4th of July picnic.

German immigrants settled the town in the early 1800s, and they fought for Texas independence from Mexico in 1836. The name Luckenbach came in 1849, when townspeople named their town after the fiancé of the clerk who worked in the little community's first post office. Seems they thought no one was unimportant in their town. Even today, a sign in the general store proudly announces that "Everybody is somebody in Luckenbach."

ROUTE 7

Johnson City to Pedernales Falls State Park

East of Johnson City, the wide-open spaces of softly rolling hills and breathtaking vistas are abruptly bisected by jagged canyons and the cool, clear, fast-flowing water of the Pedernales River. The rustic view lures you to venture onto any byway you can.

Ranch Road 2766 toward Pedernales Falls State Park is a byway that takes you through geologic time for a glimpse of 500-million-year-old rocks from the Ordovician period of geologic history. If you're any kind of rock hound, you'll be entranced by the exposed rock layers.

Drive slowly and enjoy the view as the road crosses the hilltops. Stop at the Texas Hills Vineyard to tour their facility and taste their wine. Stop at the pull-out along the road to snap a picture of the spectacular vistas. Also, keep an eye out for birds and other wildlife. Scissor-tailed flycatchers and northern mockingbirds are common on the fence wires during the summer. In the winter, look overhead for a soaring red-tailed hawk. Watch for white-tailed deer at any time of the year.

As the road nears the entrance to Pedernales Falls State Park, the surrounding terrain represents 300-million-year-old rocks from the Pennsylvanian period of geologic history. As you drive on the entrance road to the park, you'll notice yellowish-tan limestone dating from the Cretaceous period, 100 million years ago. Once you reach the park headquarters, you'll be on a hill overlooking the Pedernales River Valley with a terrain that drops away in a series of low-lying hills. Take a moment to walk the grounds around the headquarters and take a few pictures from the scenic overlook adjacent to the parking area.

Continue your drive into the park and notice how the limestone changes as you draw closer to the falls. Horizontal yellowish limestone at the park headquarters changes to the dark limestone of Ranch Road 2766, rock that dates from the Pennsylvanian era. However, the layer of dark limestone on the park road was pushed up at an incline during the Ouachita Mountain–building episode near the end of the Paleozoic era over 250 million years ago.

The inclined limestone layers enabled Pedernales Falls. Wind, rain, and water eroded the limestone and created a bed of ridges over which the Pedernales River swirls in rapid currents and, occasionally, falls a few feet into pools. Lining the riverbed is flintlike rock termed Pedernales by the Spanish. The main waterfall is a torrent of water racing over jagged limestone shelves, not a veil of water

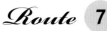

Route **7**

Pedernales Falls State Park is approximately 10 miles east of Johnson City on Ranch Road 2766. Return to Johnson City by turning south on Ranch Road 3232 outside of the park and drive until it intersects with U.S. 290. Go west on U.S. 290, then north on U.S. Highway 281.

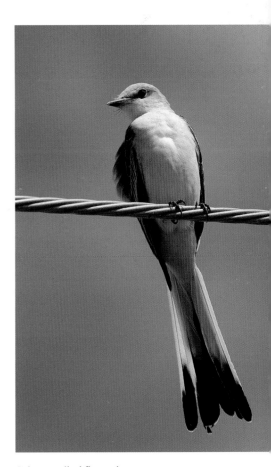

Scissor-tailed flycatchers are a common sight from spring to fall around Pedernales Falls.

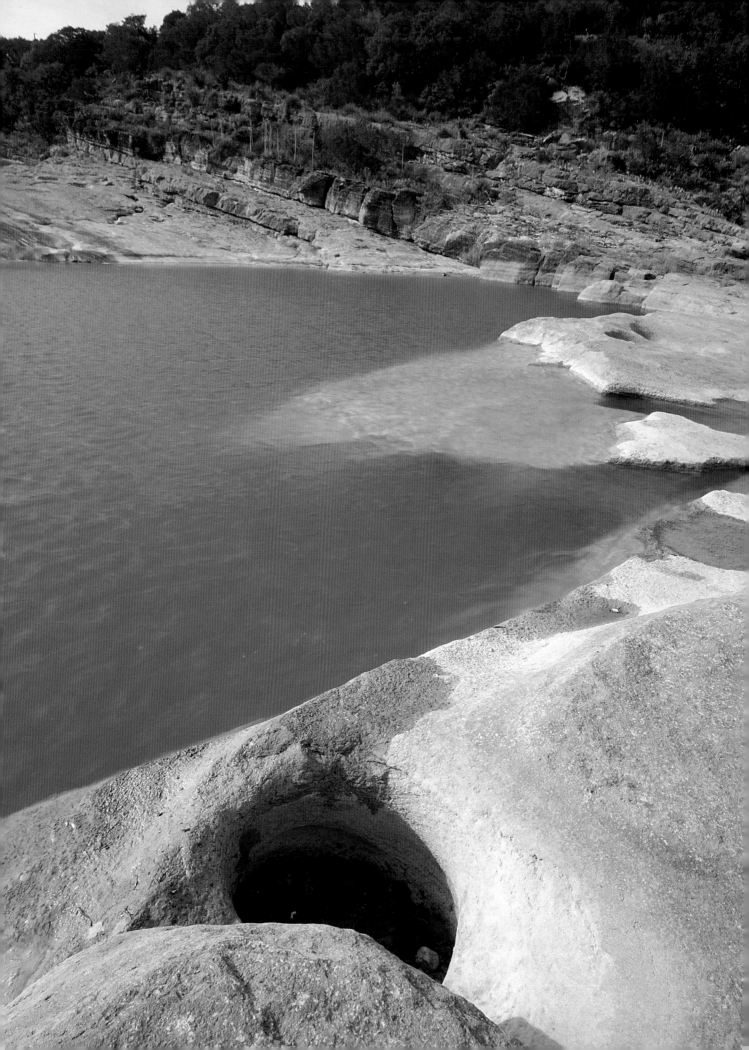

pouring off the edge of a mountain. Nonetheless it's pretty, albeit a might treacherous when water levels are high. You'll have to view it from overlooks or riverbanks rather than by swimming or tubing in the water.

If you make the steep hike down to the river, you'll notice potholes in the limestone near the riverbank. The round holes sunk in the stone measure a foot or larger in diameter and are filled at the bottom with pebbles. Swirling river water forces the rocks to move in a circular pattern, grinding away the bottom of the hole. Please do not take souvenir cobblestones from the bottom of the holes; leave the pebbles to continue their methodical work of etching through the rock.

When you reach the banks of the falls, look for fossilized crinoids in the limestone. The remnant sea creatures were buried millions of years ago when limestone was laid down under a shallow sea.

The park is not just for sightseeing or gaping at the marvels of geologic history; designated areas for swimming, camping, hiking, and mountain biking abound in the park. You may also enjoy activities as diverse as horseback riding on the equestrian trail (although you must provide your own horse) and photographing or birdwatching at a bird-photography blind secluded deep in the woods.

Small pools of clear, cool water are scattered along the riverbed at Pedernales Falls State Park.

OPPOSITE: The Pedernales River during a dry part of the year at Pedernales Falls State Park is a favorite place to cool off and play.

Steps built into the hillsides at Pedernales Falls State Park help visitors descend to the Pedernales River.

Speaking of birds, birdwatchers from around the world visit the park in the spring and summer to get a look-see at the rare golden-cheeked warbler. The bird migrates from Mexico and Central America to breed from April through July nowhere else but in the Texas Hill Country. The little warbler uses bark from the Ashe juniper to build a cup-shaped nest in a nearby juniper or mature oak. Look closely in the trees and you'll probably see a nest, if not the golden-cheeked warbler itself.

The drive away from Pedernales Falls State Park on Farm Road (FM) 3232 offers a chance to see more of this ruggedly beautiful land with small ranches staked out here and there on the arresting terrain. Watch for wild turkey and white-tailed deer feeding in the open fields at dawn or dusk. FM 3232 intersects U.S. 290 for the return to Johnson City.

Pedernales Falls State Park is located at 2585 Park Road 6026, Johnson City, TX 78636; contact them by phone at 830-868-7304.

ROUTE 8

Sandy Road and Willow City Loop

People in the Hill Country will proudly tell you the Texas state flower is the bluebonnet. Six species of bluebonnets, technically called *lupines*, grow throughout the state. In 1971, the state legislature, not wanting to favor any Texas region, passed legislation stating that any bluebonnet in Texas, regardless of the species, is the state flower. By far the most common species of bluebonnet is *Lupinus texensis*, commonly known as the Texas bluebonnet that the Texas Department of Transportation plants liberally along the highways.

Texas bluebonnets are a common sight along roads and in pastures in the Hill Country from late March to early May. The six-inch flower stalks contain dozens of deep blue blooms, each with a white center that turns deep red with age or after pollination.

The alkaline soil in central Texas can yield a blanket of bluebonnets in springtime fields. Yet vast fields of bluebonnets only come

Sandy Road is well known for wildflower viewing in the spring.

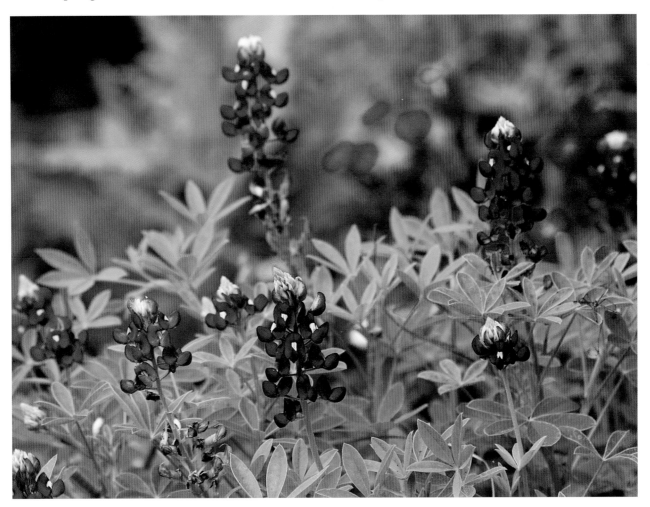

Route 8

The turnoff for Sandy Road (officially designated Ranch Road 1323) is two miles north of Johnson City on U.S. Highway 281. Willow City is 25 miles west of U.S. 281 on Sandy Road. The entrance to the Willow City Loop is marked on the outskirts of town. Sandy Road turns left outside Willow City and eventually intersects with Texas Highway 16.

A Hereford bull watches traffic near the intersection of Highway 16 and Sandy Road.

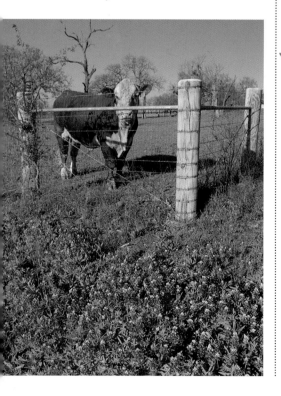

after soaking rains in fall and winter—never a sure bet in the Hill Country. When those rains do come and nourish bluebonnet seeds and sprouts, the springtime view can be electrifying. For example, bluebonnets were so prolific in 2005 that people tell a tale of a sea of bluebonnets stretching from horizon to horizon. A Texas tall tale for sure, but the scene was indeed awe-inspiring.

A favorite road for viewing Texas bluebonnets is Sandy Road, or Ranch Road 1323, with a diversion onto the Willow City Loop. The turnoff is two miles north of the outskirts of Johnson City on U.S. Highway 281.

Immediately after turning onto Ranch Road 1323, you'll find the pace of modern life slowing down. You'll follow a lazy road that gently turns and winds through pastures dotted with homes and dappled with wildflowers. The only fast-paced things are bicyclers whizzing by in outfits as brightly colored as the wildflowers. Moving more slowly in pace with the land are wild turkeys that amble leisurely along the roadside as they peck the ground for seeds and insects. White-tailed deer graze in the grass. In spring, photographers angle for the best shot of the wildflowers. Parents try to take photos of their children dressed in pastel outfits and nestled amid a field of bluebonnets. As you continue your journey along Sandy Road past the community of Sandy, you'll see the land yielding a classic view of Texas wide-open spaces as the road dips and turns through rocky hillsides and meanders past lush pastures.

The town of Willow City is situated on Ranch Road 1323 about twenty-five miles from U.S. 281. Look for roadside bars in Willow City that will give you a taste of Texas hospitality. Friendly saloons are an old tradition in the Hill Country. Step inside one and say hello.

In Willow City, the road straight ahead leads to the Willow City Loop, famous for beautiful bluebonnets and other spring wildflowers. The road can be so crowded during the spring that residents have implemented a no-stopping and no-parking policy throughout the entire loop. Respect the rights of landowners on this loop while enjoying the view. The Willow City Loop eventually intersects Texas Highway 16.

You may bypass the Willow City Loop by making a turn to the left in Willow City and continuing on Sandy Road or Ranch Road 1323. Terrain along the road consists of rolling pastures with trees in gullies near the Willow Creek. Cows graze in the pastures on either side of the road.

At the intersection of Ranch Road 1323 and Highway 16, notice a little place with a big parking lot called Knot in the Loop Saloon. Visitors are free to park in the lot, take pictures of the bluebonnets in the fields adjacent to the parking area, use the free restrooms, and order a soda or beer. The owners promise Texas hospitality to anyone traveling the area.

ROUTE 9

Burnet to Lake Buchanan, Inks Lake, and Marble Falls

Three major lakes lie within fifteen square miles of the heart of the Texas Hill Country. Each lake is the result of a dam built to control flooding and to provide a water reservoir for Hill Country towns. Each lake is also a magnet for hundreds of thousands of tourists and weekenders who visit the waters to swim, boat, and relax in the scenery.

Both Lake Buchanan and Inks Lake were created by two dams on the Colorado River, with headwaters in far west Texas near Big Springs. The Colorado River continues its route out of the two lakes and converges with the Llano River where another dam creates Lake LBJ. Water flows out of Lake LBJ downstream where a series of dams create Lake Marble Falls and Lake Travis. Considering that Caddo Lake in East Texas is the only naturally occurring lake of significant size, the string of artificially created lakes in the Hill Country could be called either an anomaly or a testament to human ingenuity.

People have inhabited the land by the Colorado and Llano rivers for over twelve thousand years. Ancient peoples benefited from the bounty of game animals and fish. European settlers in the 1800s took up farming and ranching, but their life on the Hill Country frontier was fraught with hardship. Farmers often found the soil too thin for growing crops, and ranchers often found the river running bone dry or flooding their pastures. In fact, a flood in 1915 nearly destroyed Austin.

In the early twentieth century, residents began talking about a dam on the Colorado River to stabilize water reserves, control flooding, and generate electricity. In 1931, the Central Texas Hydro-Electric Company started what is now Buchanan Dam, but the project went bankrupt. It was kept alive by state senator Alvin Wirtz, who formed an alliance with U.S. representative J. P. Buchanan to create the Lower Colorado River Authority. Under the newly formed agency, the dam was completed in 1937 as a public works project of the Great Depression.

Buchanan Dam stands with a series of arches reaching 135.5 feet high and spanning nearly two miles. Thirty-seven floodgates control water flow for electricity generation and for water-level maintenance of Lake Buchanan.

A museum complex located at the Lake Buchanan Dam on Texas Highway 29 includes a visitor's center, park, lakefront beach, and even the Lake Buchanan–Inks Lake Chamber of Commerce office, which conveniently offers brochures, books, and travel information.

Route 9

Lake Buchanan is located 15 miles west of Burnet on Texas Highway 29. Take an optional route to explore the east side of the lake and its many resorts by turning off Highway 29 to Ranch Road 690 north. Take Burnet County Road 114 to Ranch Road 2341 south to return to Highway 29. The exit for Inks Lakes is Park Road 4 or Ranch Road 2342 off Highway 29 east of Lake Buchanan. Park Road 4 south eventually connects with U.S. Highway 281. Drive south on U.S. 281 to explore Marble Falls or go north to visit Burnet.

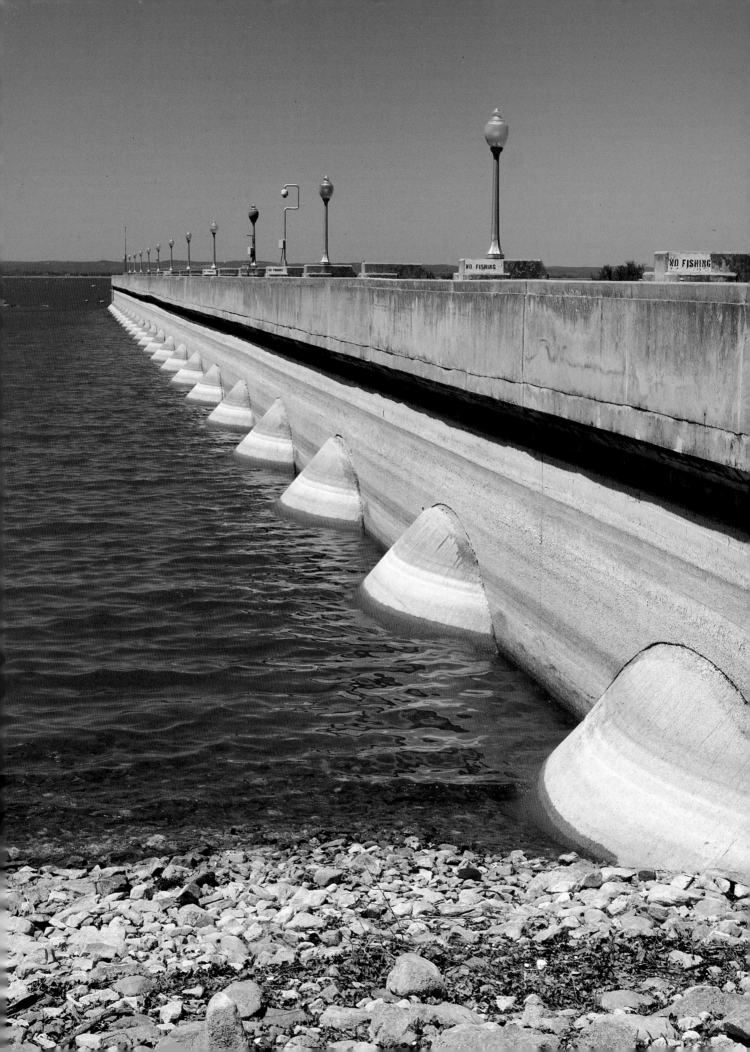

Lake Buchanan Museum contains displays about the dam and the timeline of building the dam.

Gardens around the museum feature native Texas plants like mountain laurel and salvia. Hummingbirds feast at feeders hanging from the rafters of the chamber office, and swallows in spring and summer feed in midair on insects over the nearby grassy lawn. The museum itself houses a wide variety of displays about the construction of the dam, as well as early human settlements in the area. Adjacent to the museum are buildings used by the construction crews in the 1930s. To scan the engineering marvel they created, stroll on the walkways around the dam.

You can explore Lake Buchanan by driving east on Highway 29 and turning north on Ranch Road 690, which dips and twists across rolling terrain and provides excellent views of the dam and lake. Wildflowers are common along the road in spring, summer, and fall. The road eventually becomes Burnet County Road 114, or Graphite Mine Road, as it's also called, and then intersects Ranch Road 2341, which parallels the shores of Lake Buchanan. Unfortunately, visitors have little free public access to the northern shores of Lake Buchanan, but do have access to commercial resorts such as the famous Canyon of the Eagles. Advance reservations are recommended at any resort or bed and breakfast along the road.

You may decide to explore the smaller and quieter Inks Lake State Park. From Lake Buchanan Dam, take Highway 29 west to Park Road 4 or Ranch Road 2342 and enter Inks Lake State Park.

OPPOSITE: Lake Buchanan, created by Buchanan Dam, offers a great place to swim and relax all year.

Inks Lake, one of the many scenic lakes created by damming the Colorado River, offers year-round swimming, boating, and fishing.

Park Road 4 is part of the Texas Hill Country Trail with state park facilities marked by brown wooden signs with yellow lettering. The nine-hole Highland Lake Golf Course is the first facility on the road and is open daily to the public. A pull-out past the entrance to the golf course offers a view of Devil's Water Hole at the bottom of a deep canyon. Oak trees shade the pull-out where you can sit on a granite boulder and watch people below enjoy the cool water of Inks Lake. Access to Devil's Water Hole is via the state park campgrounds farther down the road.

Recreation at Ink's Lake State Park includes swimming, fishing, canoeing, kayaking, and relaxing. Cabins, tent camping, trailer hookups, picnic areas, a park store, and boat ramps are available. The park store rents canoes and sells soft drinks, camping food, fishing tackle, and gifts. Park terrain is a mixture of granite outcrops covered with wildflowers, prickly pear cactus, mesquite, oaks, and juniper.

Exiting on Park Road 4, you'll find the road ascends in winding curves under a canopy of shade trees. The road leads to Longhorn Caverns State Park, which is Texas Wildlife Trail site number 022. In the parking area are beautiful limestone terraces under a canopy

of oaks and two buildings of a slightly different style than you'll see anywhere else on this route.

The CCC built the terraces and buildings at the park during the Great Depression. The smaller of the two buildings housing the CCC Exhibit Hall looks like a medieval castle on the inside. The larger building houses a dining hall, visitor's center, gift shop, restrooms, and exhibits about Longhorn Caverns. Daily ninety-minute tours of the caverns begin in the larger building.

Park Road 4, which takes you back to U.S. Highway 281, is a two-lane road that winds around corners and climbs low hills. It courses a countryside with irresistible views along nearly every mile. Slow down, stop at one of the many pull-offs, and enjoy the landscape, wildflowers, and birds. The peace and quiet in the area is blissful.

On U.S. 281, turn south to the town of Marble Falls or go north to the charming town of Burnet. Outside Marble Falls, the road crosses Lake Marble Falls with Lake LBJ to the west. In Marble Falls, stop at the Chamber of Commerce office or check local directories to find out about house rentals, motels, cabins, RV parks, and private campgrounds.

The Civilian Conservation Corps exhibit hall at Longhorn Caverns State Park, near the entrance to the caverns, houses displays about the CCC in Texas during the Depression, as well as restrooms and a concession area.

PART III

Central Region

Old German Towns

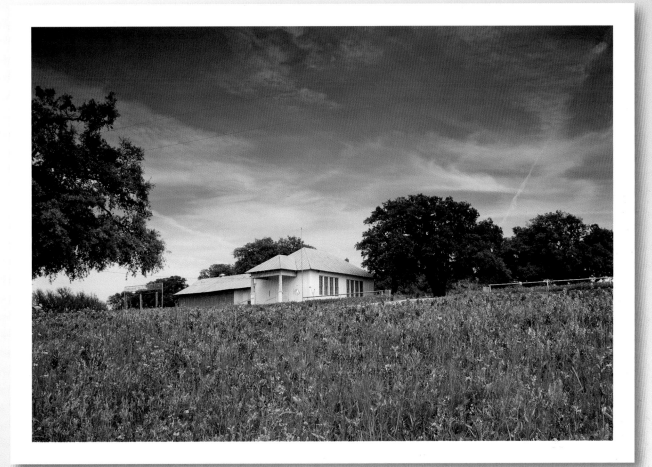

The old schoolhouse in the community of Prairie Mountain on Ranch Road 2323 was built in 1924 and served the community until 1948. Today, the building is a community center where the local 4-H club and other members of the community gather. In the spring, the grounds are covered with Texas bluebonnet and Indian paintbrush.

OPPOSITE: The Ingenhuett-Faust Hotel building in downtown Comfort was originally built in 1880 and expanded in 1894. Today, it is an inn with shops.

Names such as Fredericksburg, Luckenbach, and Boerne make you think you're traveling on the backroads of Germany instead of Texas. In a sense, you are on German backroads just west of San Antonio because German settlers carved out their towns and homes back in the 1800s in this rugged land laden with limestone and granite. Their influence on the culture of the Hill Country is writ large in town names, in local buildings, in local traditions, and in local history.

For many people, the Texas Hill Country is defined by towns such as Fredericksburg because of the numerous shops, historical attractions, and soothing landscapes that make the old German towns so appealing. Indeed, if all a visitor ever sees of the Hill Country is the Fredericksburg area, that person will have been bathed in the old-world traditions intertwined with Texas lore that make Hill Country visits a memorable experience.

In recent years, two things have brought added joy to this Hill Country region: folk music and wineries. Whether it was the climate or the old-world roots that brought these things to the Hill Country, we cannot know. What we do know is that the music and wine flow happily amid the gently sloping hills.

But the gentle hills are actually remnants of violent upheavals in the earth as evidenced by the Llano Uplift, shown vividly at Enchanted Rock State Natural Area not far from Fredericksburg. Displays in the visitor's center at Enchanted Rock will tell a tale more eye-widening than any Texas tall tale about the forces of nature that created the Hill Country.

ROUTE 10

Fredericksburg to Llano and back to Fredericksburg on 2323

Fredericksburg has rested at the crossroads of the Texas Hill Country for more than 150 years. Today, the historic German community of 9,000 residents opens its arms wide to travelers from around the world.

Baron Otfried Hans von Meusebach formed the community of Fredericksburg in 1846 for the benefit of his fellow German settlers. The baron, who later changed his name to John O. Meusebach, named the town in honor of Prince Frederick of Prussia. German settlers who came to Fredericksburg were mostly liberal, well-educated people who fostered a tradition of music and art that continues today.

Route **10**

Drive out of Fredericksburg on Ranch Road 965 heading north to Enchanted Rock State Park. Lower Crabapple Road is a small road off to the right, before the park. Past the park, Ranch Road 965 intersects with Texas Highway 16. Llano is north on Highway 16. After exploring Llano, drive south on Highway 16 to Ranch Road 2323 and take the return journey to Fredericksburg via U.S. Highway 87.

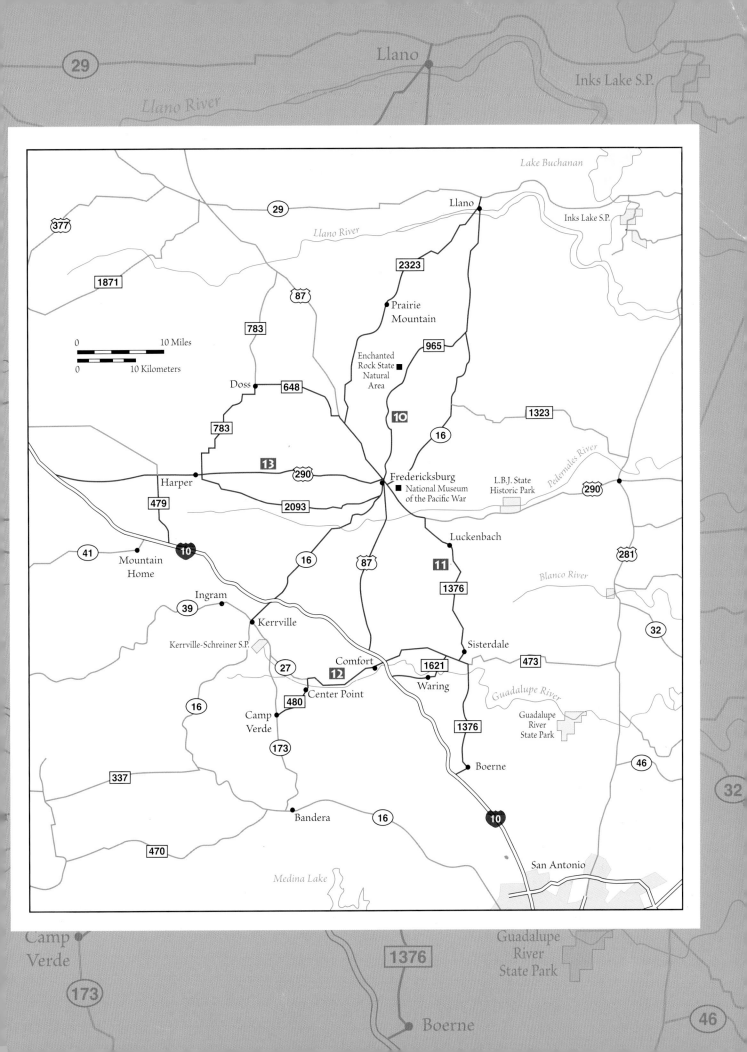

Sweet, juicy Fredericksburg peaches are on sale at a fruit market in Luling.

St. John Lutheran Church on Lower Crabapple Road off FM 965 was built in 1897 of native white limestone.

Settlers built their homes, churches, shops, and schools from timber they harvested out of the nearby hills. People built edifices out of upright timbers, filling the spaces between the vertical logs with rock and plastering the entire outside structure with white limestone. It was an architectural style known as *fachwerk*, which is reflected today in the finished white limestone that accents such buildings as bed and breakfasts, hotels, and restaurants.

Fredericksburg's restored historical center should be explored by foot, so park your vehicle and walk along the sidewalks through the historical center. Enjoy the gift shops, antique shops, restaurants, coffee shops, bakeries, and boutiques.

Fredericksburg is also rich in cultural history. For example, the National Museum of the Pacific War housed in the historic Nimitz Hotel is dedicated to the Pacific Theater of World War II. The 3½-acre site of the Pioneer Museum and the Vereins Kirche Museum displays German settler heritage with ten buildings, including a one-room schoolhouse. Both museums are on Main Street.

The town's penchant for hosting special events has become one of its main attractions. Any given weekend may find the town hosting such diverse events as a car show, a flea market, an art show, a folk-music concert, or a choral concert. Check with the Chamber of Commerce for a calendar of events.

Travel any of the crossroads radiating out of Fredericksburg and you'll discover rich adventures. Perhaps the richest adventure is on Ranch Road 965 leading north out of town. The road highlights Hill Country geology, history, and wildflowers.

A few miles outside of town, look for a distinct hill to the east named Bear Mountain. The mountain is formed entirely out of pink granite rock that people have long quarried for use as building stones. Limestone that once covered the 100-million-year-old granite mountain was gradually eroded away 10 million years ago, or during the Cretaceous period. Stop at the picnic area to the north of Bear Mountain for a stunning view.

The road continues through hills and valleys for another ten miles, at which point a sharp turn levels out to reveal one of the best vistas in Texas. Stretching from horizon to horizon in clear view are the enchanting hills, including the famed Enchanted Rock.

While driving, watch to the right for Lower Crabapple Road. Although not a road to be chanced after heavy rains, it is otherwise a fine little road where you can view the remnants of a small community that once stood in the area during the last half of

ENCHANTED ROCK STATE NATURAL AREA

ENCHANTED ROCK State Natural Area is one of the treasures of the Texas Hill Country. The park highlights a large granite bubble, or batholith, that rose up through the surrounding countryside a billion years ago.

Enchanted Rock is the second-largest granite dome in the country next to Stone Mountain in Georgia. It rises 1,825 feet above sea level, but just 445 feet above nearby Sandy Creek. More important, it could be called the geologic birthplace of Texas because it is part of the bedrock around which most of Texas, and certainly the Hill Country, was formed.

A weakly defined trail leads you on a climb to the top of Enchanted Rock, a vantage point with a breathtaking panoramic view of the countryside. The hike is strenuous, but manageable for people in normal physical condition. Children love the hike.

If you decide to hike to the top or simply around the base of Enchanted Rock, you'll notice that curved sheets of granite are separating from the rock dome.

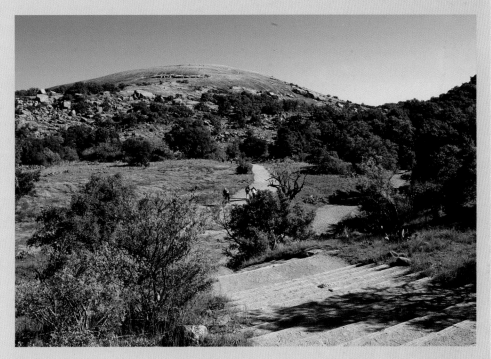

The feature is called exfoliation, which results when sheets of rock on top of the granite dome slough off due to weather erosion. Exfoliated granite can be thin sheets of rock or massive stone blocks.

Exfoliation is probably what gave Enchanted Rock its name, because Native Americans said the big rock dome creaked at night as though under a spell. Scientists have a more pedestrian explanation: The creaks are due to expansion of rocks from daytime warming and contraction from nighttime cooling.

Echo Canyon Trail leads visitors between Enchanted Rock and Little Rock. The blocks of granite scattered along the trail are the result of fractures that separated the granite along nearly right angles. On the northern side of Little Rock are excellent examples of fractured blocks and curved sheets from exfoliation.

Strange, odd-shaped blocks of granite around the base of Little Rock look like pedestals or vases. The blocks bulge in the middle but have a small, tapered base and flared top as though a talented artisan had carved them. In reality, erosional forces of water carved the rocks.

Water collects in pools throughout the area. The pools, or vernal pools, are important sources of water for wildlife and birds. Watch for wild turkey, verdin, lark sparrow, and Bell's vireo around places where water collects throughout the park.

The gift shop at Enchanted Rock State Natural Area offers a number of books that explain the geology and natural history of the area. Also, a museum display gives an overview of the Native Americans who inhabited the region long before European settlements.

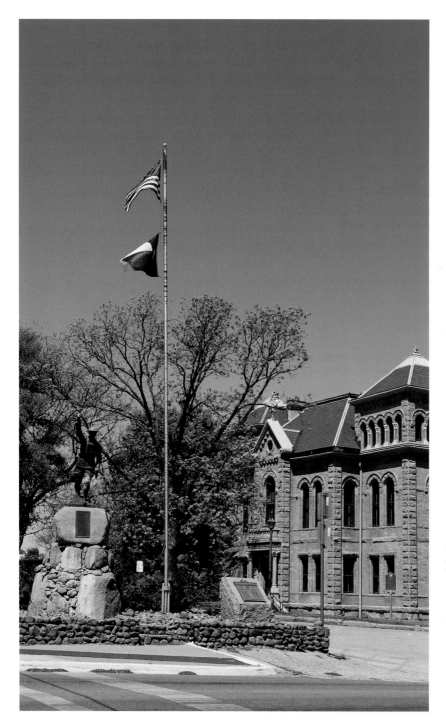

The Llano County Courthouse was built in 1893.

the nineteenth century. Among the deserted buildings are an old school dated 1878, St. John Lutheran Church dated 1897, and a post office that operated from 1894 to 1910.

Settlers constructed the Lutheran church with white limestone they pulled out of local hills; their chisel marks in the stone are still visible. A gothic tenor pervades the church architecture with its massive stone foundation, double-door entry, and four-by-four wood windows with stone lintels and sills. Services haven't been held in the church since 1962; it is a historical landmark designated by the Texas Historical Commission.

After walking around the buildings at Crabapple return to Ranch Road 965. The road continues through the Sandy Creek valley to the entrance for Enchanted Rock State Natural Area. Pull into the park where you can camp, enjoy a picnic, hike the trails, or birdwatch. Don't miss the visitor's center where you can observe displays that explain the incredible geology of the area.

Ranch Road 965 continues until it intersects Texas Highway 16 where you can turn north and enjoy the half-hour journey to Llano. In the springtime, the shoulders of the road may be covered with Texas bluebonnets, Indian paintbrush, and a variety of yellow flowers.

Downtown Llano is dominated by the Llano County Courthouse in the middle of a traditional town square lined with shops. Completed in 1893, the courthouse was constructed from red sandstone, marble, and granite. The Courthouse Historic District is bordered by Ford Street, Sandstone Street, Berry Street, and the Llano River.

Walk around the town square and visit the cafés, coffee shops, and merchants. Look for the old Llano County Jail and notice the gray granite exterior and Romanesque Revival architecture. The gallows were housed on the third and fourth floors.

An iron bridge spans the Llano River a couple of blocks north of the town square on Highway 16. The Llano River Park Project rests in the shadow of the bridge on both sides of the river. The park offers river access, picnicking, parking, and public restrooms.

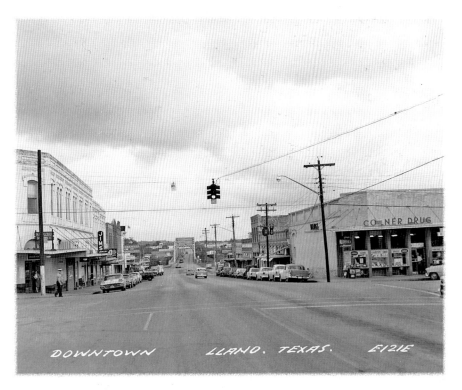

A view of downtown Llano in the mid-twentieth century shows the Roy Inks bridge in the background.

The commercial district of Llano is at the intersection of Texas Highways 16 and 29. Hotels, restaurants, and gas stations are within several blocks of the intersection.

Return to Fredericksburg back through Llano on Highway 16 and via Ranch Road 2323. The road gently twists and turns over low hills for nearly thirty miles, and in springtime it shows off an array of wildflowers. However, you'll find no towns, gas stations, or other facilities along the way—driving is the road's raison d'être.

The Six Mile Cemetery is worth a stop for history buffs. The cemetery is the final resting place for local residents, as well as for people killed in frontier skirmishes with Native Americans and for veterans—of the Civil War and all wars involving our nation since.

Slow down for the residential community of Prairie Mountain where German immigrants settled in the mid-1800s. You'll notice a few private homes near the highway, but the focal point is the old schoolhouse on the hillside. The school was built in 1924 and served the area until 1948. Today, the building is called the Prairie Mountain Community Center and houses the 4-H club, among other community organizations. In the spring, the schoolhouse grounds are blanketed with bluebonnets.

Ranch Road 2323 eventually ends at U.S. 87 where you'll turn southeast for a short drive back to Fredericksburg.

The gravestone for Susannah Scott is found in Six Mile Cemetery on Ranch Road 2323 outside Llano.

Fredericksburg to Luckenbach to Boerne to Welfare, Waring, and Sisterdale

Driving between Fredericksburg and Boerne brings you history, pop culture, and scenery. Stop in towns along the way and rub elbows with fellow travelers, buy a few knickknacks, and feast on delicious food. Your eyes will get a feast from the hilly scenery.

Begin your journey by driving east on U.S. Highway 290 a short distance until it intersects Ranch Road 1376. The road curves through ranch land with rolling hills in the distance. You'll find peach orchards scattered here and there, and you can buy fresh peaches at the orchards from May through July.

Soon, you'll see signs for the Luckenbach town loop, the signals for the legendary pop-culture mecca called Luckenbach. The loop is less than a mile long with fewer than ten houses on its route. Be sure to stop at the Luckenbach Store, a place made famous

The building that housed the Luckenbach Post Office from 1850 to 1971 is now the town's general store. Locals and tourists come to shop, listen to music out back, and maybe drink a cold beer or soda.

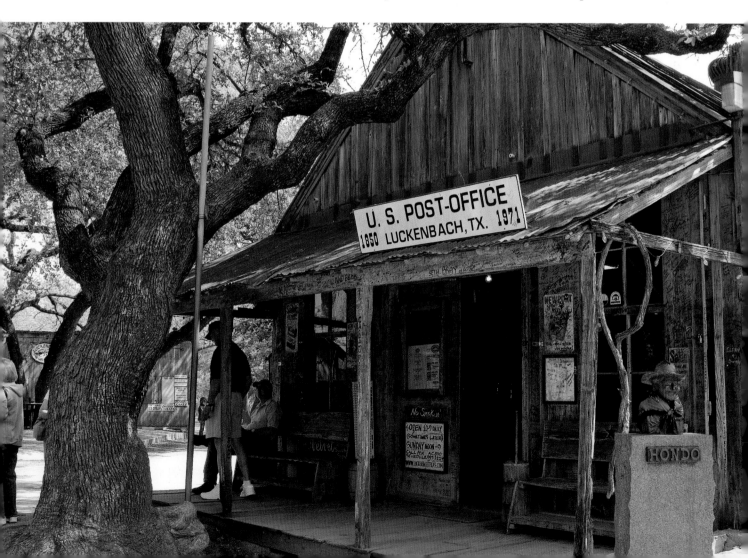

by the 1978 country-western song, "Luckenbach, Texas," written and sung by Waylon Jennings and Willie Nelson.

The store was actually a post office from 1850 to 1971. Today, it's among the more popular tourist destinations in Texas. Stop in the store and buy a T-shirt, cowboy hat, toddler clothes, handmade jewelry, and snacks. Mosey over to the bar in the back if you'd like a cold beer. A schedule for live music is posted on a wall in the bar.

Climbing roses like these decorate many of the homes and buildings in Boerne.

Before leaving the Luckenbach Store, notice the thousands of signatures, names, and greetings penned on the front of the building. People both famous and not so famous have inscribed their monikers in apparent oblivion of the sign requesting that folks not deface the building.

At the intersection of the Luckenbach town loop and Ranch Road 1376 is the Engle family home. There's nothing special about the home until you realize that Reverend August Engle, a circuit-rider Methodist preacher and teacher, lived in the home in the last half of the nineteenth century. What he would have thought of the now wild and wooly Luckenbach Store is anybody's guess.

Ranch Road 1376 goes south from Luckenbach to Sisterdale. The road dips and climbs over gentle hills while providing a good view of the surrounding country.

If you're any kind of wine lover, you'll be happy to know that Sisterdale is home to the Sister Creek Vineyards (phone: 830-324-6704), producers of outstanding Italian-style wine. The vineyard is housed in an old cotton gin originally built in 1885. Grapes grow in several fields surrounding the winery.

As you continue on Ranch Road 1376 between Sisterdale and Boerne, you'll have another chance to enjoy Texas Hill Country scenes. When you cross the Guadalupe River just outside Sisterdale, look from the bridge at the lush scene of bald cypress trees trimming the river. The two-lane road continues on a winding route through hilly terrain and delightful vistas. Cows and horses graze in the fields alongside the road. Mesquite, oak, and cedar form little thickets scattered across the countryside.

Your destination is Boerne, pronounced "Bernie," founded in 1849. Settlers originally named the community Tusculum, but changed it in 1856 to honor the German poet, political refugee, and Texas resident Ludwig Boerne.

Route 11

From Fredericksburg, drive east on U.S. Highway 290 to Ranch Road 1376 south to Luckenbach. Continue on Ranch Road 1376 south through Sisterdale to Boerne. The main shopping and historic district in Boerne is on U.S. Business Route 87 or Hauptstrasse. After exploring Boerne, drive northwest on Interstate 10 to Farm Road 1621 east to reach the town of Waring. Continue north on Farm Road 1621 to Ranch Road 473 east to Sisterdale, then take Ranch Road 1376 north back to Luckenbach and Fredericksburg.

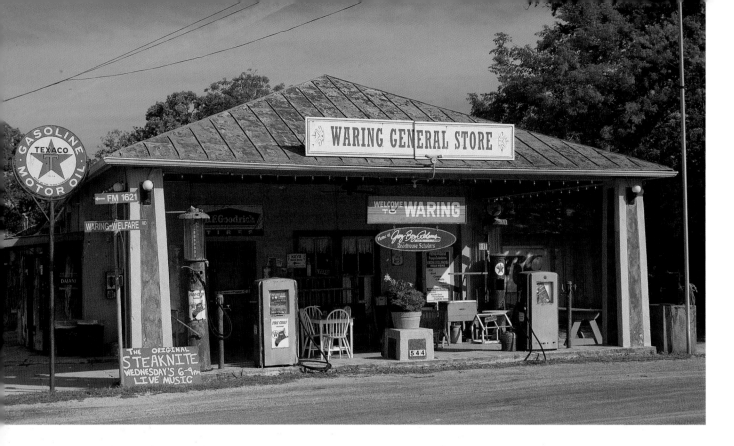

The Waring General Store on FM 1621 is a mix of mid-twentieth-century nostalgia and modern Hill Country life. Gifts and cold drinks mix with country music.

The main street in Boerne is U.S. Business Route 87, but the route is called Hauptstrasse as it passes through the historic part of town. Sidewalks along Hauptstrasse entice you to walk the town, and the comfort of your walk is enhanced by public restrooms conveniently placed in parking lots near shopping areas.

As you walk through the town, enjoy the restaurants, cafés, gift shops, and antique shops. Off the town square on West Blanco is Ye Kendall Inn, a quaint limestone building with an inn and restaurant that's popular among tourists. Rosebushes and towering trees create a homey feel to this edifice of Greek revival architecture constructed in 1859.

The street around the inn holds restored 1920s bungalows—some for rent as part of the inn, some with offices, and some with shops. Each bungalow blends into a harmonious scene in this picturesque corner of Boerne.

Continue driving along Hauptstrasse to St. Peter's Roman Catholic Church, which has a dramatic limestone façade. Look carefully and notice the large fossilized clams and seashells around the cornerstone. These fossils are common in the surrounding hills. The original part of the church was built in 1923.

Catch Interstate 10 west and take the exit for Farm Road (FM) 1621, the scenic loop back to Fredericksburg. The first town you'll reach is Waring. Look for the quaint little Waring General Store and a parking area across from the store. Live music is often played in the backyard of the general store; check for announcements of music on the outside wall of the store. Adjacent to the parking lot are little shops offering wine, art, books, and antiques.

OPPOSITE: St. Peter's Roman Catholic Church, in Boerne, is built of Hill Country limestone.

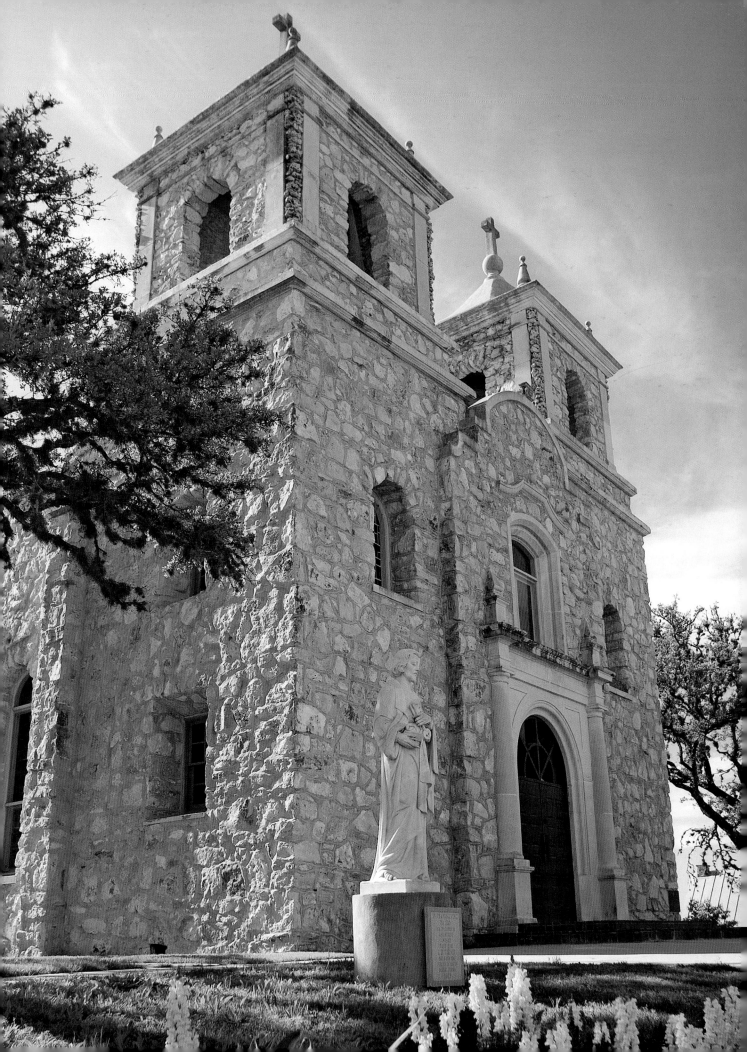

Drive around the few streets of Waring for a view of early twentieth-century houses, but watch out for chickens crossing the road. Ask yourself (an old joke), "Why did the chicken cross the road?" Answer: "To get to the other side." And that's what chickens do in Waring.

The Old Waring Schoolhouse at 108 Avenue East was built by German settlers in 1891. Robert Maxwell Waring, a native from Ireland, donated the land for the school in 1888, and residents volunteered their labor to build the school. They purchased building supplies with revenues from tuition of $1 to $1.50 per month per child. The school closed in 1954.

The intersection of FM 1621 and Ranch Road 473 is a chance to backtrack via Sisterdale and Luckenbach to Fredericksburg. An alternative is to get back on Interstate 10 and take the exit for U.S. 87 to Fredericksburg. Either route offers an interesting slice of the Texas Hill Country.

ROUTE 12

Comfort to Center Point to Camp Verde

The east-west route of Interstate 10 bisects the Texas Hill Country like a raceway over the peaceful landscape. Most travelers hurry across the region on the interstate and miss the flavor of small-town life nestled amid the serene hills.

The town of Comfort sits as an example of small-town life less than a mile off Interstate 10. Entering the town is like entering a time warp back into the early twentieth century. Accordingly, the town calls itself "an antique town," which is a fitting motto for a community of 2,300 people whose everyday life revolves around an antique ambience.

Comfort was built on the site of an old Native American village by the banks of Cypress Creek. Settlers who established the town came from New Braunfels in 1852, and most of them were freethinkers from middle-class German backgrounds who did not feel bound by traditional religious creeds or political affiliations. They built a school early on but didn't construct a church until 1892. Many were Union sympathizers during the Civil War, and a monument stands to memorialize the 68 townsmen loyal to the Union who were ambushed and killed while trying to escape to Mexico.

Many of the buildings in the community are listed on the National Register of Historic Places, and streets surrounding 7th Street in

Route **12**

Comfort is a small community off Interstate 10. From Comfort, travel along Texas Highway 27 west to Center Point. Camp Verde is a short but scenic drive west along Ranch Road 480. Take it slow and allow the journey to take a half or full day.

downtown showcase Comfort's architectural history. Recently, the town restored some of the old buildings to serve as antique shops, eateries, museums, and bed and breakfasts. Find a parking space along any of the streets and take in Comfort's comfortable setting.

On the edge of town, take Texas Highway 27 to Center Point. Along the way, the highway will pass through rich grazing land on the banks of the Guadalupe River. Look for Texas longhorn cattle in the fields, as well as horses, goats, and sheep.

Soon, you'll reach Center Point. Dr. Charles de Ganahl established the community on the north side of the Guadalupe River by opening a post office in his home in 1859, but he named the town Zanzenburg in honor of his ancestral Austrian home. When residents moved the town to the north side of the river in 1872, they renamed the town Center Point because they calculated it to be halfway, or central, between Fredericksburg and Bandera, and central between Kerrville and Boerne.

Old Bridges of Comfort, a mural on a building in downtown Comfort, was painted by several artists to honor Comfort's 150th jubilee in 2004.

CAMELS IN TEXAS

U.S. SECRETARY OF WAR Jefferson Davis thought that camels would make the perfect pack animal for the arid land that stretched from San Antonio to El Paso and beyond. In the 1850s, Davis authorized the army to import about seventy camels to various southwestern Army posts, including Camp Verde.

The army used camels to carry supplies for survey crews and to ferry mail between frontier forts. Unfortunately, camels didn't fare well on the rugged rocky terrain of the west. Also, horses and donkeys went into a panic at the smell of camels.

When the Confederates took over U.S. Army bases in

COURTESY OF THE TEXAS CAMEL CORPS

Texas in 1861, they used the forty camels at Camp Verde to haul cotton in the fields of Mexico. After the Civil War, soldiers grew weary of handling the camels and sold many of them to circuses or, at best, used them to carry mail to Mexico.

The last captive offspring of the Texas camels died in Los Angeles in 1934.

Today, the legacy of the Camel Corps is kept alive by Texas Camel Corps. The group dresses up in period costume, decks camels in period saddles and reins, and makes regular visits to schools and to historic frontier forts.

The population of Center Point has fluctuated between 500 and 800 residents for the past one hundred years. Most residents live on property outside the main center of town. Along Ranch Road 480 within the town are a few interesting shops and a memorial under development that will pay tribute to the Texas Rangers buried in the area.

Center Point's Lyons City Park is one block off Ranch Road 480, with several prominent directional signs. The park offers picnic tables, access to the river, and a swimming area (or swimming hole, as locals call it) made possible by a small dam. Such birds as green kingfishers, belted kingfishers, and black phoebes reside along the river.

Cross the river at the low-water crossing in the park and turn to the left. Here, the road is known as River Road and follows the Guadalupe River for a couple of miles through farms and ranches. Look for scissor-tailed flycatchers perched on the fence wires during summer. Eventually, River Road connects with Texas Highway 173, the highway back to Kerrville.

An alternative route to Kerrville is to stay on Ranch Road 480 through Center Point to Camp Verde. The U.S. Army had a frontier post in Camp Verde, a place used in pre–Civil War times as an outpost for the Camel Corps. Secretary of War Jefferson Davis, who later became president of the Confederate states, conceived the idea of importing camels to southwestern army posts, such as Camp Verde, to carry soldiers across the arid terrain. The camp surrendered to

The dam above the low-water crossing creates a recreation area along the Guadalupe River at Center Point.

OPPOSITE: A horse grazes in a spring field covered in verbena near Kerrville.

the Confederate army in 1861, but was reclaimed by U.S. troops after the Civil War in 1865. It was abandoned four years later.

You may want to stop at the general store or at the small park in Camp Verde before continuing on to Kerrville or Bandera.

ROUTE 13

Fredericksburg West to Harper, Mountain Home, and Morris Ranch

The scenery opens to pastureland as you leave Fredericksburg on U.S. Highway 290 heading west toward Harper. Best to take this road in the morning with the sun behind you as opposed to late afternoon with the setting sun blazing in your face.

U.S. 290 cuts a relatively straight path through the rolling hills between Fredericksburg and Interstate 10. Along the forty-one-mile route, the divided highway crosses pastureland, natural brush, small homesteads, and ranches. Several ranch roads intersect the highway, providing an opportunity for side excursions.

Harper is thirty miles from Fredericksburg. The town's Chamber of Commerce tells us that Harper is "on top of the Texas Hill Country." Harper is surely worth a stop. It has a community park, quaint cafés, gas stations, and friendly little bars where you may wet your whistle.

The crossroads in Harper offer several options. One option is to take Ranch Road 2093 to the southeast, paralleling the Pedernales River and returning to Texas Highway 16 on the outskirts of Fredericksburg.

Another option is to go south on Ranch Road 783, a quick way to get to Interstate 10 at Ingram and travel on to Kerrville.

Turning north on Ranch Road 783 takes you to the community of Doss. The fourteen-mile drive crosses rolling hills and open country that welcomed German settlers who founded Doss in 1849. The town remains a thriving little community with a library, school, post office, and grape vineyard for the Torre di Pietra Winery of Fredericksburg. Call 830-644-2829 for information.

From Doss, you can take Ranch Road 648 and return to Fredericksburg via U.S. Highway 87.

Still another route out of Harper heads west on U.S. 290. The highway crosses the headwaters of the Pedernales River at several points. Depending on the vagaries of rainfall in the Hill Country, the river can be bone dry, a calm stream, or a raging torrent.

Route 13

Harper is 30 minutes from Fredericksburg on U.S. Highway 290. There are three options to continue the journey from Harper and then return to Fredericksburg: Ranch Road 2093 southeast out of Harper meets Texas Highway 16 on the southern outskirts of Fredericksburg. Ranch Road 783 north out of Harper meets Ranch Road 648 east that connects with U.S. Highway 87 for the journey back south to Fredericksburg. U.S. 290 west through Harper is a nice straight road to Interstate 10. The return journey to Fredericksburg is along Interstate 10 southeast with an exit via Ranch Road 479 north to U.S. 290 east or take Highway 16 northeast.

OPPOSITE: Cherry Spring Lutheran Church, on Cherry Spring Road, offers regular services for area residents.

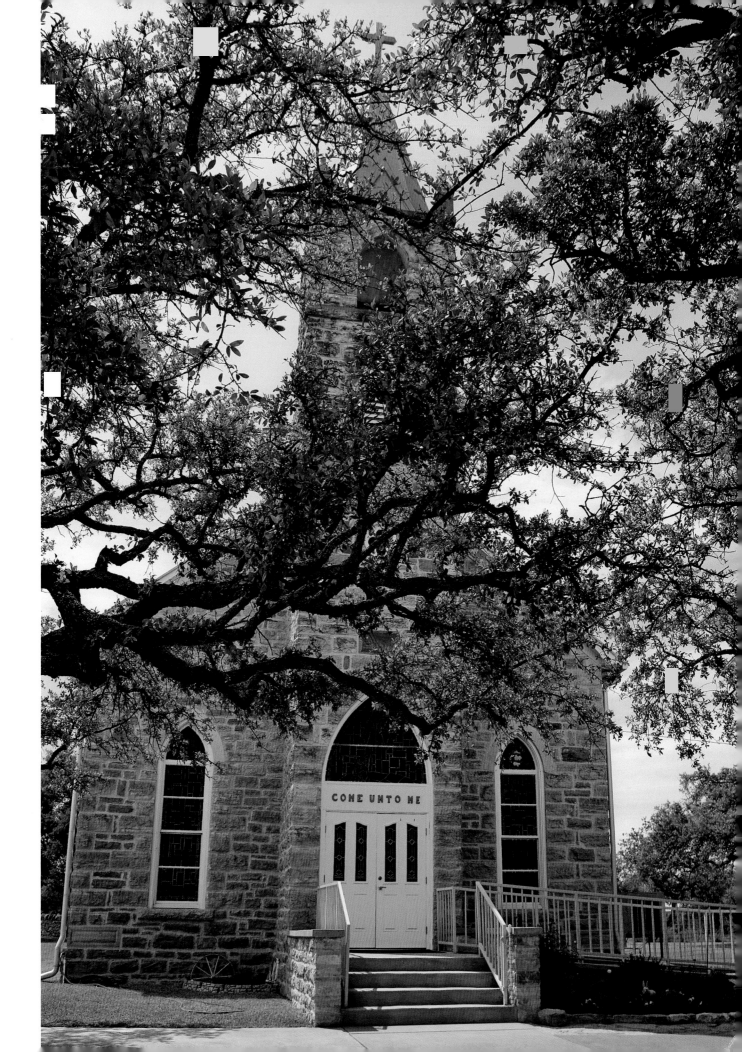

Mansefeldt is a beautiful private estate north of Fredericksburg. Here, part of the main house is framed through wooden gates.

The terrain changes as U.S. 290 heads farther west. Pasture is replaced by rocky soil covered in prickly pear cactus. Oaks and juniper are spaced wider apart, giving the land a rugged look. Yucca, a plant of the desert southwest, becomes common near Little Devil's River. The land appears more like the desert scenes of west Texas than the pastoral scenes of the Hill Country.

As U.S. 290 intersects Interstate 10, take the interstate northwest toward Junction or southeast toward Mountain Home. Rock strata revealed by road-cuts through the hills, sometimes towering fifty to sixty feet high, are spectacular.

To get back to Fredericksburg, go southeast and take the Texas Highway 27 exit for Mountain Home, once a part of the Old Spanish Trail.

Continue on Highway 27 for a short distance through rolling hills. At the intersection with Ranch Road 479, turn north and return to Fredericksburg via U.S. 290. Another option is to continue on Highway 27 into Kerrville for shopping and dining with a leisurely drive to Fredericksburg via Highway 16.

Hill Top Cafe, on U.S. 87 between Fredericksburg and Mason, offers live music and Cajun food for locals and travelers.

OLD SPANISH TRAIL

ALL SCHOOLCHILDREN in the United States learn about the Old Spanish Trail: the caravan trading route between Santa Fe and Los Angeles from 1829 to 1848.

In the 1920s, a transcontinental highway that connected St. Augustine, Florida, with San Diego, California, was dubbed the Old Spanish Trail, but it by no means followed the historical trail. The highway entered Texas at Orange, then traveled through Beaumont, Houston, San Antonio, and exited Texas at El Paso.

As the highway was being built, the Old Spanish Trail Association publicized the transcontinental highway to travelers with maps and brochures listing points of interest, ferries, bridges, services, and auto camps along the highway. Mileages between towns along the highway were listed in one 1929 brochure.

The highway was finished in 1929 with a roundtrip motorcade from St. Augustine to San Diego. There is a movement to re-create that motorcade in 2029 to commemorate the one-hundredth anniversary of the highway once called "America's Highway of Romance."

Because of the transcontinental highway, U.S. 90 and U.S. 80 became the major trucking routes through the southern United States. But construction of the interstate sidelined the Old Spanish Trail for trucking.

The transcontinental highway nicknamed Old Spanish Trail traveled through the Mountain Home part of the Hill Country along Highway 27.

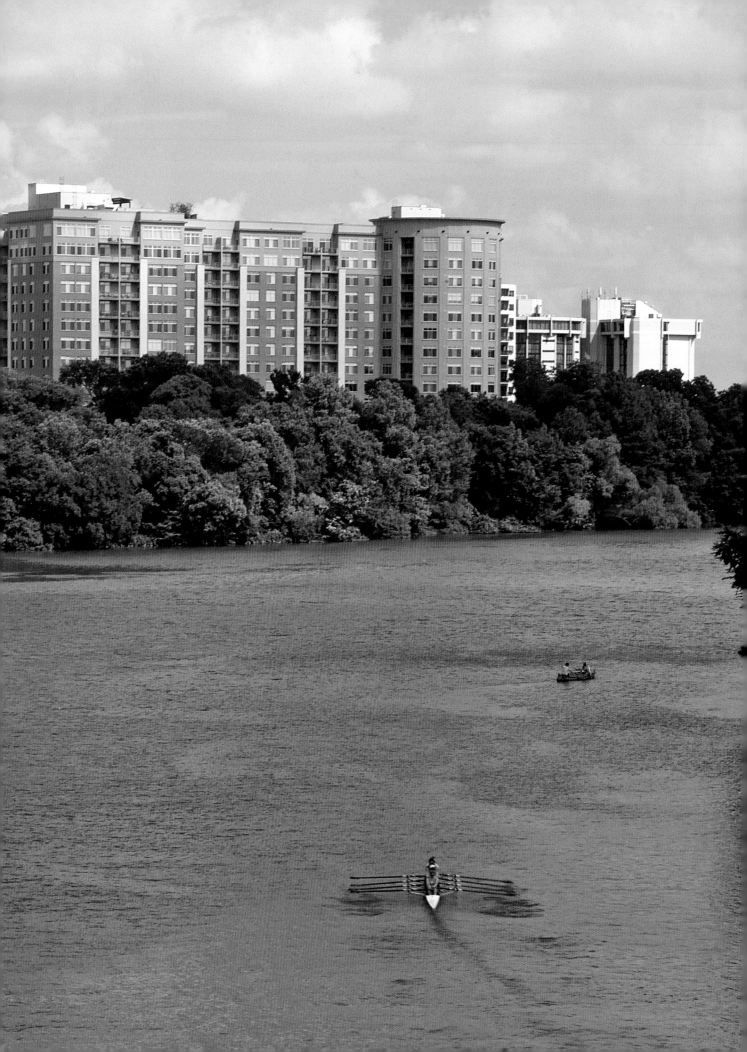

PART IV

Austin Metro Region

Natural Scenery amid Bustling Activity

The endangered golden-cheeked warbler, found at Pedernales State Park, is endemic to Texas.

OPPOSITE: Town Lake in downtown Austin was created by damming the Colorado River. Wise development created a people-friendly linear park. Hiking and biking paths line the lake, along with parks, restaurants, hotels, and condominiums. Water sports such as canoeing, kayaking, and rowing are popular lake activities.

Rock rose, sometimes called Pavonia mallow (*Pavonia lasiopetala*), tolerates the dry weather of the Texas Hill Country. Gardeners love this plant for xeriscape gardens.

Route 14

From U.S. Highway 290 west of Austin, take Texas Highway 71 north to Bee Cave. Then take Ranch Road 620 north through the resort communities to Lake Travis. Cedar Park can be reached by traveling along Ranch Road 2222 north to Anderson Mill Road or continuing on Ranch Road 620 then heading north U.S. Highway 183.

The city of Austin, once a rather small town nestled in the hills and hosting the state capitol and the University of Texas, expanded into a metropolis during the last quarter of the twentieth century. No doubt the city's mild, arid climate and serene hills ultimately drew masses of people and hordes of businesses to occupy its comfy realm.

Although Austin has grown and sprawled over the landscape with sleek high-rise buildings, exclusive neighborhoods, and a tangle of freeways, the town still retains the charm of a university town and seat of government. The youthful energy of a college campus exudes over the streets just as foot-stomping Texas music empties out of bars along the famous—or infamous—6th Street. Conversations on the streets are as likely to revolve around the future of computer technology as around the state's current legislative agenda.

Yet the city, for all its bustling activity, is a place of incomparable natural scenery. Parks prove it, as do the millions of bats that live under a bridge within sight of the capitol building. Surrounding Austin are other places of natural wonder, as well as towns with colorful histories and cultures.

Places such as Bee Cave, Convict Hill, and Dripping Springs by their names alone are enough to lure you to their environs. Well-known parks including Pedernales Falls State Park and McKinney Falls State Park will titillate your mind and calm your soul all at the same time. Such towns as Georgetown, Round Rock, and Elgin will show you a land where top-notch education, top-notch culture, top-notch agribusiness, and top-notch sausage rule.

ROUTE 14

U.S. 290 to Bee Cave to Cedar Park

Sometimes, you'll find it preferable not to drive too far from your home base. The journey around the western edges of Austin allows such a trek with a little history, an open road, and fun places to stop—all in a three- to four-hour drive from the heart of Austin.

Texas Highway 71 veers off U.S. Highway 290 west of Austin and heads northwest. The suburbs of Austin are visible for a short distance, but soon the city disappears into rolling hills. The road dips gently through limestone hills laced with cedar and oak trees. Waterways that drain the hills become visible as you approach the small community of Bee Cave.

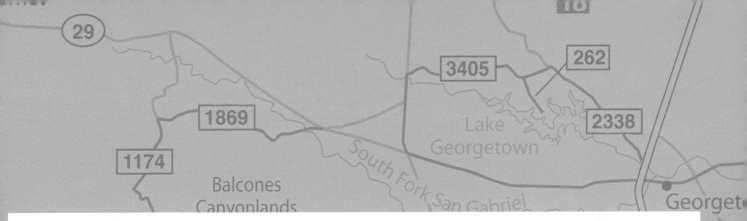
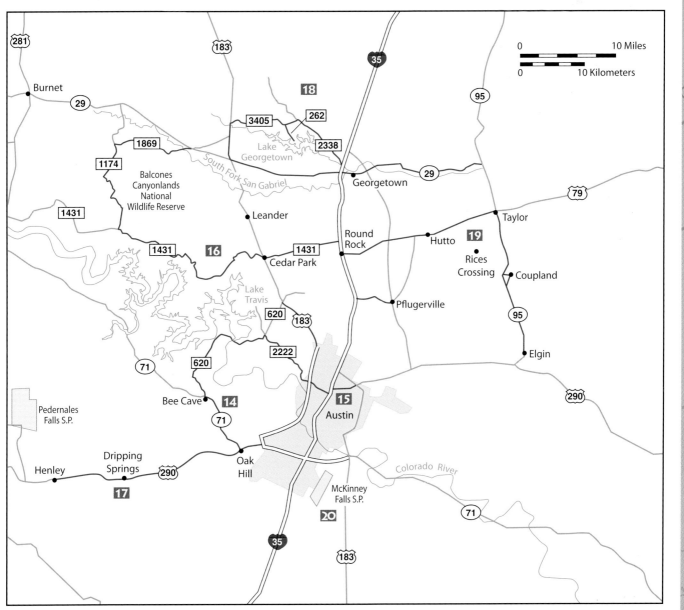

Although you could return to Austin via Ranch Road 2244 outside Bee Cave, you may want to explore the little town.

The community of Bee Cave was incorporated in 1987, and today it stands as a bedroom community for Austin. Obviously, the name of the town originated because it hosted a cave of wild bees in 1870 when Martin Lackey opened his post office. Only fifty or so residents lived in the community through the middle part of the twentieth century, but as Austin boomed, so has Bee Cave.

In Bee Cave, take Ranch Road 620 to the north. The road curves and winds through cedar-draped hills to the east and sporadic development to the west. Within a few miles, the communities associated with Lake Travis come into view. The highway comes close to the lake but no public access is available until you get to Mansfield Dam Park.

The park was created from a seventy-one-acre spit of land that juts into Lake Travis right above Mansfield Dam. You'll find plenty of parking spaces, walking trails, and boat ramps. The park is open from sunrise to 9 p.m. daily and an entrance fee is charged. Because

THE BERTRAM FLYER AND CEDAR PARK'S CAVES

ONE VESTIGE OF CEDAR PARK'S history is the Bertram Flyer, a passenger train pulled by a steam engine. The Bertram Flyer is pulled by Engine 442, a diesel-electric locomotive built in 1960. The Austin & Texas Central Railroad departs the Cedar Park train station every Saturday at 10 a.m. and 1 p.m. The short journey from Cedar Park to Bertram offers a view of rural Texas from a unique vantage point. Check the website www.austinsteamtrain.org for details.

Cedar Park is also home to a number of caves, including the Buttercup Cave Preserve, Discovery Well Cave Preserve, and the shelter cave used by Native Americans at the Twin Creeks Historical Area. A cave beetle named Ricky Rhadine (scientifically called the *Rhadine persephone* beetle) makes its home exclusively in the caves around Cedar Park.

The Texas Cave Conservancy (www.texas-caves.org) holds activities in the caves.

the water along the park is deep, it is a popular area for people with large boats and for scuba divers who can gain access to the water via steps or dive stairs.

Back on Ranch Road 620, the journey continues over Mansfield Dam and through lakefront communities. You may want to turn northwest at the intersection of Ranch Road 2222 to reach Cedar Park via Anderson Mill Road. However, a more direct route to Cedar Park on Ranch Road 620 connects with U.S. Highway 183.

Cedar Park was called Running Brushy when it was established in 1874. Running Brushy Creek flowed through town and was also the name of a ranch owned by George and Harriet Cluck, who drove cattle up the famed Chisholm Trail to Abilene, Kansas.

The community was renamed Brueggerhoff when the railway came through, but renamed Cedar Park by the Clucks' son. From the 1890s to the 1970s, the community was known for its lovely limestone building blocks. But as Austin mushroomed and spread outward in the late twentieth century, Cedar Park became a comfortable haven for suburban housing development.

Lake Travis sits to the west of Austin and provides a wide variety of recreational opportunities. The size of the lake allows power boating, sailing, scuba diving, and swimming.

Route 15

The route begins on Congress Avenue in downtown Austin at the Texas State Capitol. Four blocks north is the University of Texas. Eleven blocks south of the capital is Town Lake on First Street. Continue west on First Street to MoPac or Loop 1. Enter Loop 1 and drive over Town Lake. Take the first exit off MoPac and follow the signs to Zilker Park.

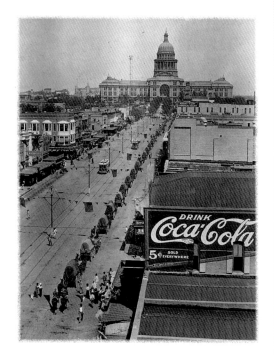

A wagon train heads up Congress Avenue to the Texas State Capitol. This undated photo was apparently taken sometime between 1912 and the first World War. The American flags have forty-eight stars, indicating that the picture was taken after 1912. The ladies in the photo wear long dresses and big hats, which were fashion trends prior to the war.

Austin Loop

The state capitol dominates downtown Austin. The capitol building is the largest state capitol building in the United States based on gross square footage. It is second in size only to the capitol building in Washington, D.C., and it sits at a conspicuously high point in Austin. The 1888 building in the Renaissance Revival architectural style was constructed primarily from "sunset red" granite quarried at nearby Marble Falls.

Architectural elements abound throughout the building with a stone exterior fashioned by stonecutters from Scotland. The original part of the building has 392 rooms, 924 windows, and 404 doors. Ornate details inside the building include door hinges engraved with the Texas state seal.

The capitol's rotunda floor is inlaid with the seals of the six nations. In the center of the floor is the emblem of the Republic of Texas, for the state was founded as an independent nation. Surrounding it are the seals of five nations that controlled Texas throughout its history: the United States, France, Mexico, Spain, and the Confederacy. Portraits of presidents of the Republic of Texas and governors of Texas line the rotunda's walls. The ornate cream-colored capitol dome rises high above the floor. Visitors often lose their balance as they crane their necks upward to see the top of the dome.

The capitol complex consists of the capitol building, extension building, and visitor's center. The Bob Bullock Texas State History Museum and a parking garage round out the capitol complex. The governor's mansion sits next to the state capitol complex. Congress Avenue leads to the front of the capitol building, and public parking is available at 12th or 13th streets.

Four blocks north of the capitol is the University of Texas. Sixth Street, famous for Texas music and nightlife, is five blocks south of the capitol.

Town Lake, a linear body of water formed by a dam on the Colorado River, skirts First Street. Parking areas are scattered all along the lake. Most people enjoy walking or biking along the ten and a half miles of paths through the green space along the lake.

Perhaps the lake's star attraction is the spectacular flight of millions of Mexican free-tailed bats as they billow out after sunset on summer evenings from a bridge at Congress Avenue. City residents and tourists gather on the grassy slopes of the lake or on the pedestrian walkways atop the bridge to take in the amazing sight. Good vantage points can also be found at restaurants and hotels in the area.

Another natural wonder is Zilker Park, a short drive along Barton Springs Road west of Congress Avenue. The 351-acre park

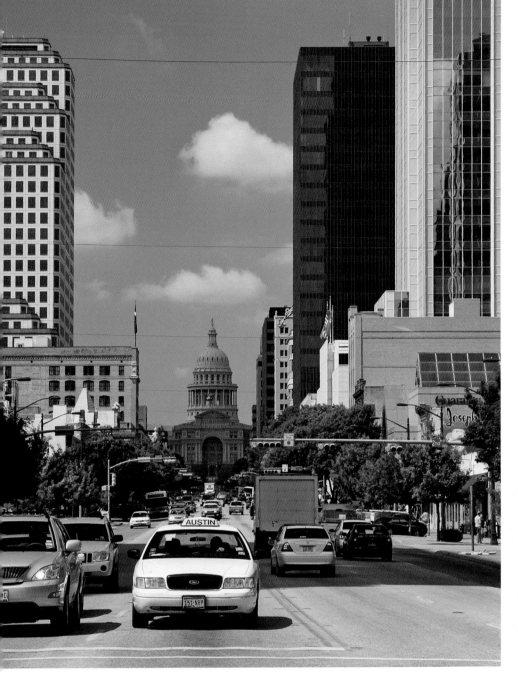

The Texas State Capitol sits at the top of Congress Avenue in downtown Austin.

BELOW LEFT: Ornate details abound in the capitol. This elaborate stairway leads to the balconies above the Senate and House Chambers.

BELOW RIGHT: The ornate dome of the state capitol rises several stories above the rotunda floor. Natural sunlight and electric lighting combine to give the dome an enchanting glow.

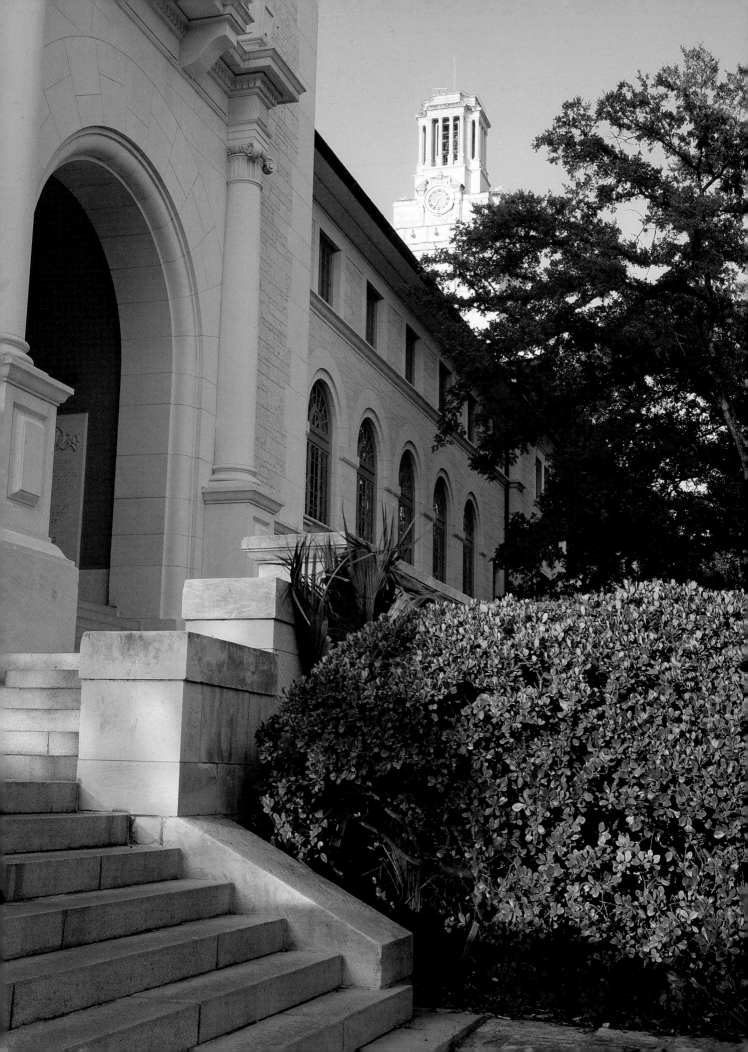

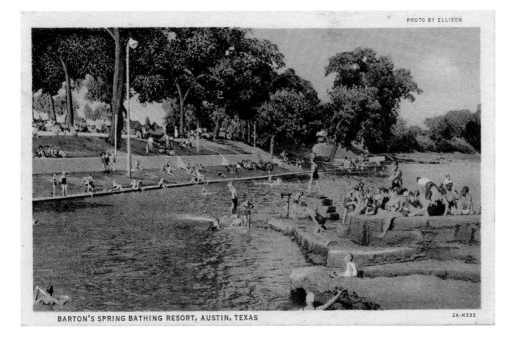

PHOTO BY ELLISON

BARTON'S SPRING BATHING RESORT, AUSTIN, TEXAS

2A-H332

A color photomechanical postcard shows people of all ages enjoying the Barton Springs pool in the mid-twentieth century.

borders Town Lake and is filled with a wide variety of activities, including the shaded Zilker Botanical Garden, with plants from around the world offset by cooling water features. The Austin Nature and Science Center houses educational displays, as well as live animals such as coyotes, bobcats, and porcupines that reside in the Texas Hill Country.

But the jewel of Zilker Park is Barton Springs Pool. Underground springs feed the three-acre pool shaded by towering pecan trees. Water temperature averages sixty-eight degrees Fahrenheit year-round. Native Americans, Spanish explorers, and early settlers to Texas bathed and relaxed in the cool water. Today, visitors can dive headfirst into the water from a diving board, swim laps around the pool, or simply luxuriate in the cool water under the warm Texas sun.

Barton Springs is the largest of three springs in Zilker Park. The second spring forms Elks Amphitheater Pool, originally built by Andrew Jackson Zilker, the first Coca-Cola bottler in Austin, to entertain his Elks Club friends. Zilker later donated the pool to the city of Austin. The third spring bubbles to the surface at the Sunken Garden on the east end of the park.

After exploring Zilker Park, cross back over Town Lake on Texas Highway 1, also known as Mo-Pac, and exit on 35th Street for a vantage point over Town Lake in the form of Mount Bonnell, a 775-foot peak located in Covert Park. Stairs make it easy to ascend the peak, depending on physical ability. A pavilion on top allows outstanding views of Austin and the surrounding Hill Country. Sunset is one of the best times to be atop the peak, but also, and understandably, one of the most crowded.

The distinctive crownlike peak on the Frost Bank Tower adds modern flavor to the Austin skyline.

OPPOSITE: University of Texas Tower dominates the campus as well as the Austin skyline.

Balcones Canyonlands

Route 16

Enter the Balcones Canyonlands National Wildlife Refuge from Ranch Road 1431 northwest of Austin, off U.S. Highway 183. After exploring the refuge from this access point, return to Ranch Road 1431 and drive west to Ranch Road 1174. The entrance to Doeskin Ranch on Ranch Road 1174 is clearly marked. Return to Ranch Road 1174 from the ranch and travel north to Ranch Road 1869 east and watch for the pull-off for the Shin Oak Observation Deck.

The Balcones Canyonlands National Wildlife Refuge, thirty miles northwest of Austin, offers extraordinary vistas of the Texas Hill Country and peeks at two of the rarest birds in North America.

Refuge biologist Chuck Sexton says, "The refuge was set up specifically to protect the habitat of the highly endangered golden-cheeked warbler and black-capped vireo, but it's also a place of ecological diversity with a wide mixture of plant and animal species."

The eighty-thousand-acre refuge offers a tranquil view of the Texas Hill Country and a panoramic view of Lake Travis. It's a place of unspoiled woodlands and grasslands with an assortment of critters, including mammals like the white-tailed deer, butterflies like the variegated fritillary, and, of course, scores of birds like the rainbow-colored painted bunting.

The refuge has three access points:

Warbler Vista off Ranch Road 1431 is the best spot to see the rare golden-cheeked warbler, a bird that migrates from Latin America in the spring to breed solely in the juniper-oak woodlands of the Texas Hill Country. The Cactus Rocks Trail leads about a half mile through a dense canopy of junipers and oaks harboring the warbler.

It's amazingly cool beneath the tree canopy on a hot summer's day. No doubt, that's why such birds as the black-crested titmouse, ladder-backed woodpecker, and Bewick's wren abound along the trail. Golden-cheeked warblers may be seen from March through early August, but most will have left for Latin America by August.

Don't miss the Sunset Observation Deck, with its stunning view of Lake Travis and surrounding limestone hills and valleys. Balcones was the word early Spanish explorers used to describe a similar view of terraced canyons in the Hill Country.

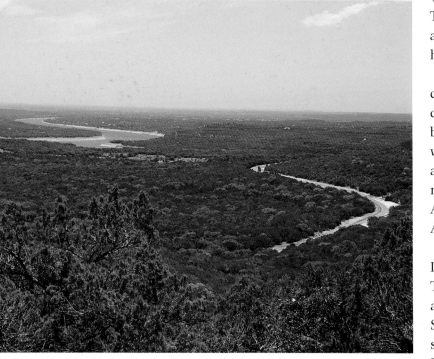

Lake Travis and Ranch Road 1431 can been seen from Warbler Vista and the Sunset Observation Deck at the Balcones Canyonlands National Wildlife Refuge northwest of Austin.

Doeskin Ranch, off Ranch Road 1174, has five miles of hiking trails, the easiest being the 0.4-mile Pond and Prairie Trail that meanders through butterfly-rich grasslands. The 0.6-mile Creek Trail leads to

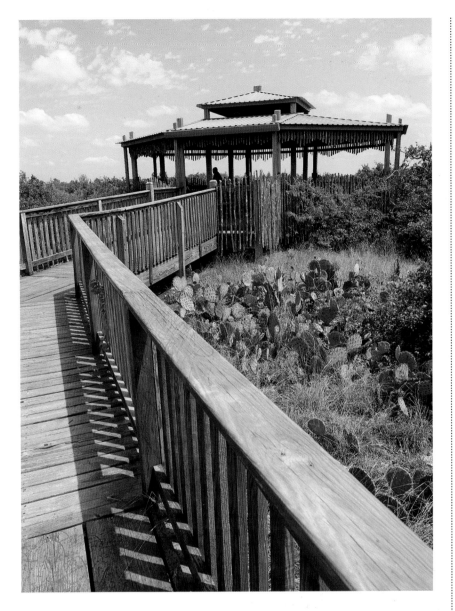

Shin Oak Observation Deck at the Balcones Canyonlands National Wildlife Refuge off Ranch Road 1869 is one of the best places to see the endangered black-capped vireo.

a stream where dragonflies like the widow skimmer and birds like the lesser goldfinch are a good bet.

The somewhat strenuous 2.2-mile Rimrock Trail leads into juniper and shin oak woodlands where golden-cheeked warblers and black-capped vireos may be found.

Shin Oak Observation Deck off Ranch Road 1869 is the best place to see black-capped vireos, birds that will be present from late March through August. The vigorously singing birds are relatively easy to hear in the low-growing shin oaks, but you'll need binoculars to spot one singing atop a tree.

The vireos sing throughout the day, as do other birds such as yellow-breasted chats and painted buntings. And because the observation deck is a covered pavilion, you can enjoy the sights and sounds of Balcones birds in shaded comfort.

REFUGE INFORMATION

- Open daily sunrise to sunset. Occasional closings of some areas for protection of nesting black-capped vireos and for dove hunting.
- Free entry.
- Restrooms at the headquarters building.
- No pets allowed.
- Take water and snacks.
- Information and directions available online or by calling 512-339-9432.

West Austin, Convict Hill, Dripping Springs to Johnson City

Route **17**

This 50-mile route begins on U.S. Highway 290 west of Austin and ends at Dripping Springs. An option would be to continue along U.S. 290 to Johnson City, or backtrack to Austin.

Bluebonnets, the official wildflower of Texas, are found on products throughout the Hill Country.

Heading west out of Austin offers an opportunity to explore history and modern-day Texas Hill Country life. This fifty-mile route contains enough adventure to occupy a half or full day of exploration.

Drive out of Austin on U.S. Highway 290 west. Look for the variety of automobile bumper stickers along the wide, modern thoroughfare—signals of the diverse opinions among denizens of Austin and surrounding towns. The car in front of you might have a bumper sticker with a black and white yin/yang sign, a Sanskrit symbol for God, or a command to "Honk if you love Jesus," which may be phrased in English or Spanish. Austin has it all.

The road narrows at the community of Oak Hill, where the driving pace slows a bit. Modern high-rise buildings give way to one- or two-story buildings made with white limestone, topped with shiny metal roofs and fronted by porches with varnished cedar posts. Large metal stars shaped in the form of the Texas Lone Star hang in prominent places. It's all part of modern Hill Country architecture in a style unique to Texas.

Notice that many buildings have one or two rain barrels, maybe more. Residents collect rainwater for household use and for watering gardens. As rainwater flows down the metal roof, it is channeled into gutters, drained through filters, and emptied into rain barrels. A 2,000-square-foot house can collect 34,000 gallons of rainwater per year in the Austin area.

A sign along the road pointing to Convict Hill gives the impression that this land is the Wild West, but, in reality, it's merely a suburb of Austin. Convict Hill got its name from incidents between 1882 and 1885 in which eight convicts lost their lives while cutting limestone in a nearby quarry for use in constructing the state capitol. Ironically, the limestone turned out to be poor building material because it blackened. Building contractors switched to granite for construction of the capitol building. The limestone quarry was thus abandoned, but the name of the community stuck.

Dripping Springs calls itself the "gateway to the Texas Hill Country." It's a fitting name because everything to the west takes on the classic Hill Country character of small, cozy historic towns among dreamy rolling hills. A stagecoach between Austin and Fredericksburg once stopped in the town to take advantage of the available water. Tonkawa Indians had also depended on the

water during their treks across the Hill Country. Settlers came to the area in 1857 when John Moss established a post office and needed a town name. His wife, Nannie, suggested the name Dripping Springs.

The town is a mixture of old and new. Older homes mix with new construction and older businesses meld with new ones. Drive around and see what strikes your fancy. Off to the side of the highway near Dripping Springs rests open country with small ranches hemmed in by fences made of cedar posts and goat wire.

After Dripping Springs, U.S. 290 becomes a four-lane highway that dips and winds through the Hill Country. Limestone protrudes from grasslands dotted with oak and cedar. The smell of cedar fills the air with a sweet aroma. Slow down and take in the sights and smells along the way.

Rainwater seeps through the porous limestone of the Texas Hill Country and eventually resurfaces at natural springs. Here, ferns and moss grow in the moist environment.

ROUTE 18

Georgetown Loop

Georgetown has been a hub of commerce since the mid-1800s. Today, the town is a thriving bedroom community of Austin with a rapidly growing population.

The town sits on the eastern edge of the Balcones Escarpment. To the east, where Texas Highway 95 intersects Texas Highway 29, the land is flat on the fertile plains of the Blackland Prairie. Coming into Georgetown from the east, the road abruptly climbs nearly two hundred feet as the terrain changes from a flat prairie to a rocky limestone grassland that typifies the Texas Hill Country.

This route starts on the eastern edge of Georgetown where Highway 29 becomes University Avenue outside the gates of Southwestern University. The university began in 1840 as a college for Methodist young men. Stately limestone buildings under a canopy of pecan trees give this campus a quiet, peaceful atmosphere. Neighborhoods around the university have the same quiet atmosphere. Towering pecan trees shade houses in nearly every yard. Homes lining University Avenue date back to the late 1800s and early 1900s, bringing to mind simpler times.

Take Austin Avenue north off of University Avenue to the historic district of Georgetown. The Williamson County Courthouse dwarfs all the surrounding buildings.

The two-story building has a copper dome with the Greek goddess of justice Themis perched proudly on top. On the ground, a statue of a Confederate soldier stands atop a pedestal like a sentry guarding the entrance of the building. Massive pillars flank the ornate front doors.

The grandeur of the county courthouse reflects the prosperity of Georgetown and Williamson County throughout the region's early history. Settlers from Illinois and Tennessee came to the county prior to the Civil War, most of them farmers who grew wheat, corn, and cotton. Others were ranchers who took advantage of wild cattle in the area and eventually built substantial herds thanks to fertile and bountiful

Route **18**

Georgetown can be approached from the eastern edge of the Hill Country where Texas Highways 95 and 29 intersect. Highway 29 cuts through Georgetown. Signs on Highway 29 point to the historic district. Travel west on Highway 29 to U.S. Highway 183, turn north, and connect with Farm Road 3405 and drive east. Russell Park is located on County Road 262 off Farm Road 3405. Continue on Farm Road 3405 to Farm Road 2338, then travel south to Jim Hogg Park. Cedar Breaks Park is located off Farm Road 2338 on D. B. Woods Road.

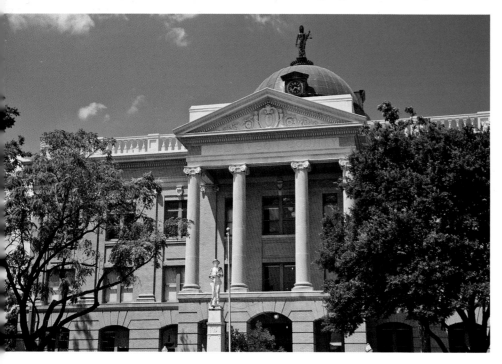

The Williamson County Courthouse in Georgetown is a striking building with a copper dome and ornate architectural features. Themis, the Greek goddess of justice, adorns the top.

grazing lands. Entrepreneurs supporting the agricultural community prospered as they began such enterprises as mills, storage facilities, farm implement companies, and stockyards.

As was typical in antebellum Texas, many white settlers in the county owned slaves. But they were closely divided on the issue of secession from the United States, narrowly voting against it. Nonetheless, the county sided with the rest of the state for secession, and when the Civil War broke out, many people who had voted against secession had to flee for their lives.

In 1865, following the Civil War, folks in the county signed a reconciliation agreement. After a few rough years during Reconstruction, the county was back on track and flourishing. Cotton, wheat, sorghum, cattle, and sheep helped build up the economy of Williamson County for the next one hundred years. From the 1860s to the 1880s, cattle were driven through the county north to the famous Chisholm Trail, which of course terminated in Abilene, Kansas. But when a rail line came down to Taylor in the 1870s, cattlemen began driving their cows there for shipment north. The county realized another boom in its economy in the 1980s as Austin's population exploded and spilled over into Georgetown.

The current prosperity of Georgetown is evident in the quality of shops and businesses that surround the Williamson County Courthouse. Restored historic buildings house enterprises as diverse as law firms, architectural firms, and graphic design companies. Antique shops, boutiques, and cafés cater to visitors as well as local residents.

The Georgetown historic district is vibrant and active with antique shops, high-end boutiques, cafés, and offices.

History fades and the modern world comes into sharp focus as you leave Georgetown's historic district via Austin Avenue and reconnect with University Avenue heading west. Outside of town, the road again becomes Highway 29 as it crosses the San Gabriel River, and runs past modern shopping centers, fast food outlets, and restaurants.

Eventually, the view changes to open fields covered in mesquite, prickly pear, oaks, cedar, and grass. At the intersection of U.S. Highway 183, drive north and take Farm Road (FM) 3405 to the east. The small two-lane road passes through rolling, lush terrain.

Turn at County Road 262 and slow down through a small residential development. Russell Park, a U.S. Army Corps of Engineers property, is located at the end of the road. It's one of three public parks on Lake Georgetown operated by the Corps, which dammed the San Gabriel River in 1979 to create the lake and opened the lakeside parks in 1981. Russell Park is a day-use facility with a hiking trail, boat launch, swimming area, and picnic sites. It's open from 6 a.m. to dusk, between April 1 and September 30.

Jim Hogg Park, located nearby off Farm-to-Market Road (FM) 2338, is open all year from 6 a.m. to 10 p.m. It has 133 single campsites in the park, plus 15 larger sites with water and electricity.

Cedar Breaks Park, located off D. B. Woods Road, is also open all year. It has sixty-four campsites, two fishing docks, picnic sites, and a hiking trail.

All three parks offer stunning views of Lake Georgetown and a chance to see something of the new Georgetown. It's a fitting end for a day touring historic Georgetown.

ROUTE 19

Elgin to Round Rock to Pflugerville

Elgin to Round Rock and Pflugerville offers an exploration of the agricultural lands and small towns east of Austin. The journey begins at the intersection of U.S. Highway 290 and Loop 109 in Elgin.

Elgin calls itself "an old town with a new spirit." The community was founded in 1872 at a stop on the Houston & Texas Central Railway. The town seemed to do everything right, thriving throughout the late 1800s with the arrival of the railroad and by engaging in brick making, broom manufacturing, agriculture, and oil drilling. Brick and tile manufacturing were major industries into the 1950s, when sausage production emerged as a prime business.

OPPOSITE: The low-water crossing at County Road 100 outside Georgetown was once the main river-crossing point for area farmers. Today it is a popular swimming and fishing spot.

Route 19

At less than 50 miles, this route begins at U.S. Highway 290 and Loop 109 in Elgin. Loop 109 becomes Taylor Road and merges with Texas Highway 95 north. Coupland can be reached by taking Spur 277 or Farm Road 1466 east off Highway 95. Continue north on Highway 95 to reach Taylor. In Taylor, take U.S. Highway 79 west to Round Rock. From Round Rock, take Interstate 35 south to Farm Road 1325. Travel east on Farm Road 1325 to Pflugerville.

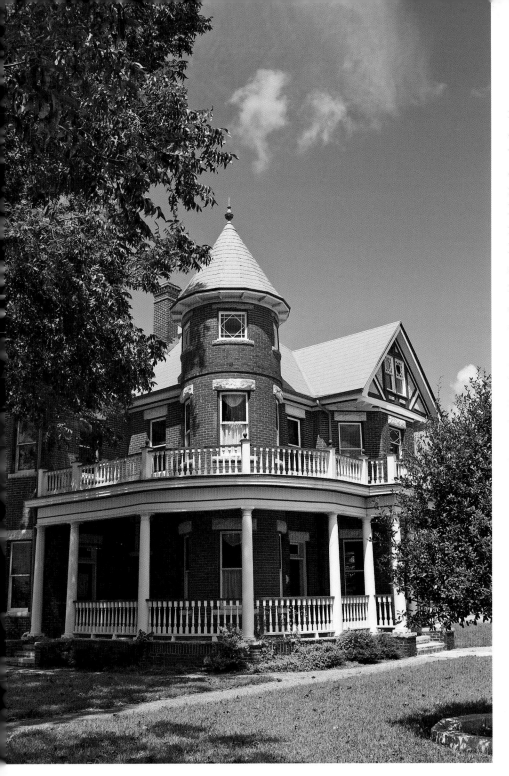

Elgin City Hall is located in the former house of I. B. Nofsinger, a prominent doctor in the early 1900s. The house is made of red bricks from a local kiln in the Queen Ann style.

Many people say that Elgin is the sausage capital of Texas, and travelers between Houston and Austin frequently stop at one of the sausage places in Elgin. Southside Market serves Elgin hot sausage from a restaurant on Highway 290. Meyer's Elgin Sausage has been making sausage since 1949, and their factory off Loop 109 sends the aroma of smoked sausage to drift over several city blocks.

After you've had your fill of sausage, take Loop 109 off of U.S. 290 into historic Elgin. The former train depot now houses the Chamber of Commerce. Park in the parking lot and enjoy the Memory Garden filled with roses and plaques memorializing local residents. A small park sits across the railroad tracks from the depot. Across the street are old buildings dating back to 1906 that nowadays house modern businesses and shops.

The entire historic district of Elgin has been nicely restored. Stroll down the three-block-long Main Street to see the shops and architecture, and visit the surrounding neighborhoods filled with historic early twentieth-century homes under the shade of towering pecan trees.

Elgin City Hall is located in the I. B. Nofsinger House on Main Street. Dr. Nofsinger built the lovely red-brick structure in a Queen Anne architectural style, and one corner of the house has a distinctive conical tower. In the front yard stands a live oak tree that grew from an acorn collected near West Columbia, Texas, on the site where Stephen F. Austin died.

Back on the road, Loop 109 heads north and becomes Taylor Road. In a short distance, Taylor merges with Texas Highway 95 north, where you now drive on the Texas Brazos Trail through agricultural land and the Blackland Prairie.

The Blackland Prairie stretches from Manitoba, Canada, to San Antonio, Texas. The rich, dark soil covers 19,400 acres in Texas with a wide array of grasses, trees, and flowers. Although most of the prairie has been converted to agriculture, remnants of the original Blackland Prairie and native grasses grow along the roadsides.

Notice that cotton, corn, grains, and hay are growing in the fields alongside the highway. In the early 1800s, the rich soils of the Blackland Prairie gave rise to farming, which led to an economic boom in central Texas. Towns east of Austin and San Antonio flourished, and their heritage is on view to this day.

Coupland is six miles from Elgin and worth a stop. When you get to Coupland, take either Farm Road (FM) 1466 or Spur 277 for a couple of miles to the center of town. Huntington Sculpture Foundation, located at the corner of North Broad and Hoxie streets, contains the granite and stainless-steel creations of sculptor Jim Huntington. The public is invited to stroll through his studio and see works in progress or walk through the sculpture garden outside.

Around the corner at Hoxie and North Commerce is the Old Coupland Inn and Dancehall. The buildings are a re-creation of an old Texas western town. Texas musicians and home cooking at the dancehall ensure everyone has a good time on Saturday nights. Check the posters outside for featured artists and showtimes.

The rich soils of the Blackland Prairie, together with dedicated landowners, have made the land around Taylor a prime place to grow hay, corn, cotton, and grains.

Back on Highway 95, choose one of two routes back to Round Rock. Continue on Highway 95 to Taylor, a town founded in 1876 with a Main Street lined in ornate buildings, and take U.S. Highway 79 west to Round Rock. Or, if cross-country driving is more your style, take Farm Road (FM) 1660 and follow the signs to Rices Crossing and Hutto. Both routes offer a bit of scenic Texas with country charm.

Round Rock, Texas, was once a sleepy little community on the outskirts of Austin. Today, it's a bustling suburb of Austin with a growing population. The historic downtown on Business 35 has been beautifully restored. Shops and cafés line the streets around East Bagdad and South Burnet streets along with City Hall, a museum, and the public library. Dell Diamond, on Palm Valley Boulevard and Telander Drive, is home to the Round Rock Express, the AAA affiliate team for the Houston Astros (www.roundrockexpress.com). Locals from miles around flock to the stadium during the season to see baseball played under the vast Texas skies.

Adjacent to Dell Diamond is Old Settlers Park. Hiking trails through the park begin in the Dell Diamond parking lot. Continue into the park and have a picnic at one of the many tables, or walk around any of the flower beds planted with native blooms to look for butterflies such as painted lady, monarch, or buckeye. The park also contains a swimming and fishing lake, soccer fields, a model airplane park, and Frisbee golf course.

The town of Pflugerville, located south of Round Rock via Interstate 35 and Farm Road (FM) 1325 east, is proud of its German heritage. Along Main Street, you'll find wiener schnitzel, a draught haus, and Texas barbeque. You can also get both German and Texas sausage.

OPPOSITE: Jim Huntington operates the Huntington Sculpture Foundation in Coupland. These granite and stainless steel sculptures grace the sculpture garden on Hoxie and Broad streets.

Round Rock has a charming historic district complete with shops and cafés housed in the restored buildings.

The J. A. Nelson Building at 201 Main Street in Round Rock has housed a bank and a hardware business during its history. The building is made of native limestone, with a façade of cast iron and pressed tin. The ornate pilasters and columns are similar to those used on other buildings in the late 1800s and early 1900s.

ROUTE 20

McKinney Falls to Lady Bird Johnson Wildflower Center

Route **20**

McKinney Falls State Park is located off U.S. Highway 183 on McKinney Falls Parkway south of Austin. Exit the park and drive south on McKinney Falls Parkway to East William Cannon Drive west. East William Cannon Drive becomes West William Canon Drive at Interstate 35. Continue driving on West William Canon Drive and turn northeast on Brodie Lane. Brodie Lane ends at U.S. Highway 290. Follow the signs to South MoPac Expressway or Loop 1 and drive south to 4801 La Crosse Avenue.

OPPOSITE: McKinney Falls is often just a trickle, but the park offers a variety of recreational opportunities.

Traveling on the south side of Austin opens up a couple of adventures that may consume several hours or an entire day.

First is McKinney Falls State Park, a wilderness park located off U.S. Highway 183 south about twenty minutes from downtown Austin. The park is open all year from 8 a.m. to 10 p.m.

The main attraction of the 744-acre park is McKinney Falls, where water from Onion Creek and Williamson Creek cascades over limestone rocks as a raging torrent during rainy years or as a trickle during years of drought. When the creek water is low, you can cross it to reach the opposite bank using limestone blocks. On the opposite bank, you'll find hiking and mountain biking trails.

Elsewhere in the park you'll find places to camp, picnic, and birdwatch. Screened shelters, showers, and two gift shops make this park a comfortable place to spend a day or more. Paved trails cover three and a half miles of the park. Also, visitors may enjoy a leisurely stroll or bike ride on the paved park roads.

White-tailed deer and rock squirrels are a common sight in the park. Birds, such as the white-eyed vireo, sing in nearby trees during the spring and summer, and tufted titmice—small gray birds with a crest—sing a whistling song all year. The park is also a prime place to see the rare and endangered golden-cheeked warbler during spring and early summer.

Leave the quiet of McKinney Falls and drive west on William Cannon Drive to Brodie Lane. Take a left on Brodie and then a right on Slaughter Lane. Enter the Mo-Pac Expressway (Texas Highway 1) and drive south to La Crosse Avenue. Follow the signs to the Lady Bird Johnson Wildflower Center.

Lady Bird Johnson said, "We are obligated to leave the country looking as good if not better than we found it." Her nationwide beautification program, implemented during her tenure as First Lady of the United States, has left a lasting mark on our country.

The mission of the Lady Bird Johnson Wildflower Center is to "increase the sustainable use and conservation of native wildflowers, plants, and landscapes." Lady Bird and actress Helen Hayes founded the center in 1982. The center has been a leading advocate for using native plants to bring beauty to our land. An added benefit of using native plants is that they use less water than cultivars sold at many local garden centers.

The fountain at Lady Bird Johnson Wildflower Center flows with pure spring water from the Edwards Aquifer.

The Wildflower Center is open Tuesday through Saturday from 9 a.m. to 5:30 p.m. and Sundays from noon to 5:30 p.m. It is closed on Mondays and most holidays. Details are at www.wildflower.org. An entrance fee is charged.

The architecture of the center will catch your eye the moment you approach the entrance. Purple coneflower, salvia, mistflower, and other blooms surround the walkway. A twelve-thousand-gallon cistern, part of the center's rain-collection system, dominates the view, and visually striking arching aqueducts transport rainwater to the cistern.

Stunning architecture continues throughout the center with an auditorium styled after a Spanish mission at the end of the entrance walkway. The gift shop, restrooms, and outdoor classrooms across from the auditorium are made of white limestone with western accents.

The gift shop could occupy you for hours, but it's best to keep moving because you'll find many more things to see. Return to the gift shop after you've explored the grounds.

A natural spring in the middle of the central courtyard bubbles crystal-clear water. Ahead are split paths lined with native grasses and a woodland garden. The paths converge and lead through an arch to theme gardens, butterfly gardens, and formal gardens. Rest on one of the benches in the shade of an arbor, snap photographs of the blooms and butterflies, or talk to one of the helpful volunteers. The senses come alive in this setting.

The black swallowtail, shown here puddling for minerals on a wet spot of earth, is a common butterfly of the Texas Hill Country.

Short quarter- to one-mile trails radiate out from the garden area. Walk through one of the wildflower meadows or over to the cave. The mile-long Restoration Research trail crosses an area where researchers study habitat restoration and conduct tests to learn about the benefits and uses of native plants.

Before leaving the wonderful gardens, stop at the café for a cup of coffee and a slice of pie. Texas women, like Lady Bird Johnson, would never let you leave their garden without having you stop in for coffee and sweets. It's only fitting that you continue the tradition in a place where the legacy of Lady Bird lives on.

Queen butterflies grace Hill Country flowers and skies from spring to fall.

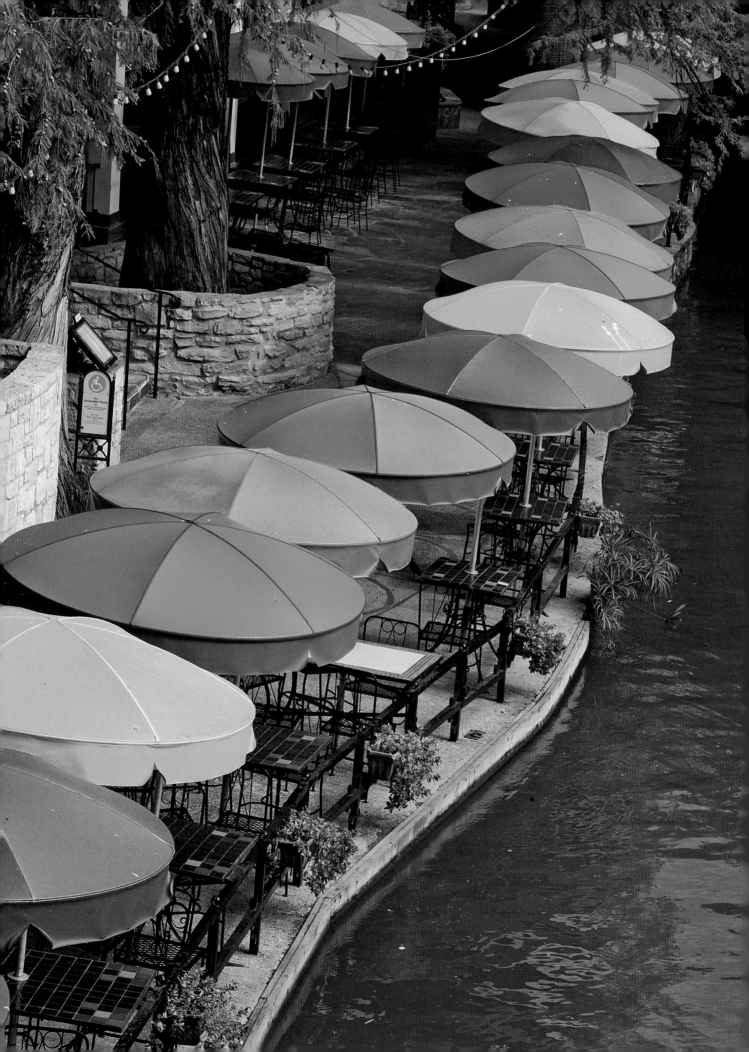

PART V

San Antonio Metro Region

A Landscape Shaped by Water

Sunrise at Canyon Lake offers a lone fisherman a moment of solitude.

OPPOSITE: Colorful umbrellas shade diners at a restaurant along the San Antonio River Walk.

More surprising than anything else about the loop from Seguin to San Antonio may be the water. The Guadalupe River dominates the scene from Canyon Lake to Seguin, offering abundant opportunities for water sports such as fishing and swimming. Additionally, water enabled the spectacular underground caverns in the limestone strata around New Braunfels. South of San Antonio, two large lakes—used primarily as cooling reservoirs for electrical generating plants—also provide opportunities for water adventures. And no visit to this region would be complete without a tour of the famed River Walk in downtown San Antonio where hotels, shops, restaurants, and joyful scenery delight every visitor.

Yet, San Antonio, so rich in history and legend, stands like a flagship for all that's special about Texas. It was here that Spain in the 1700s posted a series of missions into the Texas frontier along a trade route back to Mexico City. Most of those missions still stand on the south side of San Antonio along the Mission Trail. But the northernmost mission was in what is now the heart of San Antonio and was called the San Antonio de Valero, a mission that eventually became a military post called the Alamo. It was in San Antonio that "Texians" in the early 1800s began agitating for independence from Mexican rule, and a historic defeat of the Texans at the Battle of the Alamo spurred them to ultimate victory in their war for independence.

A visit to the region makes you realize why Micajah Autry, a friend of Davy Crockett who died with him at the Alamo, wrote of Texas, "There is not so fair a portion of the earth's surface warmed by the sun."

ROUTE 21

Seguin to New Braunfels to San Marcos

The loop that begins in Seguin, travels through New Braunfels, and ends in San Marcos could be called the family fun route. Family-oriented activities such as swimming, tubing, and cave exploring abound on this route. It's a route packed with year-round family activities.

Seguin is accessible off of Interstate 10 east of San Antonio. The city's roots go back to 1838, when the settlement was founded by Mathew Caldwell's Gonzales Rangers who fought in Texas' War of Independence from Mexico. The town was originally called Walnut Springs due to the rich water source nearby.

Route **21**

Seguin is located off Interstate 10 east of San Antonio. Its historic district is located around Mill Street on U.S. Highway 90. Max Starcke Park is on South Guadalupe Street off Mill Street. Texas Lutheran University is at the corner of Mill Street and Texas Highway 46 on the east side of town. Drive 13 miles north on Highway 46 to reach New Braunfels. San Marcos is 17 miles northeast from New Braunfels via Interstate 35 or Ranch Roads 1102 and 2439. The Hays County Courthouse is located at 111 East San Antonio Street in San Marcos. Natural Bridge Caverns can be reached by driving on Highway 46 west out of New Braunfels, then Farm Road 1863 west to Farm Road 3009 south. A more direct route is to take Interstate 35 southeast out of New Braunfels and take exit 175 to Farm Road 3009.

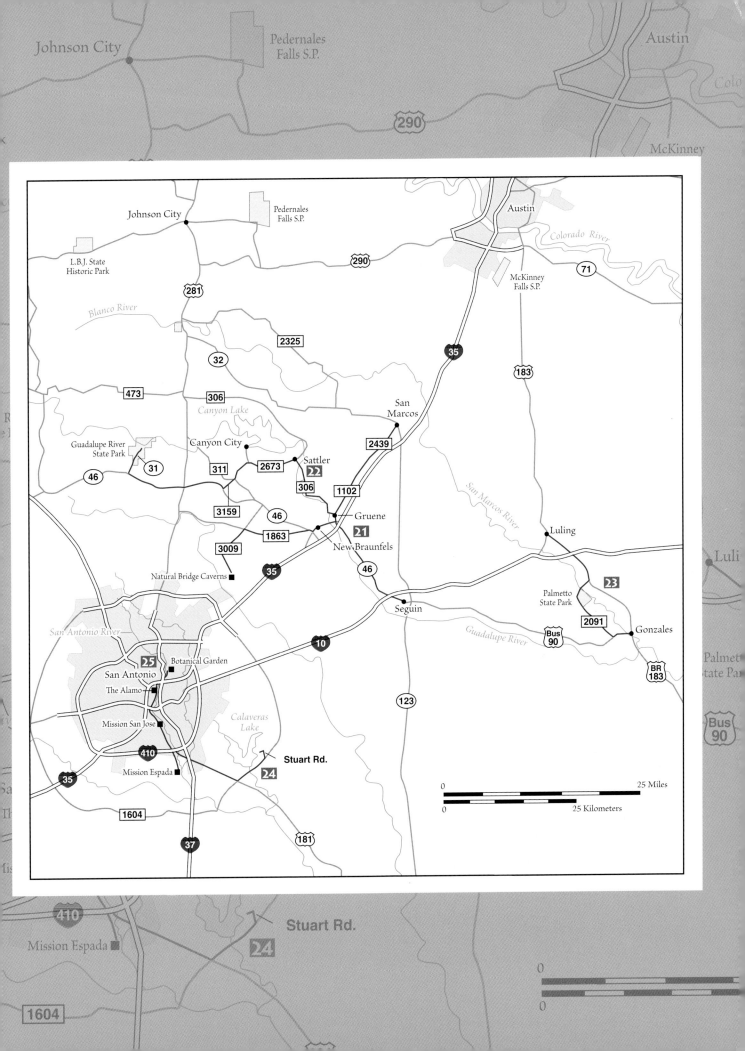

The embodiment of wisdom is depicted in a relief carving above one of the entrances to the Guadalupe County Courthouse in Seguin.

Folks wade and fish in the cool waters of the Guadalupe River in New Braunfels in the 1950s.

Today, Seguin is not known for walnuts, but for pecans. A five-foot-long, one-thousand-pound replica of a pecan rests outside City Hall. Though not the largest pecan in the United States (the largest is in Brunswick, Missouri), Seguin's big pecan is still a source of city pride. Take a moment to have your photo taken in front of the giant nut.

Other attractions in Seguin include the campus of Texas Lutheran University and Max Starcke Park. This park on Business 83 was developed by the National Youth Administration in 1937 to take advantage of the recreational opportunities on the Guadalupe River. A dam, once used to power a gristmill and hydroelectric plant, creates an attractive swimming area. Picnic tables, playgrounds, a miniature golf course, and an eighteen-hole golf course number only a few of the other amenities in the park.

New Braunfels is thirteen miles to the northwest of Seguin. Texas Highway 46 between the two cities runs through farmland and suburbs of both cities. But the area around New Braunfels is a treasure of history and recreation.

New Braunfels was founded in 1845 by German settlers and named for the Braunfels region in Germany where their benefactor, Prince Carl of Solms-Braunfels, had an estate. The community flourished on the trading route between Austin and San Antonio along the banks of the Guadalupe River. A year-round water source gave the community an advantage over many other Hill Country settlements of the mid-1800s.

During the twentieth century, New Braunfels became known as a recreational destination. Both Cypress Bend and Landa Park on the banks of the Guadalupe River have been drawing families since the 1930s. A large water park called Schlitterbahn is easy to find by following the signs. Other parks with tube rentals, golf courses, river access, and playgrounds line the river. Although the parks have different names, they are all part of the Landa Park system.

To the east of New Braunfels is the small historic town of Gruene (pronounced Green.) The town's founder, Henry D. Gruene, along with his father and brothers established a cotton farm on the site in 1872. Gruene's home still stands as the Gruene Mansion Inn and is listed in the National Register of Historic Places.

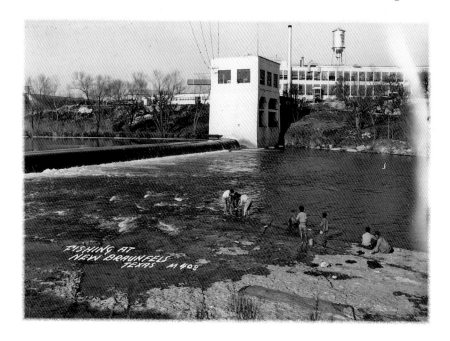

It's hard to miss the Gruene water tower standing proudly over town. The tall silver structure looms over tiny Victorian cottages, red-brick storefronts, antique stores, cafés, and gift shops. Park in one of the convenient parking areas and walk the streets under the shade of oak and pecan trees.

The Gruene Hall is a famous place to stop for a drink and a dance. The building sitting at the end of Hunter Road was built in 1878 and stands as a flagship for nightlife in this part of Texas. Billed as the oldest continually running dance hall in Texas, Gruene Hall draws famed country-western singers including Willie Nelson, George Strait, and Lyle Lovett. It also offers diverse musical fare from well-known country-western bands to gospel signers.

NATURAL BRIDGE CAVERNS

Natural Bridge Caverns consist of the largest caverns in Texas. The caverns were discovered by three students from St. Mary's University in 1960. They lowered themselves into

COURTESY OF NATURAL BRIDGE CAVERNS

the cave's opening and explored the cavern with carbide lights. What they found were capacious vestibules holding astonishing scenes of stalactites, stalagmites, and other forms of dripstone.

Cavern rock formations occur when water, air, calcium, and carbonate meet. Water that has percolated through cracks and crevices in limestone is loaded with calcium and carbonate. Chemical processes take place as the water emerges from the stone into the air of a cave. Calcium in the water stays behind as the water drips from the rock, and calcium residue eventually forms a stalactite or stalagmite "soda straw" or other eye-catching cave formation.

An old ditty to help you remember the difference between stalactites and stalagmites goes like this: *When the tights come down, the mites go up.*

Tours into the caverns take you to such eye-popping places as the Castle of the White Giants and the Hall of the Mountain King. The temperature inside the cavern is a constant seventy degrees but is considerably humid.

For a daring adventure, take the Discovery Challenge at Natural Bridge Caverns, where participants get a behind-the-scenes and muddy journey into the caverns.

You can reach Natural Bridge Caverns by driving thirteen miles north of San Antonio on Farm Road (FM) 3009. Take exit 175 off Interstate 35 and follow the signs to the caverns. The caverns offer two tours a day during the summer and one during the winter. For details, call 210-651-6101 or visit www.naturalbridgecaverns.com.

The Grapevine in historic Gruene has a wine-tasting room that specializes in Texas wines.

San Marcos is seventeen miles from New Braunfels via Interstate 35. Backroads such as Ranch Roads 1102 and 2439 cover a far more scenic route than the interstate by running alongside the Kansas-Texas Railway line. San Marcos is a recreational destination with plenty to do for everyone in the family.

The town is built around the San Marcos Spring that discharges 150 million to 300 million gallons of water each day. A nonprofit nature center called Aquarena Center sits on the site of a former amusement park called Aquarena Springs. Glass-bottomed boats tour Spring Lake, allowing visitors a chance to see deep into the clear water and learn about the fragile ecosystems that exist in the area.

Rio Vista Falls is a popular swimming destination as is a place across the street called Sewell Park on the campus of Texas State University. The university itself is filled with stunning early twentieth-century architecture and offers a gorgeous view of the San Marcos River.

Historic downtown San Marcos is centered at the 1909 Hays County Courthouse, which has a copper dome. Find a parking space and walk around the courthouse square. Many of the square's buildings have been restored to serve as law offices and business. Shops offering music, drinks, coffee, cigars, crafts, and antiques round out the mix of places in the square.

The water tower in historic Gruene is a well-known landmark.

OPPOSITE: The Gruene historic district offers streets lined with old buildings housing shops and restaurants.

Canyon Lake to Guadalupe River State Park

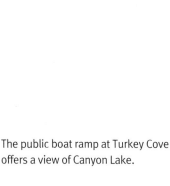

Route 22

River Road veers off Texas Highway 46 northeast of New Braunfels. Travel River Road as it winds beside the Guadalupe River to the town of Sattler on Ranch Road 2673 and then on to Canyon City on Ranch Road 306. Access points to Canyon Lake lie along both roads. Guadalupe River State Park is 20 miles west of Canyon Lake. Take Ranch Road 2673 to Ranch Road 3159, then Highway 46 west to Park Road 31 north.

The Guadalupe River is a major tributary through the Hill Country above San Antonio. Early settlers were drawn to the year-round supply of clear, pure water offered by the river. Today tourists flock to the area to enjoy recreational activities in the same clear, pure water.

The scenic route to Canyon Lake begins on the banks of the Guadalupe River outside New Braunfels. River Road veers off of Highway 46 outside of town. The two-lane road dips into ravines and winds around sharp corners as it follows the winding river. Businesses offering river rafting trips, inner tube rental, and camping line the banks of the river. Cafés, icehouses, and restaurants offer a view of the river and a respite from driving. Private and vacation homes are tucked back into the woods.

The road is also lined with signs warning that there is no parking, stopping, standing, or loading along the road. In Texas, the waters of a river are public property, but the land along the river can be purchased by businesses and individuals. All of the land along this stretch of the river is private property.

Access to the river is through any of the businesses, camps, bed and breakfasts, or private homes. If you'd like to swim, tube, camp, or simply gaze at the beautiful scenery, pull into any of the public facilities, pay the entrance fee, and enjoy the river. Proprietors are usually friendly, courteous folk anxious to share their piece of Texas.

The public boat ramp at Turkey Cove offers a view of Canyon Lake.

River Road is packed from spring to fall on weekends and holidays. People in Texas love this part of the Guadalupe River, as evidenced by how many travelers are on this stretch of highway. Advance reservations are recommended at any of the quaint little riverside cabins, such as Oak Hill River Inn, Cliffside Inn, or Mountain Breeze Campground. Companies like the River Valley Resort Rio Raft Company (1-877-rio-raft) offer day-use facilities, cabins, camping, and RV hookups. Do research in advance and make reservations early if you plan to spend the night or play in the river.

The road crosses the Guadalupe River four times along River Road. The canyon walls get steeper as the road progresses toward Canyon Lake. After the fourth river crossing, or twelve miles from New Braunfels, the large, grassy, earthen dam that holds back the waters of Canyon Lake looms on the horizon.

The Army Corps of Engineers built a dam across the Guadalupe River in the late 1950s and early 1960s to form Canyon Lake. Eight public parks are scattered around the perimeter of the lake. Some, including Overlook Park at the top of the dam, are

GUADALUPE RIVER

THE GUADALUPE RIVER is a major force in the Texas Hill Country. It begins at the north and south forks of the river in western Kerr County. Near the town of Hunt, the forks merge into a single, slow-moving stream lined in bald cypress trees; homes line the river, providing local residents with private access. Kerrville State Park allows public access to the river.

Eight small, low-water dams stand between Kerrville and Comfort. About two miles above Comfort, a mill channel with a ten-foot waterfall signals the spot where the river powered a mill whell.

From Waring to Farm Road (FM) 3160, the Guadalupe River cuts through the soft limestone of the Edwards Plateau. Public access to the Guadalupe in the form of pull-offs and sand bars is sometimes available at points where the road crosses the river.

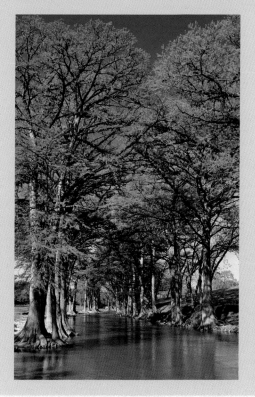

The twenty-two miles of river traverses the road six times from FM 3160 to the Rebecca Creek Crossing. The river can be placid and tranquil, but can pick up speed when it's squeezed between high limestone bluffs. A few spots along the river offer class 1 and 2 rapids, areas that become dangerous during high water. Only canoeists, kayakers, or tubers can access this stretch of river. Other public access points exist, but mainly at Guadalupe River State Park and private campgrounds.

The Guadalupe River is 250 miles long and flows through eight counties. Waters along its course are gathered in the Canyon Lake Reservoir, Lake McQueeney, Lake Dunlap, Lake Placid, Lake Gonzales, Wood Lake, and Meadow Lake. Except near its headwaters, the river has enough water for recreation during the year.

River camps are a popular destination in the Texas Hill Country along the Guadalupe River near Canyon Lake.

open from 7 a.m. to sunset and are for day use only. The restrooms, picnic tables, hiking trails, and lake access make these parks a great stopping point on your travels. Other parks offer camping and boat ramps.

Sattler and Canyon City are two of the major towns on the south end of the lake, and offer venues for shopping and eating. Hundreds of resorts, vacation rentals, and campgrounds branch off of Ranch Roads 2673 and 306. Enough accommodations exist around the lake to fit every interest and price range.

Guadalupe River State Park is a twenty-mile drive from Canyon Lake. (From Canyon Lake, take Ranch Road 2673 west to Ranch Road 3159, then Texas Highway 46 west to Texas Highway 31 north.) This Texas Parks and Wildlife facility offers camping, picnicking, hiking, and swimming in the Guadalupe River. The park is situated on several bends in the river and gives visitors a chance to canoe, tube, or simply play in the clear, cool water.

ROUTE 23

Gonzales, Palmetto State Park to Luling

This route takes you through Texas history and Texas natural beauty while delivering Texas tasty treats all in one short day.

Gonzales, a sleepy little town ten miles south of Interstate 10, may be a short journey from the modern world of the interstate, but it represents a long journey back into the history of Texas. In 1832, the town was on the edge of Anglo-American settlements in Mexican territory and was the closest Anglo settlement to San Antonio de Béxar, where discontent was brewing with the Mexican government. Mexican soldiers arrived on the scene to capture a large cannon that the Texians, as the Anglo settlers were called, had stationed in Gonzales. Waving a flag with the words "come and take it," the Texians fought to keep their cannon on October 2, 1835, in what became known as the Battle of Gonzales—the first battle in the Texas War of Independence.

General Sam Houston took command of the Texians on October 11 and began making plans to march on San Antonio. In February 1836, the Gonzales Ranger Company of Mounted Volunteers joined Colonel William B. Travis' men in defense of the Alamo. On March 6, thirty-six men of the Gonzales Rangers died in the battle for the Alamo against the Mexican army.

Six days later, word arrived in Gonzales of the tragedy. General Houston ordered the town burned and many men, with their wives and children in tow, headed off for a showdown with the Mexican army at San Jacinto, 150 miles east across fields and marshes.

Sarah Ponton Eggleston was one of those wives. Her husband, Horace, was a prosperous merchant in Gonzales who married Sarah in 1835 when she was only fifteen. Sarah followed Horace to the Battle of San Jacinto and gave birth to their first child two weeks after the Texians defeated the mighty Mexican army led by General Santa Ana.

The house that Sarah and Horace built for their family ten years later in Gonzales still stands at a park bordered by Moore, St. Louis, and St. Lawrence streets. The dogtrot-style house was made of walnut and oak trees harvested from the Guadalupe River. One room of the two-room house was used for cooking and eating. The other room was for sleeping. The open-air breezeway between

Route 23

Gonzales is 10 miles south of Interstate 10 and 60 miles east of San Antonio. The historic part of town is located on St. Lawrence Street. Drive west on Alternate U.S. Highway 90 to Farm Road 2091. Farm Road 2091 becomes Park Road 11 and eventually loops back to U.S. Highway 183. Luling is on U.S. 183 north of Interstate 10.

San Marcos Bridge, Gonzales, Texas.

Five men pose on the bridge crossing the San Marcos River at Gonzales when it was new. The old wooden bridge stands beside the new structure.

Sarah Ponton Eggleston and husband Horace built this Texas dogtrot-style house in 1845–1846 in Gonzales. The home is made of walnut and oak harvested from the nearby Guadalupe River.

BELOW: Detail of the Eggleston House in Gonzales.

the two rooms was space for the dogs, hence the name dogtrot, but it also served as an open living space.

Stand in the dogtrot and feel the cool breeze flowing between the buildings. Imagine shucking corn or shelling peas while children played in the yard. Push a button near the doorway to hear a recording that will describe what life was like in the home during the mid-1800s. Look through the windows to see period furniture and mannequins dressed in period costumes.

Continue the drive toward the historic center of Gonzales on St. Lawrence Street to see more historic homes. The magnificent J. D. Houston House, built of red brick in an elaborate Queen Anne style, towers over St. Lawrence Street. One block away on St. George Street, the W. B. Houston House exhibits the same architectural style, but in a colorful wooden construction. The two Houston men were brothers. Historic homes on surrounding streets show the name of the original homeowner and construction dates on plaques visible from the street.

Back on St. Lawrence Street, the Gonzales County Courthouse looms large over the town square. The red-brick building with details in white plaster looks like an elaborate wedding cake. In 1895, the building cost $64,000 to construct. In 1992, it cost $3 million to restore.

Historic buildings abound in this small town. A driving tour map available at the Chamber of Commerce and listed on the Internet at www.gonzalestexas.com takes visitors to the best spots in town. Each stop is marked with a green sign adorned with a picture of a cannon. Above the cannon is a banner with the words "Come and Take It."

You'll leave Gonzales on Alternate U.S. Highway 90 west and head north on Farm Road (FM) 2091 to Palmetto State Park. The first scene in the park after turning on Park Road 11 is the palmettos. Dwarf palmettos, water-loving plants with wide leaves that look like a ladies' folded fan, are abundant in the understory below hackberry, pecan, and oak trees. Green anole lizards and green tree frogs use the stiff leaves of the palmetto as solid perches to hunt for insects. Grasses and greenbriar create a mat of green vegetation over the soggy soil. Tiger swallowtail butterflies sail through the air as red-shouldered hawks perch quietly on horizontal tree branches overlooking their domain.

ABOVE: William Buckner Houston built this mansion in 1895 in Gonzales. The home is a classic example of Queen Anne–style architecture. Today, the Houston House is a respected bed and breakfast.

LEFT: The Gonzales County Courthouse was built in 1895 at a cost of $64,000. The building was restored between 1992 and 1998.

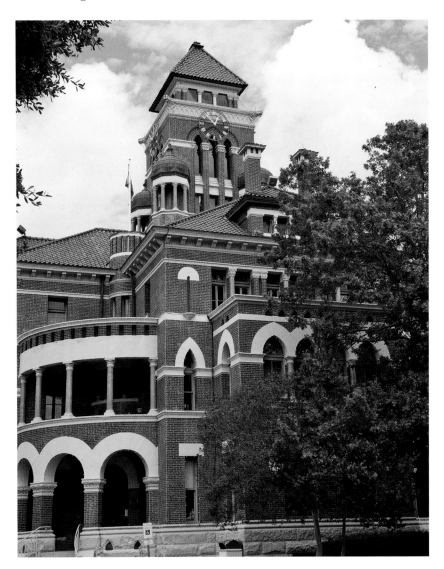

ABOVE: Detail of a door handle on the Gonzales County Courthouse.

A tiny green anole lizard at Palmetto State Park perches on the leaf of a dwarf palmetto (*Sabal minor*) to hunt insects.

The park owes its unique habitat to the river bottom formed by the San Marcos River as it changed course over the years. Today, the park abuts the river. A four-acre oxbow lake, an old river channel left behind when the river changed course, sits inside the park.

Park activities include hiking, birdwatching, canoeing, paddle-boating, swimming, picnicking, and camping. Lovely stone buildings in the park were constructed by the CCC in the 1930s. A water-pump tower made by the CCC on the Palmetto Trail is well worth a visit.

Park Road 11 and FM 2091 merge at the park headquarters in the community of Ottine to form a wondrous drive through river-bottom habitat with a thick canopy of shade trees overhead. Drive slowly and watch for white-tailed deer along the road. Stop at the Red Hill Overlook and enjoy the view of the surrounding river valley. Listen to the chickadees, tufted titmice, and blue jays calling from surrounding trees.

Park Road 11 and FM 2091 join U.S. Highway 183 a short distance down the road. The community of Luling sits four miles across Interstate 10 on U.S. 183. Luling uses the tag line, "A Celebration of What Makes Texas Great." In this small community of five thousand people there is oil, agriculture, barbeque, and watermelons.

Town folks have decorated the oil pump jacks to resemble insects, monsters, or storybook characters. A year-round farmers' market sits right next to the railroad tracks near downtown. Look for a Jubi-

Dwarf palmetto, a trunkless palm that grows low to the ground, is common throughout Palmetto State Park.

lee melon, a local variety of watermelon, for sale at the farmers' market or from any local fruit stand. For a weekend at the end of June, the town hosts the annual Watermelon Thump to celebrate the town's amazing watermelons. The new water tower is even painted to look like a giant watermelon.

RIGHT: Jubilee watermelons, for sale at a farmer's market, are the pride of Luling.

ROUTE 24

South of San Antonio Lakes

Route 24

Calaveras Lake is located 15 miles southeast of San Antonio. Reach the lake by exiting Interstate/Loop 410 on to U.S. Highway 181 south. Turn left on Texas Highway/Loop 1604 and proceed for two miles to Stuart Road. Turn left and drive a half mile to the park entrance on Bernhardt Road. To reach Braunig Lake, return to Highway/Loop 1604 and drive west to Interstate 37 north. Drive north of exit 130 and follow the signs. The park entrance is located at 17500 Donop Road.

Back in the 1950s, a horrendous seven-year drought hit south Texas; San Antonio was hit hard. The city depended on water from the Edwards Aquifer, which was recharged by rainwater. With no rain, the aquifer was in jeopardy. City leaders decided to change the way water was used to conserve the aquifer.

One way to conserve water was to change the way electrical generating plants consumed water. Each plant used water to cool machinery, and in the 1950s, all the plants used fresh, clean water from the Edwards Aquifer. The city decided to build two new generating plants that would draw water from artificial lakes. Water from the lakes would cool the machinery and be recirculated back to the lakes.

Built on the southern edge of San Antonio, the cooling lakes were named Calaveras Lake and Braunig Lake. Water from the San Antonio River mixed with processed wastewater was used to fill the lakes. Modern wastewater treatment techniques kept the water clean and usable for fishing and boating. The project was so successful that today, five power plants use the lakes for cooling.

Calaveras Lake, south of San Antonio, was built as a cooling pond for the nearby power plant in 1969. Today, the lake is a favorite fishing location, complete with lighted piers and natural banks.

Dragonflies, such as this four-spotted pennant (*Brachymesia gravida*), are attracted to the natural shoreline along Calaveras Lake and Brauning Lake.

Calaveras Lake has a surface area of 3,624 acres. The San Antonio River Authority administers the lake and maintains the facilities around the lake. Boat ramps provide easy access to the lake. Anglers line the lighted fishing piers and spread out among the picnic spots around the lake in hopes of catching perch, channel catfish, or largemouth bass. The natural shoreline, unimpeded by a manmade bulkhead, makes wade fishing or casting for bait a breeze.

The natural shoreline is also a boon for birdwatchers and other nature lovers who visit the park. American coots, great egrets, and marsh wrens love to feed near the reeds along the shoreline. Dragonflies like four-spotted pennant, red-tailed pennant, roseate skimmer, and blue dasher fly low over the water and perch on short branches in the water. Watch for butterflies such as viceroy, bordered patch, and question mark perched in the grass or in trees.

The low vegetation along the narrow road that surrounds the lake is popular with birdwatchers. Inca doves, great-tailed grackles, and northern mockingbirds are common. Red-tailed hawks might be seen overhead and northern bobwhite quail might be heard calling from the tall grass. During the winter, look for sparrows in the grasslands.

Camping is allowed at Calaveras and Braunig lakes. Both are open twenty-four hours a day with an entry fee. Entry fee paid at one lake allows access to the other within a single twenty-four-hour period.

A goatweed leafwing butterfly (*Anaea andria*) sips sap from a tree branch at Calaveras Lake.

San Antonio Loop

Route 25

The River Walk encompasses a large section of downtown San Antonio. Commerce Street is a good access point off Interstate 10 or Interstate 35. La Villita and Hemisphere Park are located near Alamo Street and East Nueva. Plenty of paid parking is scattered through the area. Brackenridge Park is north of downtown. Take Interstate 37 north and exit on Broadway then follow the signs to Brackenridge Park. The San Antonio Botanical Gardens are on Funston Place off Broadway in the vicinity of Brackenridge Park.

San Antonio is a vibrant city. Historic locations, trendy bars, restaurants, and shops line the famous River Walk and surrounding downtown streets. Near the city's center, peaceful parks beckon those interested in a little green space.

San Antonio de Béxar Presidio was founded in 1718. In 1773, the town became the capital of Spanish Texas. Although life in this part of the Texas frontier was bleak, the San Antonio settlement flourished. The small town was connected to Mexico City by the Mission Road, a trading route lined with a series of missions.

In 1813, Spain gave Mexico its independence. At the same time, many Texans also wanted independence from Mexico. They'd have to fight numerous battles, including the siege at the Alamo, until they could win independence in 1836.

Life in the newly formed Republic of Texas was no cakewalk. Comanches and Mexican invaders attacked residents many times. But stability and growth took hold when Texas became part of the United States in 1845. San Antonio was key to that growth, as it became a hub for westward expansion and European settlement of the state. Development in the city progressed through the early part of the twentieth century with major companies, schools, and the military calling San Antonio home.

TEXAS STAR TRAIL
A DOWNTOWN WALKING TOUR

ANYONE WALKING the streets around the River Walk and HemisFair Park is sure to notice silver-dollar-sized metal medallions embedded in the sidewalk. The San Antonio Conservation Society placed these medallions in the sidewalk to point the way to plaques or pavement markers indicating historically important locations.

If you follow the medallions, you'll cover 2.6 miles of the city. A

map of the tour, available from the Conservation Society, shows each of the eighty-one historical locations and provides a short description of each site. People can walk the entire trail or portions of it, depending on time and interest.

Visit www.saconservation.org for details and a map, or call the San Antonio Conservation Society at 210-224-6163.

In 1921, a major flood devastated the city, filling the downtown area with nine feet of water and killing fifty people. Afterward, the city looked at the possibility of channeling the San Antonio River to prevent future flooding. Following several years of discussion over a variety of plans, an architect named Robert Hugman proposed a plan in 1929 to build a Paseo del Rio, or River Walk, along the banks of the river through downtown.

The plan gradually took hold with area politicians, and in 1938, funding was found through the Works Projects Administration. Robert Hugman, who became the architect for the River Walk project, designed thirty-one different stairways that would lead visitors from street level to the river with footbridges allowing people to cross over.

Construction was completed in 1941, and the River Walk limped along for several years. Landscaping was enhanced as hotels and restaurants moved into the area. But in 1959, a California company that helped design Disneyland suggested that all the buildings along the River Walk should take on an early Texas motif to capitalize on the city's history. The suggestion, criticized by some and loved by others, eventually took hold and the appropriate renovations to buildings began. Growth and development of the area surrounding the River Walk were particularly spurred by the 1968 World Exposition, Hemis-Fair. More than six million people from around the world came to San Antonio during HemisFair, and downtown San Antonio became forever a major tourist destination.

Public parking around the River Walk is pricey, ranging from $5 to $10, depending on the time of day and day of the week. Downtown hotels provide shuttle service to the River Walk and surrounding attractions. Also, trolley cars ferry you to River Walk destinations. Take advantage of the shuttle services or trolleys to avoid the price of parking.

Exploring the River Walk can consume many hours or days, depending on your interests. Shops, restaurants, museums, and historical attractions abound. Maps of the River Walk are posted everywhere, allowing the freedom to take a turn here or walk over a bridge there. If you get lost, the maps make it easy to find your way back to your hotel, car, or transit stop.

A walk along any of the city streets above the River Walk offers many attractions. On Alamo Street, for instance, a community of historic homes, schools, and offices has been converted into a

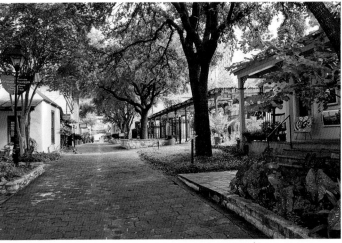

ABOVE (BOTH): La Villita began life as San Antonio's first neighborhood. Today, it is a thriving artist colony near the River Walk and HemisFair Park.

OVERLEAF: The San Antonio River Walk sits below the hustle and bustle of the city above. Stairways provide access to the River Walk from several locations throughout downtown.

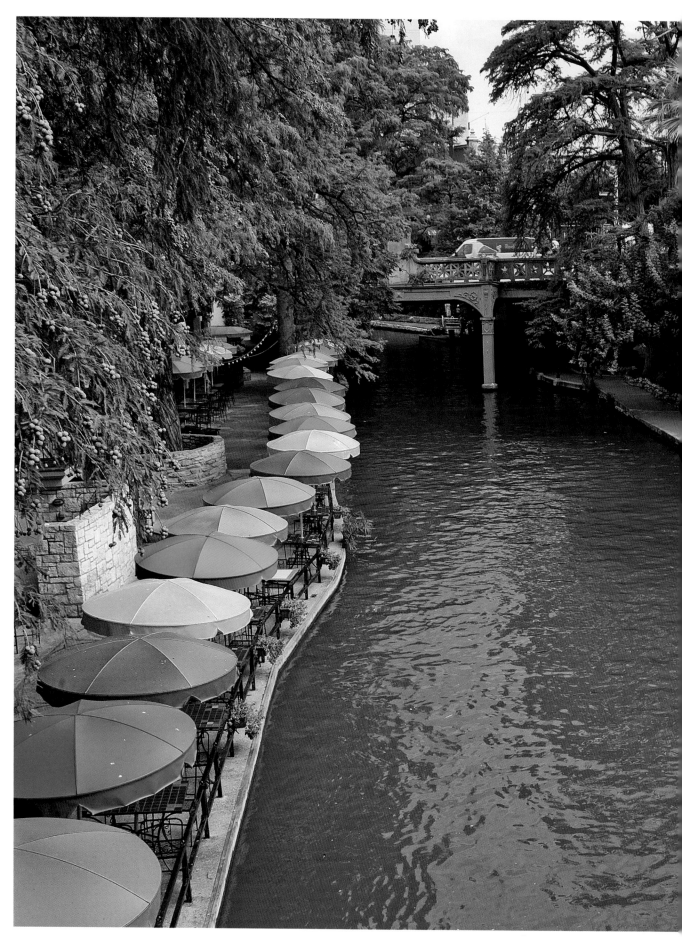

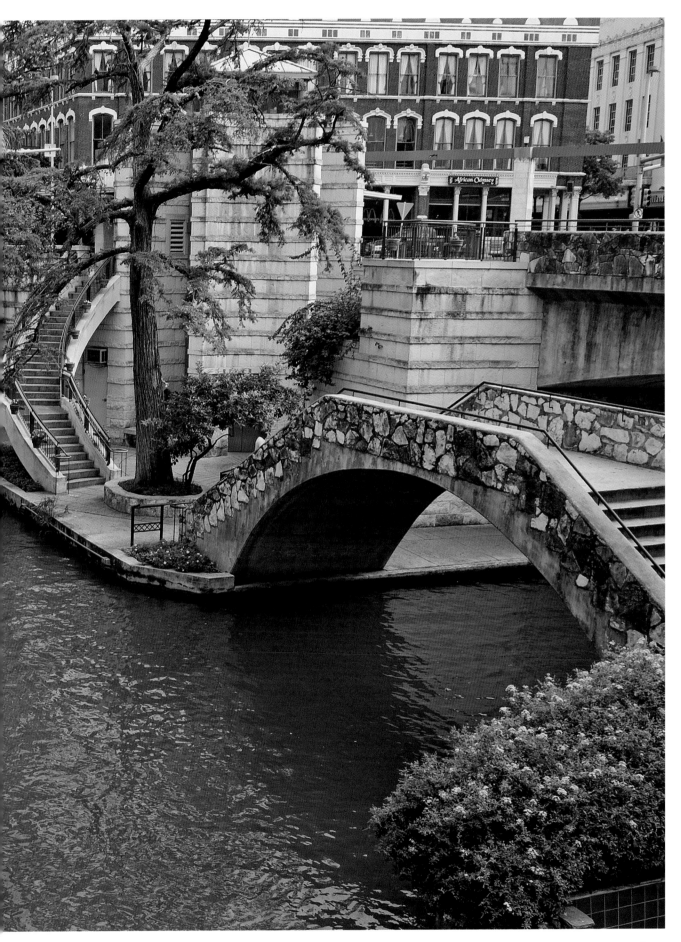

The Little Church of La Villita dates back to 1879. The Episcopal Diocese bought the church in 1895, and the city of San Antonio acquired the title in 1945 as part of the La Villita development.

The Tower Life Building was built in 1929 as the Smith-Young Tower. Once the tallest office building in San Antonio, it is designed with Neo-Gothic ornaments. Today, this landmark towers above the city's River Walk.

shopping enclave called La Villita. Exploring the boutiques, cafés, and gift shops in La Villita can take hours. Luckily, clean public restrooms and shade-covered benches make time spent in La Villita comfortable.

HemisFair Park lies across from La Villita. The dazzling spire called Tower of the Americas is 622 feet high and visible from any street in downtown San Antonio. For a small fee, you can ride a glass elevator to the top of the tower and enjoy a stunning view of the city and a tasty lunch or dinner at Eyes Over Texas. (No reservations required; open all year; $15–$20 for lunch, $25–$40 for dinner.) The grounds of HemisFair Park feature walkways under the shade of stately trees, water features, a children's playground, gardens, and historic homes.

But San Antonio offers more than the famed River Walk. For example, not far away is historic Brackenridge Park, which provides a chance to see San Antonio's natural side. The park surrounds the headwaters of the San Antonio River. Land around the spring that feeds the river was once in private hands, but was donated to the city in 1899. The San Antonio River flows gracefully through the 343 acres that make up Brackenridge Park. Water flows through stone-lined canals and over rocks, and walking paths crisscross the park with stone footbridges straddling the cascading river water. People walk, ride bikes, fish, picnic, and simply enjoy the lush green space created by the park.

Golfers will find an eighteen-hole public golf course in the park, and young ones or those young at heart may enjoy the Brackenridge Eagle, a miniature train that travels a regular circuit through the park. The San Antonio Zoo is adjacent to the train station.

The San Antonio Botanical Gardens rest near Brackenridge Park on Funston Street. The thirty-three-acre facility is filled with colorful flower beds, fountains, and themed gardens. Its quiet, secluded entrance offers a glimpse of the botanical treats inside. Sycamore, live oak, and paloverde trees shade the parking area and give it color. Brilliant orange Mexican bird-of-paradise provides nectar for gulf fritillary butterflies. Other butterflies visit the blooms on the hamelia, salvia, and yellow trumpet flower in the understory.

The headwaters of the San Antonio River are in Brackenridge Park. Water flows through canals and under stone footbridges throughout the park.

BELOW: Children of all ages enjoy a ride on the *Brackenridge Flyer*, a replica steam engine passenger train that winds through Brackenridge Park in San Antonio.

ABOVE: Benches under an arbor of wisteria vines offer a cool place to sit and rest at the San Antonio Botanical Garden.

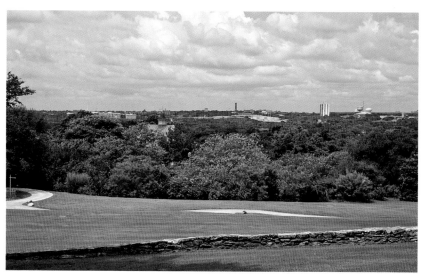

RIGHT: From the manicured overlook at the San Antonio Botanical Garden you can see the suburbs of San Antonio below.

After passing through the visitor's center and gift shop, you can stroll on well-maintained paved trails winding through gardens, across open spaces, and over hills. Stately formal gardens with elegant fountains offer a quiet place to sit and enjoy the scenery. A Texas native area, complete with a historic cabin, contains native plants centered on a natural spring with water gurgling over rocks covered in moss and ferns. Trails lead to a high point where the entire city of San Antonio appears on the horizon.

ROUTE 26

San Antonio Missions

Back in the 1700s, Spain established missions in the land north of the Rio Grande River. The missions, with the church as the main focus, were settlements lining the trade route from Mexico City to the northern frontier in Texas. Because people who wanted to become citizens of Spain had to convert to Catholicism, the mission route was as important to new citizens as it was to commercial trade.

Today, the Mission Trail is a linear park created by the City of San Antonio and the National Park Service. This tour loop starts at the Alamo on Alamo Street in downtown San Antonio and ends at Mission Espada on the outskirts of San Antonio. In between are historical buildings, green spaces, and residential neighborhoods.

The building we call the Alamo began its life back in 1744, when the cornerstone was laid for a church at San Antonio de Valero. The mission was secularized in 1793, and in 1803, it became a Spanish military post called the Alamo. The Mexican independence movement began a tumultuous time in 1811 up until Mexico gained independence from Spain in 1821. In 1836, after years of unhappiness under Mexican control, a group of Texans confronted the Mexican army in a series of skirmishes.

The Mexican army, under General Santa Ana, arrived in San Antonio in early 1836 to squelch the uprising. The Texans, or Texians as they were called, retreated inside the protective walls of the Alamo in late February 1836. Texas declared its independence from Mexico on March 2, 1836. Four days later, the Mexican army laid siege to the Alamo, and on April 21, 1836, broke through the walls, killing about two hundred Texian fighters but sparing the women, children, and two slaves. The Mexican army lost at least six hundred men during the siege and subsequent sacking of the Alamo.

The Mexican army moved on to the east, leaving the Alamo behind, but not its legacy. The Battle of the Alamo became a battle cry for Texas independence and a symbol of a Texas spirit that would live on.

The Texians defeated the Mexican army at the Battle of San Jacinto in 1836, and the Republic of Texas became an official independent nation. The new Republic donated the Alamo mission buildings to the Catholic Church in 1841. But after Texas became part of the United States, the U.S. military leased the buildings from the church, made repairs, and added the façade that we see today on the outside of the Alamo. The military, Catholic Church, and local community battled over ownership of the Alamo until the Daughters of the Republic of Texas became custodians in 1905.

Route 26

The San Antonio Mission Trail runs between the Alamo in downtown San Antonio and Mission Espada on the south side of San Antonio near Interstate 410/U.S. Highway 281. The entire route is well marked by roadside markers or overhead signs at major intersections. All missions are managed by the National Park Service. The Visitor Center at each mission has driving maps and historical information.

OVERLEAF: A symbol of Texan spirit and determination, the Alamo began life in 1744. Today, it is a major tourist attraction administered by the Daughters of the Texas Revolution.

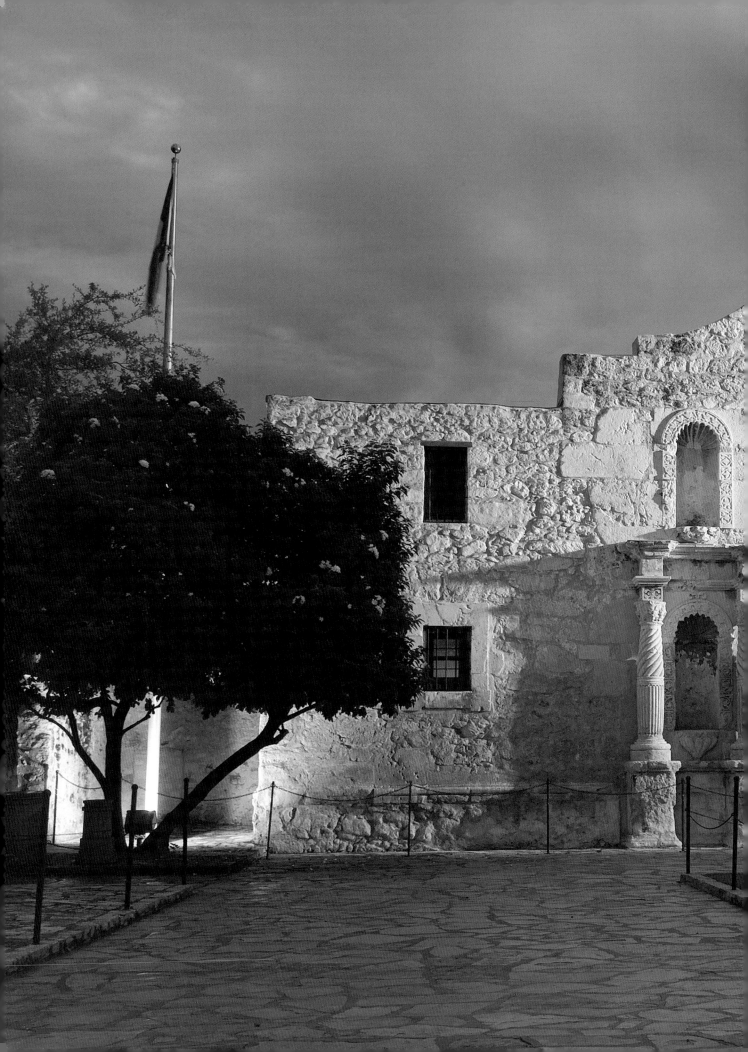

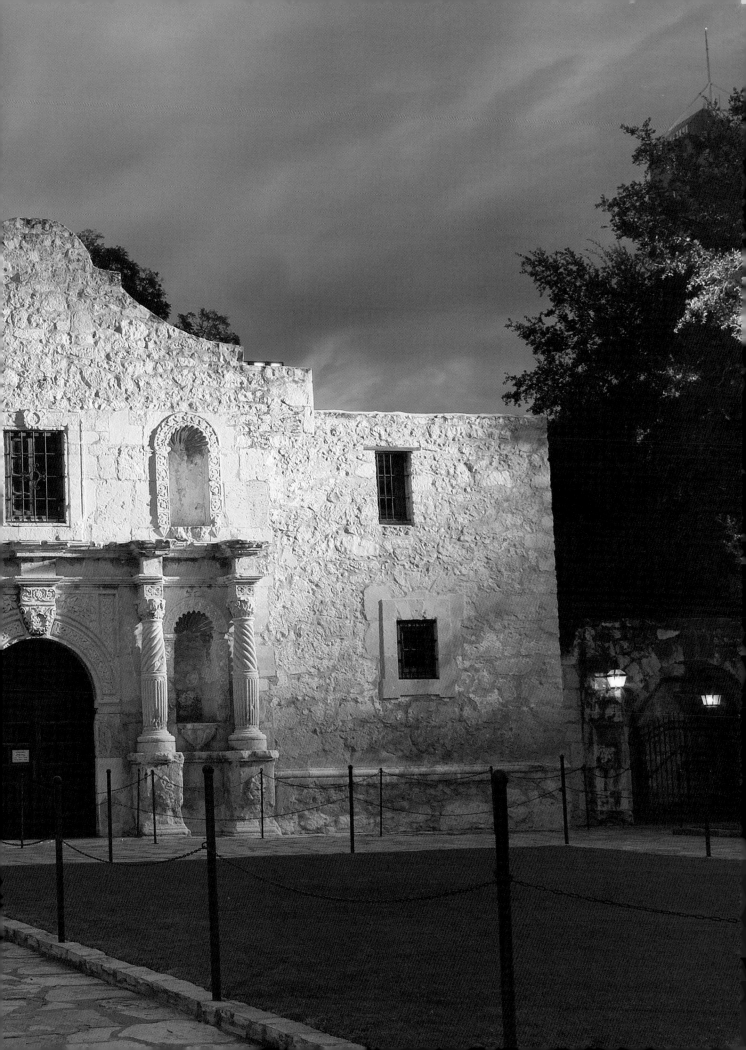

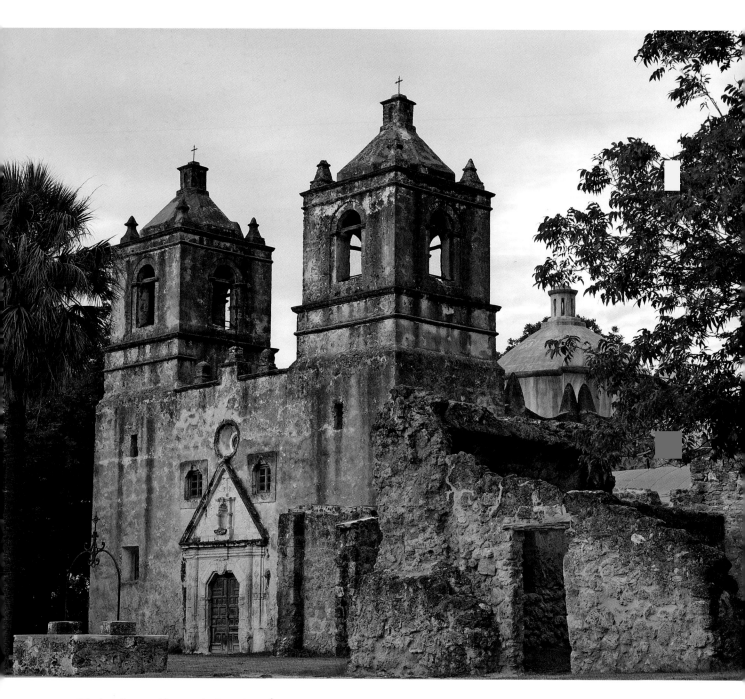

Mission Concepción was dedicated in 1755. The building hasn't undergone extensive restoration, but it remains a commanding presence on the San Antonio Mission Trail.

Walk around the Alamo, touch the walls, and sit in the quiet sanctuary of the chapel. Tour the gardens and view the displays to learn about the history of this icon in Texas.

The Mission Trail driving tour leaves the Alamo behind and heads south toward more history and stunning architecture. The route along Alamo Street to South St. Mary's Street and on to Mission Road is clearly marked. (Look for street signs with the words "Mission Trail" written across the bottom edge.)

Mission Concepción was dedicated in 1755. The building hasn't undergone extensive restoration, but it still has a commanding presence. Notice how local citizens use the expansive grassy lawn around the church for picnics or as playgrounds for their children. These

Detail of a lamp and doorway at Mission Concepción.

historic buildings have become the focal point of green space in modern San Antonio. The National Park Service has a small visitor's center on the grounds, open from 9 a.m. to 5 p.m.

Continuing along the mission trail, you'll find a larger visitor's center at Mission San José. The mission, named for Saint Joseph, was completed in 1782. It is the largest mission on the trail and the best restored with a breathtaking façade around the main entry to the sanctuary. Services are still held in the church. Check listings nearby for more information.

A small statue graces a secluded spot at Mission Concepción.

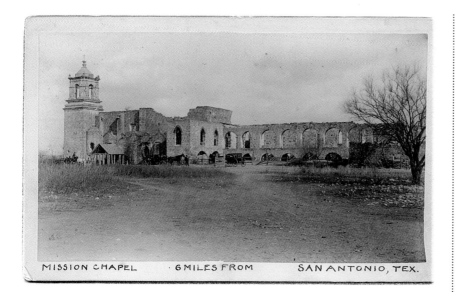

MISSION CHAPEL · 6 MILES FROM · SAN ANTONIO, TEX.

LEFT: An old postcard shows horse-drawn carriages outside the chapel at Mission San José. Today, the mission is part of the Mission Trail in San Antonio.

LEFT: A small statue of a woman graces the grounds of Mission San Juan.

OPPOSITE: The convento building at Mission San José dates back to 1782. It is the largest mission on the Mission Trail and the best restored.

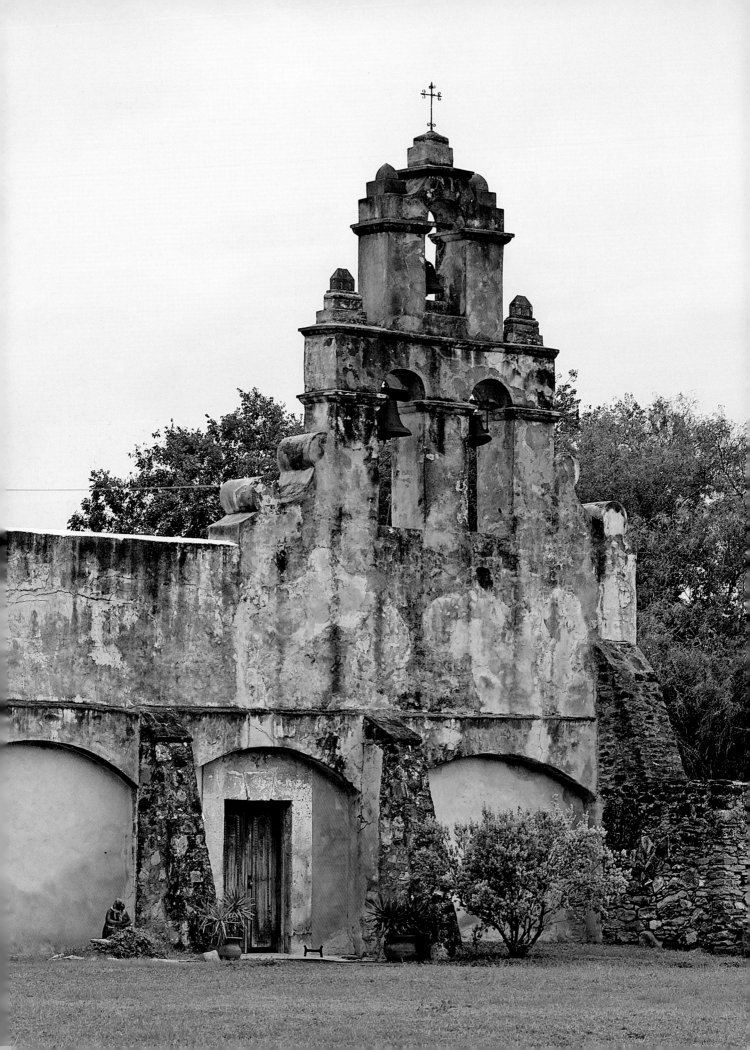

Interior details at Mission San José. The church is still an active part of the community.

Mission San Juan, the next stop on the mission trail, was completed in 1756. The tower, called an *espadana*, houses three bells and overlooks the surrounding parkland and residential houses. Some buildings around the church have been restored, but many have been left unfinished. It's interesting to be able to walk inside the buildings to see how they were constructed more than two hundred years ago.

Mission Espada is the last stop on the mission trail. The church was finished in 1756 and displays another three-bell *espadana*. Nearby, the Espada aqueduct carries water from the San Antonio River to nearby agricultural fields. This aqueduct brought life-giving waters to the arid fields around the mission in the 1730s and has been in continuous use ever since.

ABOVE: Mission San Juan was completed in 1756. Some of the buildings around the church have been restored, but many, such as this one, have been left unfinished.

OPPOSITE: Mission San Juan's three-bell tower, or *espadana*, rises above the surrounding parkland and residential houses.

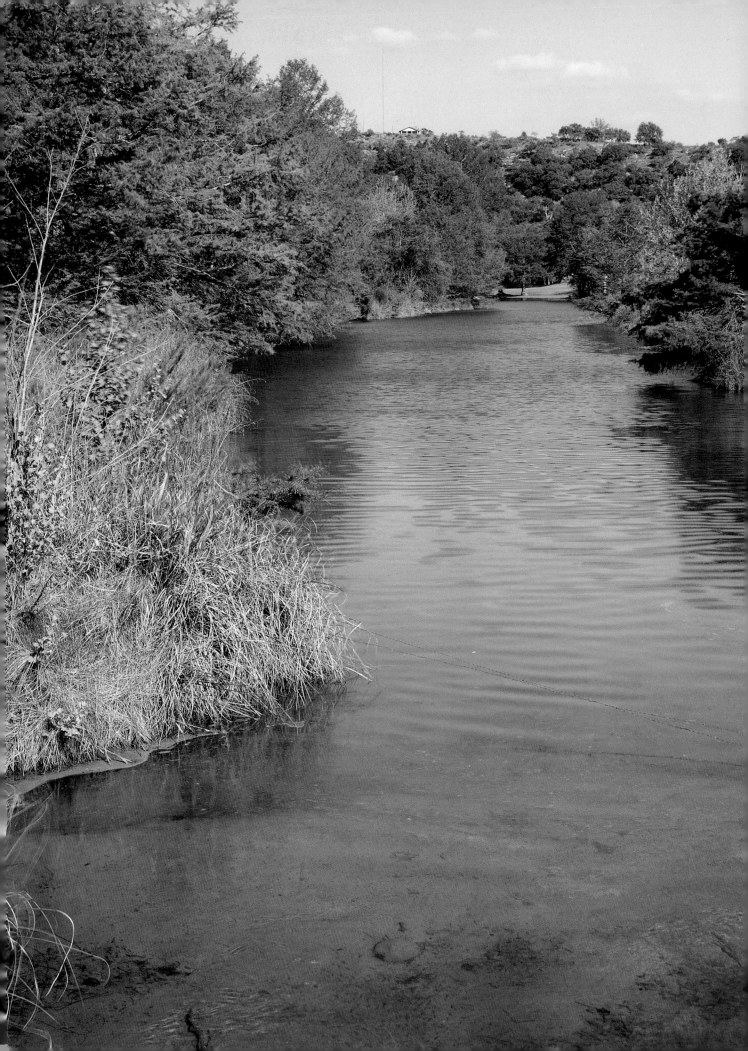

PART VI

Northwest Region

Halcyon Hills to Roughhewn Slopes

Limestone cliffs and clear, turquoise waters await divers along Highway 39 near Kerrville.

OPPOSITE: A drive along Highway 39, near Kerrville, rewards travelers with stunning views of the South Fork of the Guadalupe River.

The route between Kerrville and Junction is astonishing for its seamless transition from halcyon hills to rough-hewn slopes. At Kerrville, streams cut through quiet valleys. At Junction, streams slice through stark limestone canyons. In both cases, the landscape is so sweeping and breathtakingly beautiful that you have to pinch yourself to be sure you're not having a dream.

No two places illustrate the contrasts in the land more than Lost Maples State Natural Area and South Llano River State Park. Lost Maples rests in a quiet canyon bound by rugged limestone hills, but decked with grassy plateaus and draped in broad-leafed trees, including the bigtooth maple. The rare maples, stranded and isolated in the canyon after the last ice age, present a spectacular array of color in autumn. Llano Park runs along two miles of the clear Llano River and typifies river bottomland in the mighty limestone hills of the region. Wild turkeys are abundant, as are white-tailed deer, jackrabbit, javelina, and armadillos. Foxes and bobcats are not uncommon, either, but are uncommonly seen. The abundant wildlife and clean water suggest how early settlers—even ancient Native Americans—were able to sustain themselves in an otherwise harsh land.

One good way you may sustain yourself on a trip through the region is to never pass up a barbeque restaurant, particularly Cooper's Old Time Pit Bar-B-Que & Grill and Lum's Bar-B-Que and Country Store in Junction.

ROUTE 27
Junction to South Llano River State Park

Junction is appropriately called the "front porch of the west." The town certainly has a homey, comfortable feeling to it, like sitting on a neighbor's front porch. Adding to the homeyness are the friendly barbeque restaurants offering food and pies to die for.

Junction's surrounding terrain eases you out of the Hill Country and into the vast open spaces of West Texas, as it rests at about the halfway mark between the eastern border near Beaumont and the western border at El Paso. Folks usually enter Junction via Interstate 10 driving from the east as the highway slices through a hilly ridge revealing towering fifty- to sixty-foot road-cuts of exposed limestone. The uniformly spaced strata reveal fine debris and marine sediments deposited when this part of the country was a seabed 200 million years ago.

Route 27

Junction is on the northwest edge of the Hill Country off Interstate 10. South Llano River State Park is four miles south of town on U.S. Highway 377. Both locations can be explored in a day or less.

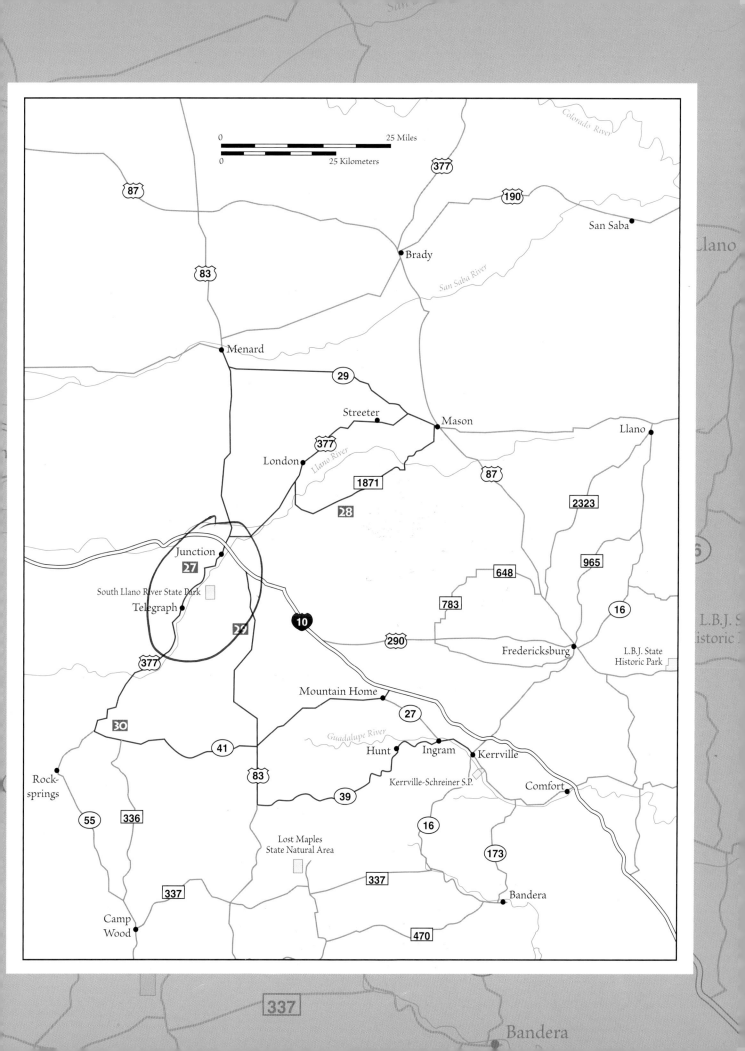

Bar-B-Que is serious in Junction. Cooper's Bar-B-Que offers some of the best.

The Llano River and hundreds of small tributaries carved the valley where Junction sits. U.S. Highway 377 leading out of town to the southwest offers views along the Llano River of pastures, cultivated fields, and limestone cliffs. The hillsides are covered in grasses shaded by juniper and oak trees.

About four miles from town on U.S. 377 is South Llano River State Park. The turnoff for the park is at Park Road 73, which leads you down into the river valley of pecan trees and large open grasslands. Slow down and enjoy the descent into this quiet valley and peaceful park.

The road goes through a low-water crossing in the bottom of the valley. During the warm months, and some cooler months,

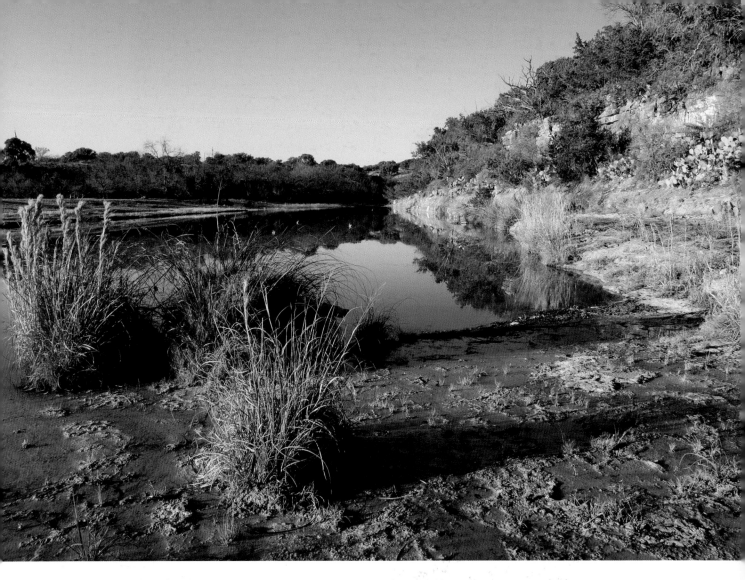

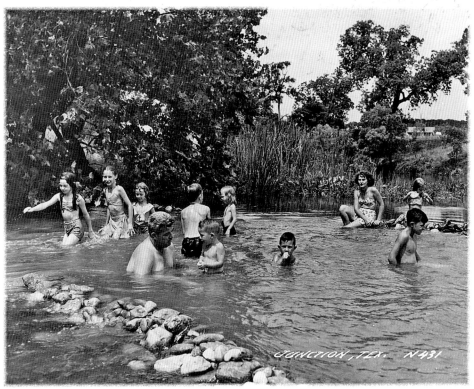

JUNCTION, TEX. N 431

Maynard Creek, near Junction, flows past limestone cliffs topped with Ashe juniper in the late winter.

In the 1960s, two rock dams were created across the river near Junction to create a family swimming pool.

A male northern cardinal takes advantage of a water feature at the South Llano River State Park bird blinds.

BELOW: Several ranches in the Junction area have opened their doors to nature and wildlife photographers. Rental from photo blinds serves as an added income flow for the ranch.

swimmers play in the blue water on either side of the crossing. The river on the left side (west) is turbulent, but placid on the right side (east). Stop and enjoy the scene.

The park headquarters at 1.5 miles from the low-water crossing is situated in a lovely, one-story, 1920s-style white-painted house. Sit in the swing on the front porch and enjoy the scenery. During the spring and summer, a family of purple martins resides nearby in a purple martin house. Enjoy the sights and sounds of nature from the front porch, or go inside the headquarters to view the displays and meet the nice staff.

The area to the left of the headquarters is a famous turkey roost. Wild turkeys come out into the open area in the mornings and evenings. Ask park personnel for details.

The park has camping, trailer hookups, and picnic facilities. Wild turkey and deer are common sights around the tents. Such birds as roadrunners, orchard orioles, indigo buntings, and spotted towhees are common sights at the three bird-viewing blinds; bird feeders and water features at each blind attract the birds. The Agarita blind is popular with local bird photographers.

ROUTE 28

Junction to Mason and Points South

Wide-open spaces and vista-laden highways characterize this route. U.S. Highway 83 north out of Junction offers a chance to drive a straight, wide road and enjoy the scenery all the way to Menard. The road to Mason offers another opportunity for driving and sightseeing. Several options back to Junction allow the journey to continue on open roads and to explore narrow ranch roads.

Begin by traveling north out of Junction on U.S. 83. As you leave Junction, notice the concentration of eighteen-wheelers and vehicles around Interstate 10, a major east-west trucking route between Jacksonville, Florida, and Los Angeles, California. U.S. 83 is another important trucking route connecting Laredo, Texas, with Minot, North Dakota, and the Canadian border. Now you know how Junction got its name.

U.S. 83 north between Junction and Menard seems to let the big eighteen-wheeler trucks slide along without perturbing the surrounding countryside. The highway is wide with spacious grassy shoulders. Views of the surrounding rolling terrain and wide-open Texas sky are utterly breathtaking.

Notice the many goat ranches that front the highway. This part of the country boasts a long history of goat ranching for meat and wool. In fact, the National Angora Goat Raisers Association is located in Rocksprings, Texas, south of Junction. Angora goats were imported from Turkey to the United States in 1849, and by 1900, nine-hundred thousand angora goats were being raised in the states. About a quarter of a million were being raised in Texas, principally in the Junction area.

On to the town of Menard, a sleepy little community far removed from the touristy towns of the Fredericksburg area. The historic downtown area has a few restored buildings around the courthouse, and adjacent to downtown along the San Saba River is a charming and surprisingly large city park completely shaded by a canopy of pecan trees. The Menardville Museum is located on U.S. 83 in an old railway station once used by the Atchison, Topeka & Santa Fe Railway.

No visit to Menard is complete without a jaunt to the Presidio San Saba located a mile west of town on U.S. Highway 190. Originally called the San Luis de las Amarillas Presidio when it was established in 1757, the presidio was built to protect a mission on the south side

Route 28

This route covers 111 miles if driven as a loop and offers numerous options to explore the countryside. From Junction, take U.S. Highway 83 north to Menard and the Mission San Saba. Mason is 37 miles east on Texas Highway 29. Return to Junction via Ranch Road 1871 southwest then Ranch Road 385 north, which joins U.S. Highway 377 south for a journey through wide-open terrain. U.S. 377 back to Junction is more direct.

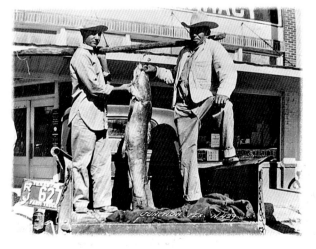

Fishermen show off their prize catfish on the streets of Junction in the late 1940s.

ABOVE: Located west of Menard, the Presidio San Saba, also known as the Presidio de San Luis de las Amarillas, was established in 1757. The presidio was built to protect a mission on the south side of the San Saba River. In 1758, two thousand Comanches attached the mission, killing priests and civilians. The mission was abandoned, and the presidio was decommissioned in 1772. Today, there are simple ruins, some from a 1930s restoration.

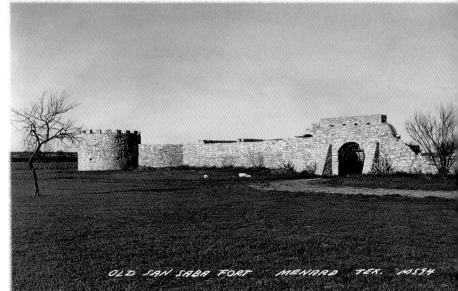

The Presidio at San Saba was rebuilt in the 1930s. Unfortunately, little of the rebuilding effort stands today.

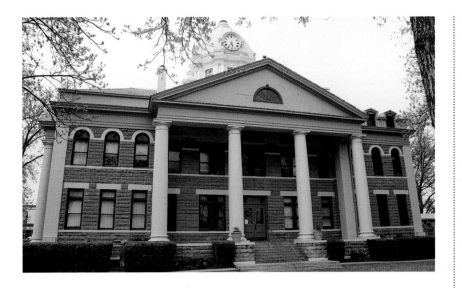

Mason County Courthouse in Mason is made from the dark brown limestone common to the area.

of the San Saba River. The mission was established to convert to Christianity (and, of course, pacify) the Lipan Apaches.

However, Comanches were mortal enemies of the Lipan Apaches and were in no mood for pacification by the Spaniards. With their Spanish horses and French guns, Comanches were a formidable foe to the Spanish presidio. In March 1758, two thousand Comanches assembled on the surrounding hills, attacked the mission, and killed priests and civilians. As a result, the Spanish abandoned the mission in 1758, and decommissioned the presidio in 1772.

Part of the structure of the presidio was restored in 1936, but little remains today. No structures remain of the mission that rested across the river, although archeologists continue to unearth remnants of the building and of the people who lived there. Still, it's worth a visit to see the stone walls of the presidio that yet stand these nearly 250 years later, and it's certainly worth the time to study the displays telling the history of this fascinating frontier fort.

A painted Texas flag adorns a cedar building in the small community of Art.

The town of Mason, which calls itself the "gem of the Texas Hill Country," lies a short thirty-seven miles east of Menard on Texas Highway 29. Situated on Comanche Creek, the town has an ever-sought-after, old-fashioned hometown atmosphere. The Mason County Courthouse and other buildings around the town square are made from stone quarried in the area. Visit the cafés, antique shops, gift shops, and wineries around the square. Each of the attentively restored historical buildings around the square is occupied.

From Mason, your journey can continue to Fredericksburg on U.S. Highway 87 or to Junction via one of two routes. The first route, Ranch Road 1871, is a fun road to drive southwest out of Mason as it crosses open Hill Country terrain and the Llano River. The second route, U.S. Highway 377, is a more direct route passing through the communities of Streeter and London, both small with little to do but offer a chance to savor the wide-open spaces of Texas.

ROUTE 29

U.S. Highway 83 to Texas Highway 39 to Kerrville

Kerrville is the quintessential Texas Hill Country town. It's filled with history, charm, outdoor activities, and modern conveniences. From Junction, a trip to Kerrville is a destination for spending the night or the day, and the adventure of getting there is half the fun.

Depart Junction on Interstate 10 heading east and take the exit for U.S. 83 south. The next forty-seven miles are easy driving through picturesque Hill Country habitat. Hilltops allow views of the rolling terrain on both sides of the road. Curves and dips in the road add adventure to this section of the route.

But the situation changes at the turnoff for Highway 39. Road signs indicate that it's a mere forty-three miles to Hunt, but the stretch of highway could take an hour or two to travel. Dips, turns, and twists in the road make the route slow going. Rugged, rocky fields on each side show scant evidence of topsoil. Nonetheless, wild turkeys are rather common in the fields and sometimes fly over the roadside fences. Exotic wildlife like axis deer graze behind the fences with native white-tailed deer.

After passing the intersection with Farm Road (FM) 187, the road begins to follow the south fork of the Guadalupe River. Slow down and enjoy the scenery. For the next twenty-three miles, the road will hug the shore of the river and traverse it at low-water crossings. The Yellow Rose Crossing, Second Smith Crossing, and First Smith Crossing offer stunning views of the Guadalupe River and the surrounding limestone cliffs.

Not many pull-offs are provided at the crossings, but at the La Casita Crossing there are wide areas for pulling off on each side of the bridge. Stop and enjoy the scenery of white limestone cliffs that surround the clear, turquoise river.

Near Hunt, you'll find overnight accommodations if you wish to spend more time on the river. The River Inn Resort and Conference Center is one of the more well-known accommodations, but the local Chamber of Commerce can provide you with information about other fine accommodations.

After the River Inn Crossing, look for a "boot fence" on the left-hand side of the highway. Boot fences are where local landowners put boots or shoes upside down on fence posts. The fence at this location with its astonishing variety of footwear is one of the best boot fences you'll see anywhere in the Hill Country. It's worth a few minutes of exploration.

The community of Hunt was settled by farmers and ranchers in the late 1850s. In 1912, the town of Hunt was officially formed at the

Route 29

This route begins in Junction and ends in Kerrville. Take Interstate 10 east out of Junction and exit onto U.S. Highway 83 south. The intersection with Texas Highway 39 is 47 miles south. Drive Highway 39 east to Texas Highway 27 and Kerrville.

confluence of the south and north forks of the Guadalupe River. In the 1930s, the community became a magnet for artists. Afterward, summer camps, religious camps, corporate retreats, and exotic game ranches followed. Today, Hunt is a small Hill Country community attracting visitors of all ages and from all walks of life throughout the year.

Highway 39 connects with Texas Highway 27 in Ingram, which also hosts year-round visitors who are drawn by its access to the Guadalupe River. Visit Old Ingram Loop for a chance to shop for designer clothing or antiques, or to pick up food and drink. River access is allowed one block from the Old Ingram Loop.

Travel east out of Ingram on Highway 27 to Kerrville, where it's easy to "lose your heart to the hills," according to locals. Kerrville is reputed to have the most ideal climate in the nation. At 1,645 feet in elevation, the city's winter is mild, its spring glorious, its summer temperate, and its fall resplendent with autumn colors. Residents of Kerrville luxuriate in all four seasons.

The surrounding hills are covered in cedar and oak grasslands. The Guadalupe River, edged in towering bald cypress trees, is the centerpiece of the town, and several city parks allow access to the river. Golf courses, equestrian trails, camping locations, cycling routes, nature centers, and shopping districts abound. A number of

Verbena and plains bitterweed grow along a cedar-post fence on Highway 39 near Hunt.

Old boots placed on fence posts, called a boot fence, adorn Highway 36 near Hunt.

annual festivals are held in the city, including the famous Kerrville Folk Festival held every Memorial Day Weekend.

Historical downtown Kerrville has been restored with several pedestrian walkways. Park near Earl Garrett and Waters streets in a public parking area.

Visit the Hill Country Museum–former home of Captain Charles Schreiner–for a chance to see the house built by one of the Hill Country's most famous philanthropists. The scrollwork carved into the gray limestone on the exterior of the building is worth a closer look. Flowing leaves carved in geometric patterns grace each of the columns on the front of the house. The carvings continue to the second-floor

RESTROOM LABELS

A LINGUISTIC GUIDE for people not familiar with Texas restroom-labeling techniques: In most cases, restrooms are labeled "men's" and "women's." In other cases, the restrooms are labeled "steers" and "heifers," and in some cases "bucks" and "does." With the state's huge Hispanic culture, restrooms are increasingly labeled "caballeros" and "mujeres" or "hombres" and "mujeres."

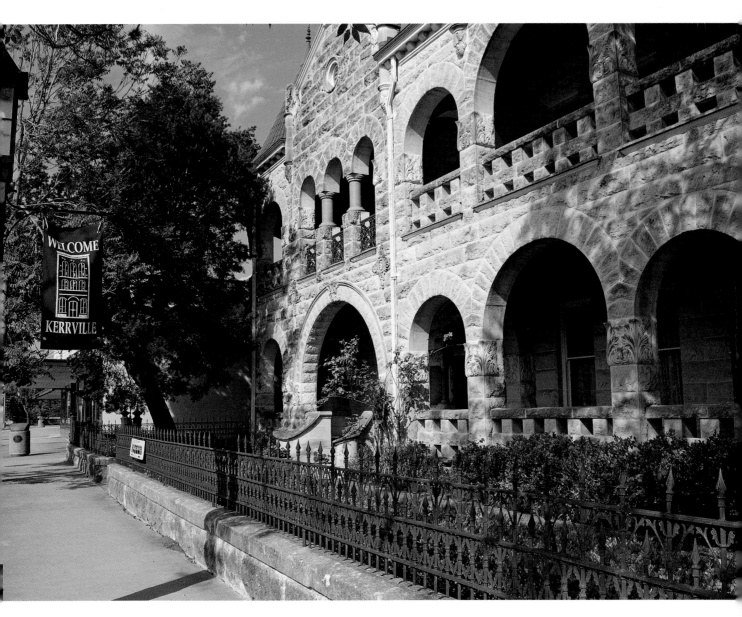

balconies and up to the peak of the roof. The wide wooden doors inset with cut glass finish off the grandeur of the building.

The historic district of Kerrville can be explored for hours or days, but other sights, such as Schreiner College, await you. In 1923, on the banks of the Guadalupe River, Captain Schreiner founded a liberal arts facility designed to prepare young men for college and the military. In the 1970s, military training and high school preparation ceased as the school became a college. In 1981, Schreiner College became a four-year institution recognized for its high standards of excellence. Today, Schreiner University is a treasure of the Texas Hill Country. Visit its quiet campus with red-brick buildings to experience the school's charm.

On the other side of Kerrville via Highway 27 is the Riverside Nature Center, another Hill Country treasure. Founded in 1989 and developed in the early 1990s, the nonprofit facility on Francisco Limos Street offers education about the local ecosystem.

Captain Schreiner's house in downtown Kerrville is made of limestone and has intricate carving on the exterior. The structure is home to the Hill Country Museum today.

SCHREINER WOOL & MOHAIR COMMISSION CO ONE OF THE LARGEST PRIMARY HANDLERS OF WOOL & MOHAIR IN THE WORLD. KERRVILLE TEX. MS56

Kerrville was a center of mohair and wool production in the mid-twentieth century. In this historical photo, the Schreiner warehouse is filled to the roof.

Park in the large parking area and stroll under the huge pecan trees to the one-story, limestone visitor's center. Before entering, listen for a Carolina wren, white-eyed vireo, blue jay, or great-crested flycatcher calling from nearby vegetation. Inside the center, tour the displays, visit the gift shop, or take advantage of the restroom facilities.

Outside the center is a sensory garden filled with fragrant herbs, a wildflower meadow that hosts blooms from spring to fall, a prairie grass meadow, plant store, and nature study lab. Volunteers host bird, butterfly, and nature study walks throughout the day. Look for a schedule of activities in the visitor's center.

Kerrville Schreiner Park on Texas Highway 173 south of Kerrville offers more opportunities to get outside and enjoy the comfortable, if not calming, climate. The park was long operated by the Texas Parks and Wildlife Department, but park operations were turned over to the City of Kerrville in 2006. The park offers river access, camping, swimming, cabins, fishing, and an enclosed butterfly garden. Parkland across Highway 173 offers primitive camping and hiking.

ROUTE 30

Mountain Home Loop to Junction

The small community of Mountain Home just off of Interstate 10 opens up a unique area of relatively unspoiled and wide-open lands. Be sure to fill up your tank with gasoline before leaving the interstate—you'll find few gas stations along this route.

Texas Highways 27 and 41 intersect at a four-way stop in Mountain Home. Take Highway 41 west and watch for the crossing of Johnson Creek just outside of town. Notice the pink sandstone exposed during highway construction that towers over the road. As you drive through the open grasslands, keep an eye out for birds, like blue grosbeaks that fly up in spring and summer from grassy fields on each side of the road.

The road gradually climbs and then levels out to a flat, wide plain with grasslands spreading out on both sides. Game-fences rising six to eight feet along the road are designed to keep deer and exotic game animals in while keeping undesirable animals out.

Entrance to the YO Ranch is fifteen miles west of Mountain Home. Charles Armand Schreiner, a famous businessman from Kerrville and founder of what ultimately became Schreiner University, bought the Taylor-Clements Ranch and the YO brand in 1880. Schreiner raised Texas longhorn cattle and drove them along the Chisholm Trail to the railhead in Abilene, Kansas.

The YO Ranch, still famous for keeping longhorn cattle as well as native and exotic wildlife, offers daily tours and photo safaris. Organized activities throughout the year include trail drives, getaway weekends, day visits, and hiking. Call 830-640-3222 or go to www. yoranch.com for information.

Graven Store sits on the corner of Highway 41 at the intersection of U.S. Highway 83. Folks at the store are serious about cooking tasty barbeque, and they'll welcome you to sit out back for a mouthwatering lunch with a soda or cold beer. Gifts

Route 30

Mountain Home is off Interstate 10, 35 miles east of Junction. Texas Highways 27 and 41 intersect in Mountain Home. Continue on Highway 41 west, past U.S. Highway 83, to U.S. Highway 377. U.S. 377 north leads back to Junction. The route can be shortened by taking U.S. 83 north back to Interstate 10 and then west to Junction.

A longhorn made of iron graces the entry gate to the YO Ranch.

are available inside the store and restrooms outside. Stock up on snacks and drinks before you continue your journey.

The route continues west on Highway 41 for another thirty-five miles on a wide-open road. An alternative would be to return to Junction on U.S. 83, but that would be missing the pleasure of driving seemingly boundless straight roads through gorgeous country.

At the intersection of U.S. Highway 377, turn northeast toward Junction. You'll find U.S. 377 a wide road with expansive grassy shoulders and rolling terrain dotted with oaks and juniper. Within thirteen miles of Junction, you'll reach the small community of Telegraph. The only building in the charmingly small town houses a post office and store. The town got its name from a nearby canyon where wood was cut for telegraph poles.

Coke R. Stevenson, who served as Texas governor from 1941 to 1947, hailed from Telegraph. Stevenson ran in the Texas Democratic Primary of 1948 for the U.S. Senate against a U.S. congressman named Lyndon B. Johnson, but lost the race by a mere eighty-seven votes. The race ranks among the most notorious election scandals in American history, with accusations of ballot-box fraud against both Stevenson and Johnson. After his defeat, Stevenson retired to his ranch in Telegraph and lived to be eighty-seven years old, ironically, the same number by which he lost his Senate bid. Johnson, of course, went on to become the thirty-seventh president of the United States.

But back to the highway past Telegraph where you'll get a view of the Llano River here and there. An overlook atop a bluff provides a scenic vista with the Llano River flowing below. The wide-open spaces along the route eventually close in as the road approaches Junction.

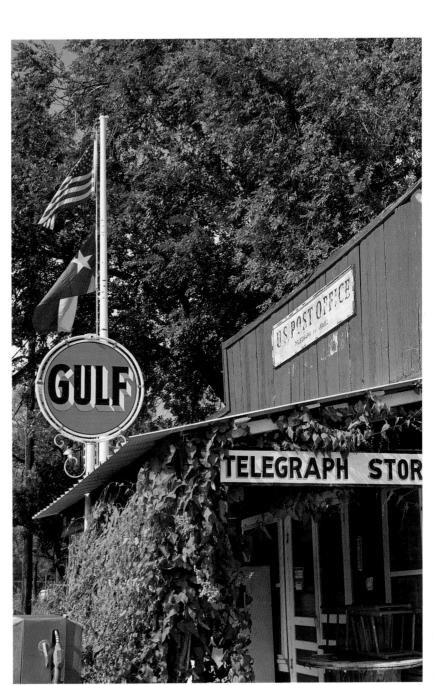

Telegraph is thirteen miles outside Junction on U.S. 377. The only building standing is this store housing the post office. The town got its name from a nearby canyon where wood was cut for telegraph poles.

OPPOSITE: The wide-open skies of Edwards County are visible on a summer day from U.S. 377 in the Texas Hill Country.

Post oak trees are common in the Texas Hill Country. These oaks are silhouetted against an early evening sky decorated with a crescent moon.

FURTHER READING

Texas Parks and Wildlife Department: www.tpwd.state.tx.us. Reservations can be made online or by calling 512-389-8900.

Free Texas travel guide available at www.traveltex.com or at visitor information centers.

Geography

Roads of Texas Atlas. College Station, TX.: Texas A&M University Press, 2005.

Geology

Spearing, Darwin. *Roadside Geology of Texas.* Missoula, MT: Mountain Press Publishing, 1991.

History

Beschloss, Michael R. *Taking Charge: The Johnson White House Tapes, 1963–1964.* New York: Simon & Schuster, 1997.

Campbell, Randolph B. *Gone to Texas: A History of the Lone Star State.* Oxford, UK: Oxford University Press, 2003.

Lemon, Mark and Craig R. Covner. *The Illustrated Alamo 1836: A Photographic Journey.* Abilene, TX: State House Press, 2008.

McDonald, Archie P. *Texas: A Compact History.* Abilene, TX: State House Press, 2007.

Pace, Robert F. and Donald S. Frazier. *Frontier Texas: History of a Borderland to 1880.* College Station, TX: Texas A&M University Press, 2004.

Tingle, Tim and Doc Moore. *Texas Ghost Stories: Fifty Favorites for the Telling.* Lubbock, TX: Texas Tech University Press, 2004.

Natural History

Dunn, Jon L. and Jonathan Alderfer. *National Geographic Field Guide to the Birds of North America,* 5th Ed. Washington, D.C.: National Geographic Society, 2006.

Hodge, Larry. *Official Guide to Texas Wildlife Management Areas.* Austin, TX: Texas Parks and Wildlife Press, 2000.

Loflin, Brian and Shirley. *Grasses of the Texas Hill Country, A Field Guide.* College Station, TX: Texas A&M University Press, 2006.

Loughmiller, Campbell and Lynn. *Texas Wildflowers, A Field Guide.* Austin, TX: University of Texas Press, 2002.

Parent, Laurence. *Official Guide to Texas State Parks.* Austin, TX: University of Texas Press, 1997.

Tveten, John and Gloria. *Butterflies of Houston & Southeast Texas.* Austin, TX: University of Texas Press, 1996.

INDEX

ABOUT THE AUTHOR AND PHOTOGRAPHER

Author **Gary Clark** is a Dean of Instruction at Lone Star College–North Harris in Houston, and he writes the weekly "Nature" column for the *Houston Chronicle*. He has published numerous nature articles in such magazines as *AAA Journeys, Birds & Bloom, Birder's World, Living Bird, Rivers, Texas Highways, Texas Parks & Wildlife, Texas Wildlife,* and *Women in the Outdoors.* Gary wrote the text for the books *Texas Wildlife Portfolio* (Farcountry Press, 2004) and *Gulf Coast Impressions* (Farcountry Press, 2007). He is a contributing author of the book *Pride of Place: A Contemporary Anthology of Texas Nature Writing* (University of North Texas Press, 2006) and *Birding the Border* (Publish America, 2007). He has won seven writing awards, and he is the recipient of the 2004 Excellence in Media Award from the Houston Audubon Society.

PHOTOGRAPH © KATHY ADAMS CLARK

Gary also co-leads bird-photography tours with his wife, professional photographer Kathy Adams Clark. He has been active in the birding and environmental community for over thirty years. He founded the Piney Woods Wildlife Society in 1982 and the Texas Coast Rare Bird Alert in 1983. He is past president of the Houston Audubon Society and currently serves on the Board of Directors for the Gulf Coast Bird Observatory and on the Board of Advisors for the Houston Audubon Society.

Photographer **Kathy Adams Clark** has been a professional nature photographer since 1995. She runs a stock agency that represents the work of fifteen outstanding nature photographers. Kathy's work has been published in many places, including *Nature's Best, New York Times, Birder's World, Texas Highways, Texas Parks & Wildlife,* and *Family Fun.* Her photos have also appeared in numerous books and calendars. Her photos appear every week in the "Nature" column in the *Houston Chronicle* written by her husband, Gary Clark. Kathy and Gary have published four books and have two more in the works that combine their photography and writing skills.

Kathy teaches photography at local and national events. Through Strabo Tours, she leads photo workshops to Costa Rica, Ecuador, and other locations. Kathy is past president of the North American Nature Photography Association.

PHOTOGRAPH © BILL FRANKLIN